THE MAKING OF SCULPTURE

The materials and techniques of European sculpture

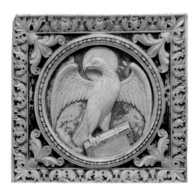

Edited by
Marjorie Trusted

V&A Publications

Dedicated with thanks to all past curators of sculpture
at the Victoria and Albert Museum

First published by V&A Publications, 2007
V&A Publications
Victoria and Albert Museum
South Kensington
London SW7 2RL

Distributed in North America by Harry N. Abrams, Inc., New York

Paperback edition
ISBN 978 1 85177 507 1

Library of Congress Control Number: 2007924510

10 9 8 7 6 5 4 3 2 1
2011 2010 2009 2008 2007

A catalogue record for this book is available from the British Library.

Designed by Caroline and Roger Hillier, The Old Chapel Graphic Design
www.theoldchapellivinghoe.com

New V&A photography by Christine Smith, V&A Photographic Studio

Cover illustration: Auguste Rodin, Dante, V&A: A.50–1914. Plate 80.
Half title: Giambologna, Samson and the Philistine, V&A: A.7–1954. Plate 172.
Frontispiece: Gilbert Bayes, The Lure of the Pipes of Pan, V&A: A.3–2004. Plate 307.
Title: An eagle, the symbol of St John the Evangelist, V&A: 269–1867. Plate 210.

Printed in Hong Kong

V&A Publications
Victoria and Albert Museum
South Kensington
London SW7 2RL
www.vam.ac.uk

Contents

Acknowledgements

We are grateful to the following for their invaluable help during the writing of this book: Frances Ambler, Paul Atterbury, Philip Attwood, Charles Avery, Francesca Bewer, Mary Butler, Judith Crouch, Patrick Elliott, Graham Franses, Alun Graves, Irene Gunston, Diana Heath, Charlotte Hubbard, Ken Jackson, Mark Jones, Alexander Kader, Andrew Lacey, Antoinette Le Normand-Romain, Victor Hugo López Borges, Tessa Murdoch, Charles Pineles, Felicity Powell, Joseph G. Reinis, Alain Richarme, Alicia Robinson, Mariam Rosser-Owen, Christine Smith, Danuta Solowiej-Wedderburn, Robert Wenley, Joanna Whalley, Paul Williamson and Hilary Young. We are extremely grateful to Diane Bilbey for her patient and careful co-ordinating, as well as her painstaking copy-editing of the text.

We are particularly grateful to The Gilbert Bayes Charitable Trust for their generous sponsorship of this publication, and of the gallery that partly inspired it. The publication was additionally supported by the bequest of Catherine Ward.

Foreword

If you take the trouble to stand in a gallery and observe the behaviour of visitors – as curators often do – it is quickly apparent what attracts most interest. Beautiful paintings and objects will always appeal aesthetically, and many are struck by works of art on a visceral level. Yet innumerable visitors are also fascinated by the creative process, by the actions which transform often intractable materials into works of the highest quality. The design process of sculpture, from the first ideas transmitted through drawings, clay or wax sketches to the completed figure or relief, represents a story to which all can relate.

In recent years, special efforts have been made to explain the creation of sculpture and other works of art in our galleries. Didactic models have been displayed, short films have been included and text panels have illustrated the methods of craftsmen from the Middle Ages to the present day. The new Gilbert Bayes Sculpture Gallery is dedicated entirely to this subject, and objects made in all the various materials available to sculptors are presented in an accessible and attractive manner. The success of the gallery has led to the production of this book, which seeks to highlight the common working practices over time, and to place the works in the context of what came before and after. Understanding the physical properties of the works and the methods employed in their manufacture can only increase the pleasure taken in viewing them.

The Victoria and Albert Museum is uniquely well placed to produce this book. Its National Collection of post-classical sculpture provides a rare and comprehensive resource for such a survey, and the interaction between curators and specialist sculpture conservators is endlessly productive and fruitful for both parties. It is a volume which has involved every member of the Sculpture Section, under the editorship of Marjorie Trusted, with the invaluable assistance of our conservation colleagues.

Paul Williamson
Keeper of Sculpture, Metalwork, Ceramics and Glass

Introduction

Sculptures can be made in a great variety of materials, determining their colour, size and texture. Why are different materials chosen and how are they worked? And what are the qualities of specific materials which make them more suitable for one type of sculpture rather than another?

In the past, a hierarchy of materials was perceived to exist, so that bronze and marble, for example, were considered superior to plaster or wax. This was partly because of the durability of metal and stone. Bronzes and marbles survive from ancient times, and are often used to commemorate people or events, since the sculptures or monuments endure over centuries. Semi-precious materials, such as gemstones and amber, are valued for their rarity. Conversely, plaster and wax are less costly and more vulnerable, but their distinctive qualities mean that sculptures made from them are often startlingly life-like, and both play a vital part in the process of sculpture when used for models. Some materials are more readily available in different parts of the world, such as limewood in southern Germany, or alabaster in Nottinghamshire, and workshops grew up in these areas. Geography and geology can therefore play a part in the evolution of sculpture (plate 1).

The historical contexts of sculptures, and the development of particular techniques, or the popularity of specific materials at certain times, clearly had an impact on the types of sculptures produced and the nature of patronage, or the way in which the marketplace operated. The choice of materials also undoubtedly affected the style of sculpture, and this too will be acknowledged in the following chapters.

Although this is not a comprehensive history of sculpture, neither is

1 Map of Europe showing the leading centres of sculpture

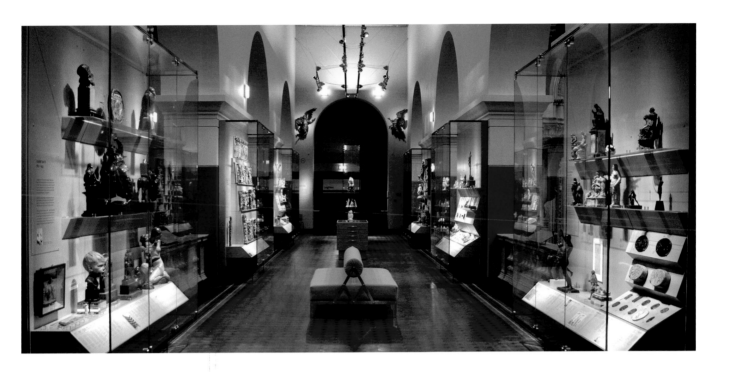

it purely a technical handbook, and so the demands made by individual contexts, and the purposes for which the sculptures were made, will also be discussed. In addition, sculpture cannot be seen in isolation from other arts, notably paintings, drawings, engravings, architecture and ceramics, and, when relevant, such connections are made here.

The National Collection of sculpture at the Victoria and Albert Museum has provided a rich resource for this study of the making of sculpture, in particular the displays in the Gilbert Bayes Sculpture Gallery (Room 111), which opened in 2004 (plate 2). As such, this publication can be read as a handbook for those visiting the Museum, although it is also intended to stand independently, for anyone interested in sculpture. Each chapter is devoted to one material, or a related group of materials or type of sculpture, but at the same time acts as a narrative description of the production of sculpture, rather than a dictionary of terms. Brief bibliographies of related publications are appended to the chapters, as well as a list of those artists mentioned in the text, with their dates. A glossary of terms is also included.

The book complements two previous publications: Nicholas Penny's *The Materials of Sculpture* (1993), and Jane Bassett and Peggy Fogelman's *Looking at European Sculpture. A Guide to Technical Terms* (1997). We concentrate on European sculpture from the Middle Ages onwards, and have aimed to provide an account of sculpture which both celebrates its diverse forms and elucidates how sculptors worked.

2 View of the Gilbert Bayes Sculpture Gallery (Room 111)

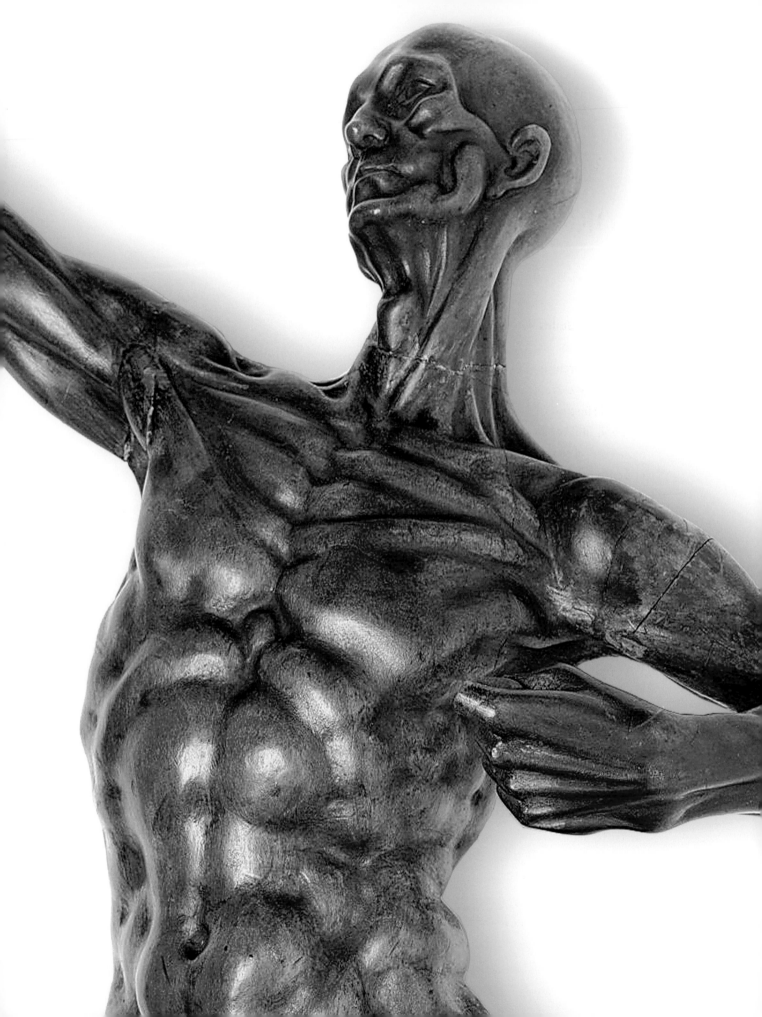

Chapter 1

WORKING PRACTICES

Patronage, Guilds and Academies

Throughout the Middle Ages, the most important patron for sculpture was the Church. In Carolingian and Ottonian times, from the late eighth to the early eleventh centuries, sculptors worked mainly in workshops in monastic institutions or episcopal cities, producing small devotional reliefs in ivory, and other works of art for the Church. An increased interest in monumental sculptures in wood and stone evolved over the course of the eleventh century, the majority of which were used to adorn the exteriors of cathedrals and churches.

In the second half of the twelfth and during the thirteenth centuries, cities such as Paris, Cologne, Florence and London grew rapidly, and became important centres for the practice of sculpture and other arts. The architects and mason-sculptors were part of masons' lodges, organizational centres and workshops attached to greater or lesser buildings, in particular cathedrals and large churches. The masons' lodges monitored work and imposed certain rules of trade and practice, while training was provided to younger men by experienced sculptors and craftsmen. In addition, many artisans, including sculptors, belonged to guilds, which regulated certain aspects of their work, such as the quality of materials, payments, and the number and training of apprentices, protected the interests of their members and promoted their professional standing.

Guilds evolved in cities from the late twelfth century onwards, but most were formally established in the fourteenth and fifteenth centuries, and were often a strong force in political and civic life. From the fifteenth century onwards, sculptors generally learned their skills through apprenticeship to a master who was a member of a guild. They were regarded as skilled craftsmen rather than artists in the modern sense, however a slight shift in their status and attitudes towards their work had taken place by the end of the fourteenth and during the early fifteenth century, when sculpture started to be increasingly admired, particularly in Italy. This tendency

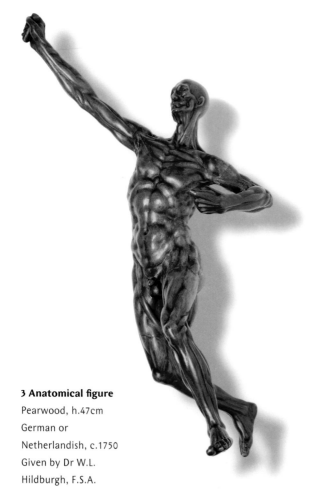

3 Anatomical figure
Pearwood, h.47cm
German or
Netherlandish, c.1750
Given by Dr W.L.
Hildburgh, F.S.A.
V&A: A.16–1951

continued during the sixteenth century, and as a result sculptors gradually emancipated themselves from the strict regimes of the guilds.

The rising status of the artist was reflected in Giorgio Vasari's *The Lives of the Most Excellent Painters, Sculptors and Architects*, which was first published in Florence in 1550. Vasari, himself a painter and architect, was the first to give an account of the lives and achievements of mainly Italian artists from the thirteenth to the sixteenth century, including sculptors such as Donatello and Michelangelo. More than a collection of individual biographies, the underlying conception of Vasari's work was that stylistic development is driven by the innate genius of the artist.

Vasari was also instrumental in setting up the first artistic academy, the Accademia del Disegno, in Florence in 1563. This was followed by the Accademia di San Luca in Rome, which was founded in 1593. During the seventeenth and eighteenth centuries, academies were established all over Europe: in Paris (1648), Vienna (1692), Berlin (1697), Dresden (1705), Madrid (1744) and London (1768). These academies provided theoretical and practical training, including life drawing, as well as opportunities for exhibiting works. They also formed collections of plaster casts of celebrated classical sculptures to be drawn and studied. Anatomy was an important part of the tuition of young artists; giving them an understanding of the human body and muscular structures, and three-dimensional models of flayed figures (*écorchés*) in bronze, wood, wax and plaster played a major role in this training (plates 3 and 4).

Major changes in the relationship between artist and patron began to occur from the sixteenth century onwards. On occasion the two parties met almost as equals, because of the high esteem in which the creative artist was held. The patron himself was no longer the mere donor of an ecclesiastical work, but was often able to appreciate and discuss the artistic qualities of his commission.

New contexts for works of art evolved during the seventeenth century. Sculptures could be seen in royal and aristocratic collections, and in cabinets of curiosities (*Kunstkammern*), although access to works of art

was restricted until the establishment of public museums. The first public museum in Britain, the Ashmolean Museum in Oxford, opened in 1683, while the British Museum was founded by an Act of Parliament in 1753, followed by many others elsewhere in Britain and on the Continent in the late eighteenth and throughout the nineteenth centuries. Such collections raised the status of art, and also enabled artists to study and copy works of art more freely.

From 1667 onwards, the Académie Royale de Peinture et de Sculpture in Paris held occasional exhibitions of recent works for periods of three weeks in the Louvre. The Paris exhibitions were succeeded by the Salon, named after the Salon Carré in the Palais du Louvre in 1737. Both shows of official French art were reserved for members of the Académie, but from 1795 all artists were admitted, and at the same time it became an annual event throughout the nineteenth century. Soon other groups and academies in Europe followed this example. In London the Society of Artists organized annual exhibitions for painting and sculpture from 1762 onwards, to be followed, and indeed superseded, by the Royal Academy, which was founded in 1768; this institution inaugurated annual exhibitions for painting and sculpture in 1769.

The Great Exhibition of Products of Industry of All Nations, held in London in 1851, was the first of many international exhibitions held in the nineteenth century which included sculpture, and which were seen by a wide audience. The Great Exhibition led directly to the founding of what are today the Victoria and Albert Museum and the Royal College of Art. The Royal College was established in 1863 on the perimeters of the Museum. It has now moved to new premises nearby, and a variety of crafts are taught, including sculpture, jewellery and fashion.

Travel and study, especially to Italy, was another important way in which sculptors could train. Many northern artists, including Giambologna and François du Quesnoy, went to Italy to work and settled there, while others, such as Hubert Gerhard, Willem van Tetrode, Johann Gregor van der Schardt and Balthasar Permoser, returned to the north after a sojourn in Italy. Some academies awarded travel scholarships, enabling young students to travel to Italy to study sculpture. Joseph Nollekens and John Deare were both beneficiaries of prizes from the Royal Academy, which paid for them to spend some years working in Rome.

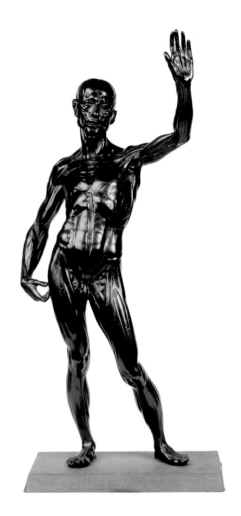

4 Anatomical figure by Ludovico Cigoli
Bronze, h.62cm
Italian, c.1580
Bequeathed by Dr W.L. Hildburgh, F.S.A.
V&A: A.25–1956

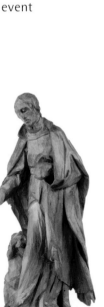

Drawings and Models

Although model books existed for sculptors in the Middle Ages, it was not until the fifteenth century that sculptors expressed their initial ideas in drawings or sketch models: usually a preliminary drawing followed by a three-dimensional model. Models could be rough or detailed, and large- or small-scale, and often formed part of the sculptor's contract with the patron. They were generally made in relatively cheap, ephemeral materials, such as wax, clay, plaster or wood.

Several examples in the V&A illustrate this first stage for individual figures. Sometimes only the model is extant, and the finished work is no longer known to have survived – possibly lost or never actually made. Such is the case with this boxwood figure of a male saint, probably St John the Evangelist, which was produced in the northern Netherlands in about 1610 (plate 5). The sculpture for which it was a model has not been identified, but it is likely to have been a large alabaster sculpture, similar to the figure of St John (see also plate 199) by the seventeenth-century Netherlandish sculptor Hendrik de Keyser, placed between the spandrels on the 's Hertogenbosch rood-loft (plate 6).

The small pearwood figure of St Francis Borgia of about 1750–51, carved by Paul Egell (plate 7), was a sketch model for a larger wood figure commissioned for the Church of the Jesuits in Mannheim. The finished sculpture was intended to surmount one of the side altars – designed in around 1750 by Egell – dedicated to St Francis Borgia. The model represents an early stage in the evolution of Egell's design for a figure, which was never executed because the St Francis Borgia altarpiece was not in the event

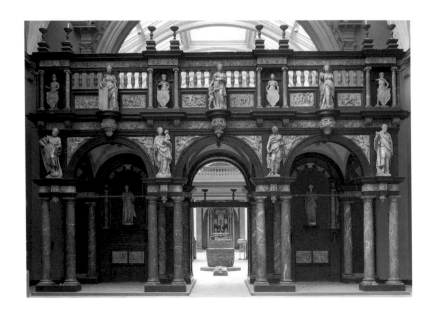

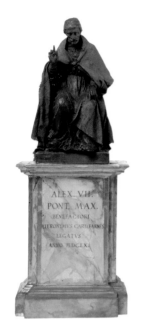

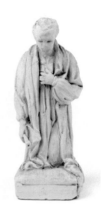

erected. Nevertheless the model has survived, suggesting it was considered of some importance.

This wax model on a wood base (plate 8), dated 1660, is by Dorastante Dosio, who was active in Bologna in the second half of the seventeenth century. The figure is partly draped in stiffened fabric and was probably an early design for the monumental bronze figure of Pope Alexander VII for the Sala Farnese in the Palazzo Pubblico in Bologna (plate 9). Although the finished bronze differs in some details, probably at the instigation of Cardinal Girolamo Farnese, who commissioned the monument, its base is almost identical to that of the model.

A rare surviving example of a preliminary sketch model in unfired clay is the kneeling figure of Reginald Heber, Bishop of Calcutta (plate 10). It was made by Sir Francis Chantrey in about 1827 for the life-size marble monument in St Paul's Cathedral in London (plate 11).

Models could occasionally be made of other more durable materials. Plate 12 shows one for the cover of a funerary monument in North Germany, dating from about 1580. Exceptionally it is of alabaster and depicts a recumbent female figure surrounded by heraldic shields and devices. The funerary monument for which it served as a model has not been identified, and may have been destroyed, or was again perhaps never erected.

above
**10 Reginald Heber,
Bishop of Calcutta
by Sir Francis Chantrey**
Clay, h.24.5cm
English, c.1827
Given by Mrs Hugh
Chisholm
V&A: A.29–1933

far left (top)
**8 Pope Alexander VII
by Dorastante Dosio**
Wax, partly draped with
stiffened linen, wood,
h.52.1cm
Italian (Florence), 1660
V&A: A.60–1921

far left (bottom)
**9 Pope Alexander VII
by Dorastante Dosio**
Bronze
Italian (Florence), c.1660
Palazzo Pubblico,
Bologna

left
**11 Reginald Heber,
Bishop of Calcutta
by Sir Francis Chantrey**
Marble
English, c.1827
St Paul's Cathedral,
London
Reproduced by
permission of English
Heritage, NMR

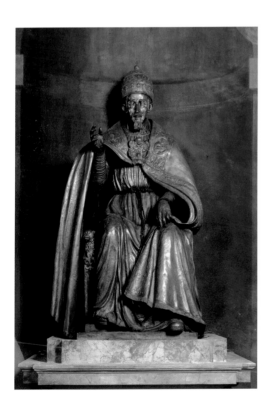

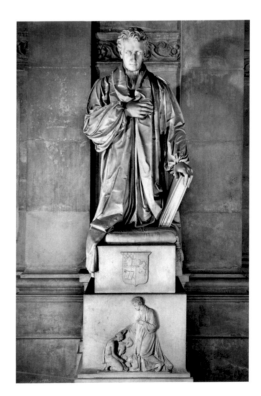

**12 Model for the
cover of a funerary
monument**
Alabaster, l.24cm
North German, c.1580
V&A: 1170–1864

Two surviving models by Louis François Roubiliac provide insights into the creative design process for the funerary monument of John, 2nd Duke of Montagu (d. 1749), which was commissioned in 1749 and erected in 1754 in St Edmund's Church in Warkton, Northamptonshire (plate 13). The terracotta model (plates 14 and 15) shows an early stage in the process: slight differences are evident between this and the actual monument, such as the trophies and the portrait of the Duke, who is shown wearing a wig in the model, but who is represented in a more classic mode in the finished sculpture. Its reverse reveals how it was built up by roughly formed pieces of clay (plate 15). Another model for the same monument (plate 16) is made of painted wood and plaster, and represents a more advanced version, closer to the completed work. The trophies are now three-dimensional, and the portrait of the Duke in the oval medallion is rendered without a wig.

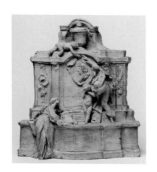

above left
**14 Model for the
funerary monument
of John, 2nd Duke
of Montagu by Louis
François Roubiliac**
Terracotta, h.34.8cm
English, c.1749
Given by Dr W.L.
Hildburgh, F.S.A.
V&A: A.6–1947

above right
**15 Reverse of the model for
the funerary monument of
John, 2nd Duke of Montagu
by Louis François Roubiliac**

right
**13 Funerary monument of
John, 2nd Duke of Montagu
by Louis François Roubiliac**
English, 1749–54
St Edmund's Church,
Warkton, Northamptonshire
Photo courtesy of The Paul
Mellon Centre

left
**16 Model for the funerary
monument of John, 2nd
Duke of Montagu
by Louis François Roubiliac**
Painted wood and plaster,
h.63.2cm
English, c.1750–4
Loaned by the Dean and
Chapter of Westminster
Cathedral

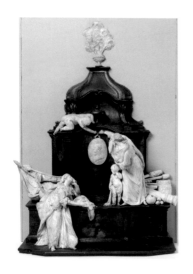

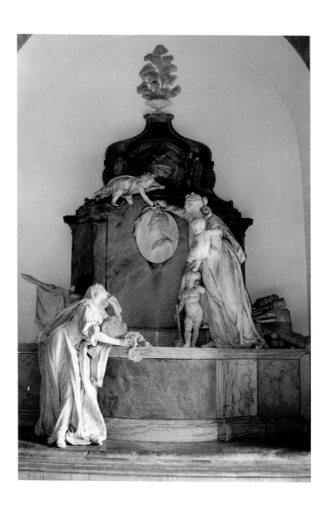

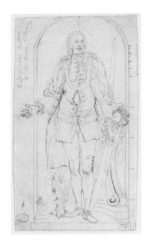

Drawings can also form part of this first stage of the design of a sculpture. They can be ideas approximately sketched out, designs for certain specific details, or more finished presentation drawings of the whole. The design in pen and ink by John Francis Moore for a commemorative marble statue of Alderman William Beckford (1709–70) (plate 17) was clearly a presentation drawing and includes a scale indicating the size in feet on the right. The statue was to be erected in the Guildhall in London, following a competition held in 1770, the year of Beckford's death, in which London sculptors were invited to submit drawings and models. The sculptor Nathaniel Smith submitted a terracotta model (plate 18) for the competition, and although he and Moore were rivals, it is surprisingly closely related to Moore's design. Other London sculptors, including Agostino Carlini and John Flaxman, also submitted models, but Moore had in fact already been secretly selected to carve the monument by the Committee set up by the Common Council, and so the competition was in effect a sham.

Once a design was approved by the patron, the next step was the translation from the small-scale model to a transitional larger model in plaster, and then to a full-size version in marble or some other material. The technique of pointing was frequently used to enlarge a model. Pointing involves transferring relative distances between high points on the model, such as limbs or other extremities, to the corresponding points on the marble block. This was achieved by a mechanical device, either callipers or a pointing machine (plate 19).

far left

17 Design for the marble statue of Alderman William Beckford by John Francis Moore
Pen and ink, h.30cm
English, c.1770
V&A: 4911.12

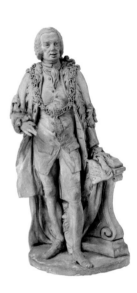

above

18 Model for the marble statue of Alderman William Beckford by Nathaniel Smith
Terracotta, h.28cm
English, 1770
V&A: A.48–1928

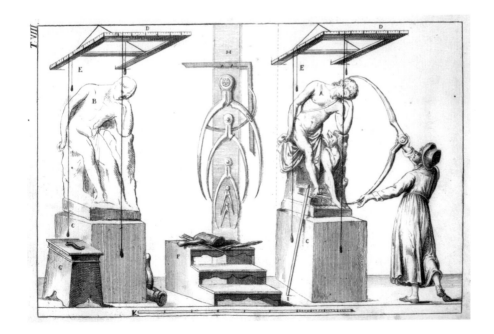

left

19 A sculptor measuring for pointing by Francesco Carradori
Print from F. Carradori, *Istruzione elementare per gli studiosi della scultura*, Florence, 1802

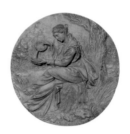

right
21 Temperance by Peter Flötner
Solnhofen limestone, diam.6.8cm
German (Nuremberg), c.1540
V&A: 184–1867

Dissemination of Styles

The design and production of sculpture was sometimes closely linked with the decorative arts – in particular the work of ceramicists and goldsmiths – and sculptors often played a seminal role in providing designs to be executed by other craftsmen. Ideas might be transmitted through plaquettes, as well as by decorative objects, for which sculptors produced the models. One of the most versatile artists of the German renaissance, Peter Flötner, who was active in Nuremberg in the sixteenth century, produced several series of plaquettes, among them *The Virtues, Eminent Women of Classical Antiquity* and *The Seven Gods of the Planets*. The three plaquettes of *Temperance, Cleopatra* and *Mars* are examples from each of these series (plate 20).

While in Italy plaquettes were predominantly made of bronze, Flötner often used lead or a copper alloy (brass). He employed wood or Solnhofen limestone for the initial design (plate 21), which was then widely disseminated through the plaquettes. These were used by goldsmiths, clock-makers, ivory carvers and pewter-makers, as well as for the decoration of bells, mortars and stove tiles. Sculptors of large wood decorations to adorn façades of houses in Lower Saxony also drew on these designs.

above

**20 Temperance,
Cleopatra and Mars
by Peter Flötner**
Lead, cast, diam.7.6cm
German (Nuremberg),
c.1540
V&A: A.29–1954;
A.32–1954; A.21–1954

right

22 Priming flask
Brass, gilt, h.9.5cm
German (Nuremberg),
1574
V&A: M.1630–1944

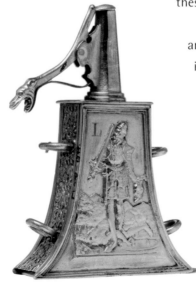

The frequency with which goldsmiths and other craftsmen copied these reliefs indicates their popularity; they were easily portable and were also used by artists outside Germany. A salt-cellar made for Queen Elizabeth I, for example, made by a London goldsmith in 1572–3 and now preserved in the Tower of London, shows five reliefs which are based on Flötner's plaquettes, among them *Cleopatra* (see plate 20). Another example is a priming flask, made in Nuremberg and dated 1574,

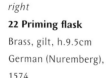

now in the V&A (plate 22), which depicts relief figures of Arminius and Ariovist from the sculptor's series of the *Twelve Mythical German Kings*.

In the eighteenth century sculptors supplied models for the first European porcelain manufactory, founded in Meissen near Dresden in 1710 by Augustus the Strong (r.1694–1733). The figure of *Charity* or *Abundance* (plate 23) from the circle of Balthasar Permoser was probably made in preparation for a figure group in porcelain or perhaps red stoneware. Other sculptors, such as the ivory carvers Johann Christian Ludwig von Lücke and François Bossuit, provided models of their works for the manufacture of ceramics. Some of Bossuit's ivories were also copied for Böttger stoneware. In eighteenth-century France the sculptor Etienne Falconet produced numerous models for the Sèvres factory, while in Britain various sculptors worked for Josiah Wedgwood (1730–95) in the 1770s (see also *Wax*). Parian ware, produced by the Minton factory in Britain in the mid-nineteenth century, reproduced models by the French sculptor Albert Ernest Carrier-Belleuse, and the British artists John Gibson, Joseph Durham and John Bell amongst others.

Sculptors continued to work with ceramics manufacturers into the twentieth century. The German sculptor Ernst Barlach, for example, collaborated with the Meissen factory in the 1920s and 1930s, while other sculptors worked in-house in various factories designing figurative pieces in porcelain. In Britain the twentieth-century ivory sculptor Richard Garbe worked for the Doulton factory, his ivories being copied in porcelain, while the Argentinian artist Lucio Fontana, who trained in Italy as a sculptor, worked at the Sèvres factory designing porcelain figures in the 1930s. **NJ**

23 Charity or Abundance by circle of Balthasar Permoser
Terracotta, h.33cm
German (Dresden)
V&A: A.4–1989

Chapter 2

WAX

For ladies who have a taste for modelling, wax is infinitely more convenient for portraits or other small subjects than clay, because it can be laid aside and taken up again in a moment, after a day, week, or year, as it does not spoil like a clay model.

Archibald Billing (1791–1881)

Wax is central to the production of sculpture in other materials as diverse as bronze, terracotta and marble, but it is also a sculptural medium in its own right. It is at once an additive and a reductive technique: it may be modelled by being built up gradually, but can also be carved. In addition, it can be melted down and cast in a mould, often subsequently hand-finished by the artist. Although it is a versatile and commonplace material, the history of wax sculpture has only been researched sporadically, and much remains to be discovered.

Wax Effigies

The earliest known wax figures date back to 2100 BCE, and were used by the Egyptians in funerary rites. The most popular surviving type are amulets depicting the four sons of Horus, which were placed between the wrappings of mummies (plate 24). Ancient Egyptian figures thought to have been used in the production of bronze statuettes using the lost-wax technique also survive.

In the first century CE, the Roman writer and natural historian Pliny (23–79 CE), in his *Naturalis Historia,* recorded how different types of wax could be treated and refined to make small votive figures for domestic altars, and larger effigies used in the veneration of thedead. He referred to ancient Greece, citing Lysistratus, who lived in the fourth century BCE, as the first person to make a statue in wax. Death-

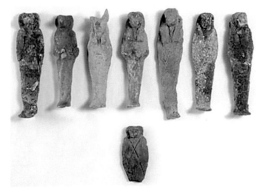

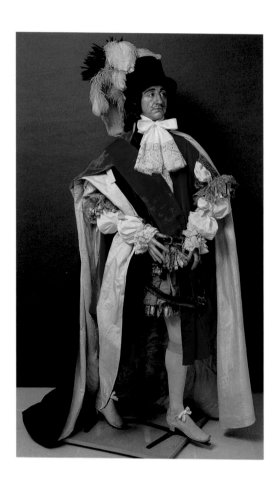

25 Charles II
Wax, h.188cm
English, 1685
Westminster Abbey,
London
Copyright: Dean and
Chapter of Westminster

masks made from wax were evidently commonplace at this time, and extraordinarily an example from Pliny's time survives in the Archaeological Museum in Naples.

The popularity of funerary wax effigies was revived during the fifteenth century, the Medici in Florence being particularly instrumental in promoting their use. However, these waxes were not valued primarily as works of art. An exceptional level of verisimilitude can be achieved in wax; an effigy can reach an astonishing, almost sinister level of similarity to the dead person. Funerary effigies of this kind continued to be popular during the seventeenth and eighteenth centuries, and examples survive in Westminster Abbey of the monarchy and illustrious personages buried there, including Charles II (1630–85) (plate 25) and Queen Anne (1665–1714). Although no monument was erected to Charles II in the Abbey, this life-size wax stood by his grave for over a century, and according to a contemporary source, 'tis to ye life, and truly to admiration'.

In medieval times it was common for the nobility to lie in state between death and burial. In instances where the faces of the dead had been disfigured, a wax mask modelled in the person's likeness would be substituted. This practice evolved into the use of full-size figures which were held aloft at the head of the funeral procession. From this grew the tradition of the waxwork, popularized by Marie Grosholtz, better known as Madame Tussaud, who opened her first museum in London in 1802.

One of the Westminster Abbey effigies, that of Admiral Lord Nelson (1758–1805), was executed by Catherine Andras. Andras specialized in wax and became official Modeller in Wax to Queen Charlotte at the beginning of the nineteenth century, thus providing a link between the historic use of wax in the production of rather macabre effigies, and its employment as a material for sculpture.

Recipes for Wax

Originally the wax used for sculpting was principally beeswax. In the early nineteenth century however this was replaced by the use of synthetic waxes, such as paraffin wax and stearin, which are obtained as by-products of manufacturing industries and are therefore cheaper and more plentiful.

The different uses of wax necessitated a variety of recipes in order to facilitate production and obtain the desired finished product. A sketch model to be fashioned in the hand, for example, needs to be malleable during production at room temperature, and would need to remain so to enable later revisions.

Several historic wax recipes survive, including one recorded by Giorgio Vasari (1511–74): 'To render it softer a little animal fat and turpentine and black pitch are put into the wax, and of these ingredients it is the fat that makes it more supple.' The wax also has to adhere to itself so that the build-up of material will not end up looking patchy. For this both Vasari and the nineteenth-century artist and writer Archibald Billing recommended the addition of turpentine. Billing wrote, 'A little oil of turpentine is to be mixed in whilst the wax is still liquid – about seven or eight drops to every ounce of wax; this is for the purpose of making the wax adhesive; as without the turpentine fresh-added bits of wax would not stick on in working the model.' For casting, however, a harder mixture can be used, because it is heated more strongly and cools directly afterwards, without requiring a prolonged period of plasticity.

Varying degrees of translucency and opacity may be required, which can be modified by the addition of differing amounts of the pigment lead white. Adding a significant amount of lead white will reduce the 'waxy' look and render a more opalescent effect, which is desirable for a monochrome wax. Adding colour was often a primary concern for the artist, and this was done by mixing finely ground pigments into the molten wax. On the whole, wax retains colour effectively and is resistant to fading, thus bright and subtle colours were chosen and many have survived well. Pigment was also important in monochrome waxes in order to highlight contours. For modelling, red was favoured, but pink, white and yellow were also common in eighteenth- and nineteenth-century works.

Sketch Models

Although drawings were sometimes used, a three-dimensional model was an intrinsic stage in the process towards a finished sculpture, and many models were made in this versatile material. However, the very nature of such an object means that it is unlikely to survive. Sketch models had to be easy to alter, but their adaptability meant they were vulnerable, and indeed they were generally not intended to last. During the sixteenth century, the fame of certain artists, such as Michelangelo and Giambologna, meant that objects associated with them, including sketch models, became desirable in their own right. Often they were more closely linked to the artist because his

right
**26 Model of a slave
by Michelangelo**
Wax, h.16.5cm
Italian, c.1516–19
V&A: 4117–1854

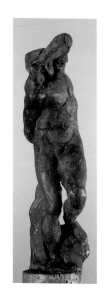

below
**27 Young slave
by Michelangelo**
Marble, h.235cm
Italian, c.1520–23
Galleria dell'Accademia,
Florence
©2004. Photo Scala,
Florence – courtesy of
the Ministero Beni e
Att. Culturali

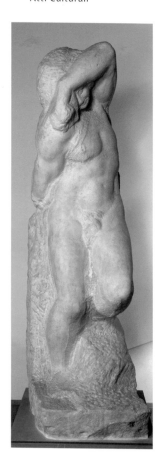

hands had actually formed the composition, whereas the finished piece would have been completed by a workshop or foundry. The worth attached to such objects increased, and their preservation became more commonplace, the artist giving models to favoured pupils; in some cases they were sought by rival sculptors as a source of inspiration.

One of the most remarkable sculptures in the V&A's collection is the Michelangelo sketch, *Model of a Slave* (plate 26). Although it stands at a mere 16.5cm high, its power and force are undeniable. Michelangelo would have roughed out this wax himself. It is a model for the *Young Slave* (plate 27), one of the unfinished group of monumental marble sculptures which were part of a scheme never actually realized for the tomb of Pope Julius II in the church of S. Pietro in Vincoli in Rome.

Vasari described the technique of modelling wax in his *Lives of the Artists*. He noted that the raw material, once prepared to the artist's favoured recipe, would be formed into sticks or rolls. It would then be warmed in the hand and formed into shapes, often built up in sections, or a metal core or armature embedded in a base of wood or cork to give the wax some support. Michelangelo's project was conceived on a grand scale, comprising some 40 life-size figures in marble, and so working out the figures individually on a small scale would have been essential. The pliability of the wax enabled changes to be made repeatedly, until the artist was happy with the composition. The sketch could then be scaled up into the full-sized marble. According to Vasari, Michelangelo immersed the wax model in water so that initially only the top part was visible. When that section had been executed in marble he would raise the wax further out of the water so that more of the composition was revealed and it in turn could then be completed, and so on until the marble figure was finished.

According to the Florentine writer and collector Filippo Baldinucci (1625–97), soon after Giambologna's arrival in Italy he met the aged Michelangelo and presented him with a finely finished wax statuette. The older artist was said to have taken the statuette, crushed it in his hands and then remodelled it into a more vibrant composition before the young man's eyes, demonstrating in a dynamic way the importance of composition as opposed to surface details.

As a mature artist Giambologna modelled some exceptionally forceful wax studies. Two of these were for the monumental three-figure marble

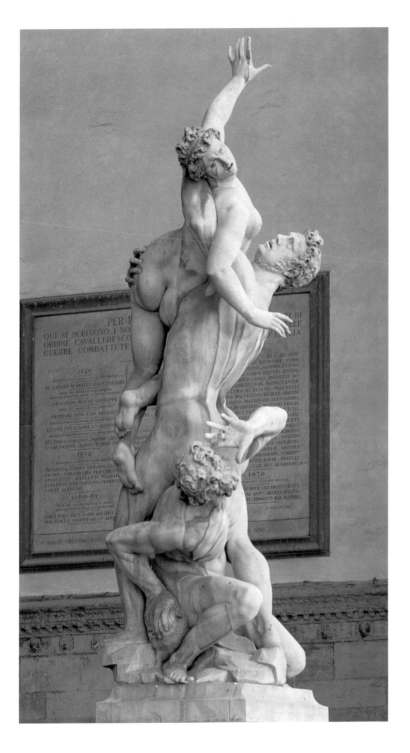

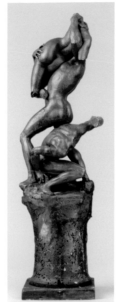

far left
**28 Rape of the Sabines
by Giambologna**
Marble, h.412.5cm
Italian, 1581–2
Loggia dei Lanzi,
Florence
©1990. Photo Scala,
Florence

left
**29 Rape of the Sabines
by Giambologna**
Wax, h.47.2cm
Italian, 1579–80
V&A: 1092–1854

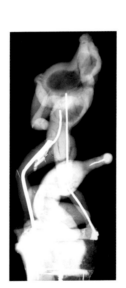

left
**30 X-ray photography
of Giambologna's
Rape of the Sabines**
Wax, h.47.2cm
Italian, 1579–80
V&A: 1092–1854

group he called the *Rape of the Sabines*, installed in 1583 in the Loggia dei
Lanzi in Florence (plate 28). The waxes illustrate the process and complexity
which lay behind the production of this most magnificent of Giambologna's
figure groups. X-ray photography of one of the waxes, a three-figure group
(plate 29), has revealed interesting aspects of Giambologna's wax modelling
technique (plate 30). The bold white lines extending vertically through the
group are metal armatures fixed into the base in order to strengthen the
structure. The pieces of metal used for the armatures and the wood for
the base would have been simply oddments in the artist's studio; their

roughness is in keeping with the immediate and transient nature of the sketch model. Wax has then been built up gradually over the armature to form each figure. It is also possible to discern where sections have been adhered to one another, particularly in the patchwork appearance of the torso of the standing figure. The armatures clearly extend from the base, up through both legs of the standing central figure, to enable him to bear the weight of the struggling female at the top. Interestingly, the figure at the top has a dark hole at the centre, indicating it is hollow, and therefore cast. It is most unusual to find both cast and modelled elements within the same sketch, and this suggests that this piece was worked on over a prolonged period. Probably in an earlier sketch the artist achieved a successful version of the struggling female, which was possibly too heavy to sit at the top of the three-figure composition. The hollow cast meant it was much lighter and could be added to a new configuration below, and the whole could stand upright. When the artist and patron were content with the composition it was scaled up into a full-size version in plaster, from which the final version was executed in marble. The plaster survives in the Accademia in Florence.

A vivid example of the artist's intimate engagement with his material when working in wax is Alfred Gilbert's unfinished *St George and the Dragon* (plate 31), which dates from about 1895. The wire armature is still fully visible, and the fact that the piece is unfinished enables the viewer to see clearly how the wax was built up in small beads, softened in the hand and then pressed into the rest of the composition. Fingerprints are clearly visible, providing a direct link with the artist himself. This group is again only a sketch model for a finished work (possibly the silver rose-water ewer and dish presented to George V (1865–1936) as a wedding gift by the Brigade of Guards), but nevertheless has great intensity.

31 St George and the Dragon
by Alfred Gilbert
Plasticine and wax on a wood base, h.20cm
English, c.1895
Given by Mr Sigismund Goetze through The Art Fund
V&A: A.88–1936

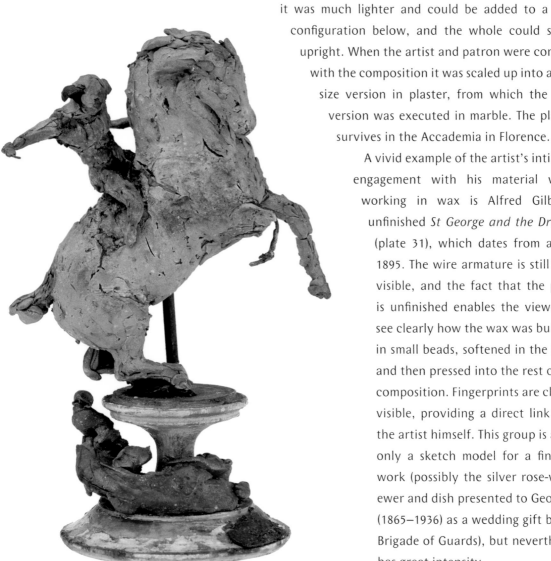

Portraits

Wax portrait sculpture originated in the sixteenth century. Antonio Abondio was an Italian medallist and wax modeller who spent most of his life working in Prague and Vienna for the Holy Roman Emperor Maximilian II and his successor Emperor Rudolf II (1522–1612), executing commissions for portraits of sitters such as Don Carlos (1545–68), son of Philip II of Spain (1527–98) (plate 32). Abondio is not only the earliest recorded maker of wax portraits, but his waxes were among the first to be recognized as sculptures in their own right. This portrait is set in a finely chased copper-gilt locket, and the surface of the brightly coloured polychrome wax is embedded with seed pearls and semi-precious stones. This type of object would often have been found in a cabinet of curiosities (*Kunstkammer*).

During the eighteenth and nineteenth centuries, low-relief portraits in wax became popular in Britain; they were often exhibited at the Royal Academy, the Society of Artists and elsewhere. Waxes were used in a similar way to prints and medals, in order to disseminate the image of the sitter, or, like miniature paintings or silhouettes, as portable mementos. Wax was well suited to being cast and reproduced many times over from the same mould in order to propagate an image. Individuals might have their portraits made during their lifetime in order to raise their public profile, or as treasured keepsakes for friends or relatives, and as remembrances after death.

Peter Rouw was a successful early nineteenth-century London wax-modeller who exhibited extensively at the Royal Academy. Rouw produced a portrait of the industrialist Matthew Boulton (1728–1809) (plate 33), commissioned by his son, Matthew Robinson Boulton, in commemoration of his father's death in 1809. Rouw's standard price for a wax portrait was 10 guineas, however Boulton's portrait was somewhat larger and cost 25 guineas for the initial model, and 14 guineas for each subsequent cast.

Perhaps the finest exponent of the monochrome wax portrait was Isaac Gosset, whose work is typified in this wax of Augusta of Saxe-Gotha (1719–72), Princess of Wales and mother of George III (1738–1820) (plate 34). The portrait emerging from a background of the same material is characteristic of his work. It was also common to mount the profile portrait on a backing of slate, blue glass or clear glass, which was painted from behind in order to emphasize the contrast with the pale cream or pink wax. The use of the same material for both background and figure highlights Gosset's virtuosity in creating an image from a flat surface.

The popularity of wax portraits was in part driven by their links with other types of portrait manufacture. In 1774 Josiah Wedgwood (1730–92)

**32 Don Carlos
by Antonio Abondio**
Wax on glass in copper-gilt locket, h.14.3cm
Italian, c.1671–2
Salting Bequest
V&A: A.525–1910

**33 Matthew Boulton
by Peter Rouw**
Wax on glass, d.37cm
English, 1814
Given by Charles Vine
V&A: 1058–1871

34 Augusta of Saxe-Gotha, Princess of Wales by Isaac Gosset
Wax, h.14cm
English, c.1760–70
V&A: 414:1356–1885

35 Napoleon
by Benedetto Pistrucci
Wax on slate, h.6.5cm
Italian, 1815
Bequeathed by Miss A.F.
Long
V&A: A.3–1940

36 Lord Moira
by Catherine Andras
Wax on glass, h.6cm
English, c.1800–12
Bequeathed by Rupert
Gunnis
V&A: A.125–1965

37 Lord Moira
by Catherine Andras
Wax on glass, h.6cm
English, c.1800–12
Bequeathed by Rupert
Gunnis
V&A: A.126–1965

instituted the production of ceramic portrait medallions. The first stage in their manufacture was a modelled wax portrait, and Wedgwood employed sculptors who are now famous as wax portraitists, including John Charles Lochée, Eley George Mountstephen, as well as Gosset and John Flaxman. A plaster mould was then made from the wax and thereafter used to make multiples in ceramic. James Tassie, the prolific gem-engraver, was also employed by Wedgwood; Gosset was later to work for Tassie, alongside Catherine Andras.

The nineteenth-century gem-engraver and medallist Benedetto Pistrucci used wax for sketch models, and was also aware of the versatility of wax in portraiture (for Pistrucci, see *Medals and Plaquettes* and *Semi-precious Materials*). He was commissioned to make a portrait in wax of Napoleon (plate 35) during the so-called Hundred Days, between Napoleon's return from exile on the island of Elba and his defeat at the battle of Waterloo in 1815. Pistrucci recorded in his autobiography:

> I made a model in wax of Napoleon – though not from a sitting; but I had many opportunities of seeing him very well – at chapel, in his garden, and in public, when he reviewed his troops – so that always comparing him with the wax model, which I kept in my pocket on purpose, with a little trouble, I at last completed a portrait which was considered extremely like, and was, I believe, the last portrait of him taken in Europe.

This portrait was probably the first stage in the production of a proposed commemorative medal, which was in the event never made because of Napoleon's defeat. Pistrucci's description is revealing not only in terms of the portability and versatility of wax in modelling, but also as a medium for rendering a life-like portrait which was to become a work of art in its own right.

The process of making a portrait in wax would begin with a model in plasticine or soft wax; this would be worked using ivory or wooden tools, in much the same way as a model in clay. At this stage only the most basic part of the design would be executed, because the next step was to make a plaster mould, during which process any fine details would be lost. The soft wax model itself would almost certainly be destroyed at this point, and the material re-used. The plaster mould was immersed in hot water to stop it from being porous to the molten wax; the inner face of the mould was then lubricated with oil to ease removal of the cast wax after it solidified. The molten wax would then be poured into the mould.

Wax shrinks when it hardens, and this can be seen when inspecting the back of a portrait of this type, which will often display a slight depression.

Although this shrinkage allows the wax to be removed from the mould more easily, it also gives rise to a high incidence of cracking. Lead white is therefore added in order to reduce this effect by increasing the bulk of the mixture.

After removal from the mould, the relief would be hand-finished by the artist. Shrinkage also causes fine surface detail to be lost, hence the increased need for hand-finishing. Details of the hair would be hand-etched using heated metal tools, while intricate details of the costume, such as cravats or layers of lace, would be added using separately fashioned pieces of wax. The separate hand-finishing can be seen by comparing two versions of a portrait by Catherine Andras of Francis Rawdon, Lord Moira (1754–1826), diplomat, soldier and close friend of the Prince Regent (plates 36 and 37). The dimensions and form of these two waxes are almost identical. Only in the fine detail can differences be noted, for example in the cravats and the tooling of the hair. Some of Andras's plaster models have also survived and are mounted and framed in the V&A's collection (plate 38).

Virtually no records survive of techniques used in the making of monochrome wax portraits. As a result their methods of production were sometimes misunderstood. Recently, detailed analyses have elucidated some aspects of their manufacture. The nature of wax is such that a high level of detail is achievable. This is evident in Gosset's *Augusta of Saxe-Gotha* (see plate 34): the pierced decoration of her bodice is meticulously detailed, as is the pearl decoration of her head-dress; the ribbon at the nape of the neck is delicate and realistic, while the fur collar and hair are visibly hand-tooled. It had been assumed that such portraits were carved from a solid block of wax, however analysis undertaken at the V&A in the 1970s and 1980s revealed that reliefs like this one were in fact initially cast, and the fine details added afterwards by the artist.

The surface of this wax is remarkably smooth and even, and its consistency is very hard. Such uniformity in the material is only possible

38 Plaster moulds for wax reliefs by Catherine Andras
Plaster of Paris,
h.17.5cm
English, c.1800
Bequeathed by Rupert Gunnis
V&A: A.118 to 123–1965

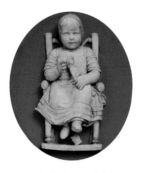

**39 Relief of a child
by John Flaxman**
(possibly the artist's
sister)
Wax on glass, h.15.5cm
English, 1772
V&A: 295–1864

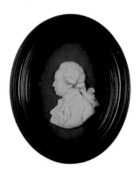

**40 John Henderson
by Eley George
Mountstephen**
Wax on glass, h.15.5cm
Irish, c.1782
V&A: 414:1368–1885

right top
**41 Mr Thomas Best
by Samuel Percy**
Wax on glass, h.9.3cm
English, c.1780–90
Bequeathed by Rupert
Gunnis
V&A: A.88–1965

right bottom
**42 Mrs Elizabeth Best
by Samuel Percy**
Wax on glass, h.9.3cm
English, c.1780–90
Bequeathed by Rupert
Gunnis
V&A: A.89–1965

to achieve in wax by melting it and pouring it into a mould, so that the whole of the surface hardens at the same time. Flaxman's *Relief of a Child* (plate 39) is markedly different. The piece has been built up gradually, using beads of wax softened in the hand, giving an overall inconsistency on the surface. In addition, a crystalline deposit is now visible; this is the result of the softening agents which were added to the wax in order to model it. Over time they have migrated to the surface, appearing as a mould or bloom which in some instances can develop into a sticky appearance. This is much less common in relief portraits, as additives were not necessary. Often large quantities of lead white were added to the molten wax in order to make it more opaque and to give it a flawless surface. This addition can be observed in the portrait of the actor John Henderson (1757–1888) by Eley George Mountstephen (plate 40). When wax is left to solidify, naturally heavy pigments will sink to the bottom unless it is stirred continually. For this reason, when wax is poured into a mould an increased opacity can be observed in the higher parts of the relief; the wax becomes progressively more transparent in the shallower parts. This is because the wax would have been left to harden face-down in the mould, and the particles sank to what become the highest points after the mould is turned out. Artists have exploited this by thinning out the periphery of the design, giving the whole a more delicate appearance. This phenomenon has been observed during the conservation of some waxes. Samples of wax are sometimes scraped from the back of a relief in order to fill losses on the surface. However, this wax is less densely filled with pigment, and so when it is added to different parts of the surface the match is imperfect; the added wax has therefore to be recoloured specifically for each part.

Low-relief polychrome wax portraits were produced using the same basic principles as monochrome ones: modelling in soft wax, taking a plaster mould and then casting. However, when the initial mould was finished it was cut into separate sections and each part cast in the prevailing colour. The pieces were then joined together on their backing using molten wax, and the surface finishing completed in a similar way. Foremost among artists working in polychromed wax was Samuel Percy, whose pair of portraits of Mr and Mrs Thomas Best (plates 41 and 42) would have been executed in this way. The finishing on these portraits is astonishingly detailed, and much use has been made of both additional sheets of sculpted wax and the chasing of the surface.

Percy's style evolved from low-relief portraits towards more three-dimensional work, and in doing so he adapted his working

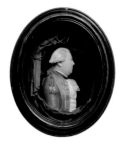

43 Mary Berry
by Samuel Percy
Wax on glass, h.30cm
English, c.1790–1820
V&A: A.14–1970

left
44 Death of Voltaire
by Samuel Percy
Wax, h.49cm
English, c.1775–1800
Given by Miss J.M. Duncombe
V&A: A.19–1932

practice. In portraits such as *Mary Berry* (plate 43) the figure can almost be seen in the round. The surface appearance suggests that the work is cast, but investigations during conservation reveal that, unlike the low-relief portraits, these high-relief portraits are hollow rather than solid. The reasons for this are two-fold. When the wax was poured into the mould it would only be allowed to cool long enough to permit the first few millimetres to solidify, before the remainder was poured out. This enabled savings of molten wax to be made. In addition, large solid areas would be subjected to shrinkage, which would adversely affect these compositions. Percy made polychromed waxes, and in this instance he would probably have cast multiple versions of the composition in different colours, and then cut the sections and fitted them together. He also made use of overlaid wax sheets and surface finishing, including incrustations of seed pearls, to create an altogether impressive effect.

Percy also employed these techniques to create narrative scenes in high relief on a larger scale. Among the most impressive of these is his *Death of Voltaire* (plate 44), which shows a variety of technically masterful surface finishes. In the execution of such scenes Percy has much in common with his German counterpart Caspar Hardy, who achieved similarly impressive results in his creation of high-relief scenes in wax such as *The Poor Man Prays* (plate 45).

Wax portraiture reaches its natural conclusion with busts fully in the round, which proved moderately popular in the early part of the nineteenth century. The only known examples are monochrome in the characteristic pink, yellow and white tones. As can be seen from the underside of this bust of a young Queen Victoria (1819–1901) by Nathaniel Palmer (plate 46), they were generally cast hollow and surface finished.

45 The Poor Man Prays
by Bernhard Caspar Hardy
Wax, h.22.2cm
German, c.1775–1815
V&A: A.2–1993

46 Queen Victoria
by Nathaniel Palmer
(underneath)
Wax, h.24.5cm
English, 1838
Bequeathed by Rupert
Gunnis; V&A: A.78–1965

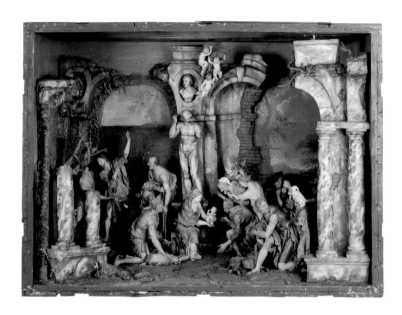

47 Adoration of the Shepherds by Gaetano Giulio Zumbo

Wax on wood, h.61.5cm
Italian, c.1691–5
Given by Mr Sigismund
Goetze
V&A: A.3–1935

Tableaux in Wax

As indicated above, wax sculpture is not confined to portraiture. One of the most interesting artists to work in the material was Gaetano Giulio Zumbo, who was active in Italy in the second half of the seventeenth century. Typical of Zumbo's oeuvre is his *Adoration of the Shepherds* (plate 47). His surviving works are all tableaux of this type, a variety of figures in a landscape contained within a wooden box. Often they depicted heavily populated scenes of a somewhat macabre nature: *The Plague, The Triumph of Time, The Corruption of the Body* and *Syphilis* are the titles of his extant works, now housed in the museum of anatomical waxes, La Specola in Florence.

Zumbo made an initial model in clay, from which he produced plaster piece-moulds. When the moulds were prepared he would begin the wax version. At first the mould had to be in two halves so that he could work on the inside faces more easily. He used thin layers of warmed wax, which he brushed gently into the contours of the mould. Beginning with translucent wax, he added up to five layers with slightly varying pigmentation each time, in order to achieve the resultant subtlety of coloration. He would then add a backing layer of molten wax (beeswax and vegetable resin) at a lower temperature, in order not to melt the first pigmented layers. He would subsequently bind the two (or more) piece moulds together, leaving some channels to the outside through which a third layer of even thicker reinforcing wax would be poured. Once the mould was removed, he would finish the surface in the usual way. The figures were then installed within the enclosing structure, in this instance a wooden box without a front in which a hole has been cut in the upper right corner at the back in order to illuminate the scene. The scenes themselves were often already gruesome and the light directed through the hole completes the chilling effect.

Zumbo's technique was so intricate and his modelling so accurate that he was known not to have completed many works during his career. A tableau in the V&A, *Time and Death* (plate 48), formerly attributed to him, has been reattributed to Caterina de Julianis. De Julianis was a nun from Naples who was active in the first part of the eighteenth century and specialized in

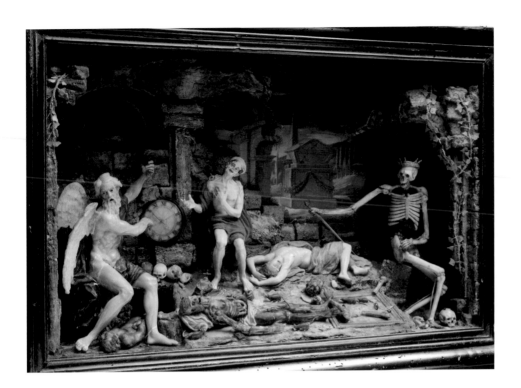

**48 Time and Death
by Caterina de Julianis**
Wax, h.83cm
Italian, c.1700–40
V&A: A.3–1966

tableaux of this type, in the style of Zumbo. However, the reattribution
was made on the basis that the anatomically inaccurate skeleton could not
have been made by Zumbo, whose work was always scientifically correct.

Wax has historically been a popular choice for female artists, as can be
inferred from the epigraph at the start of this chapter. During those periods
when convention dictated that women were restricted in their occupations,
wax was a versatile and affordable medium which was both acceptable
and expressive. In the early part of the nineteenth century, Catherine
Andras and Mary Slaughter established a tradition of wax sculpture made
by women; this continued into the early twentieth century via the Casella
sisters, Ella and Nelia. They specialized in historicizing portraits, such as
the *Woman in Renaissance Costume* (plate 49). These owe much to their
progenitor Antonio Abondio in their use of surface incrustation of pearls
and semi-precious stones, and real lace.

**49 Woman in
renaissance costume
by Ella Casella**
Wax, h.8cm
English, c.1890–1900
V&A: A.18–1996

Wax has been used to create a wide variety of works of art, from sketching
out objects as small and detailed as a rosary bead (plate 50), to sculptures as
large and powerful as a monumental marble by Giambologna. In addition, it
is a versatile sculptural material
in its own right, exhibiting on a
small scale arresting dramatic
qualities and often astonishing
verisimilitude. **AC**

**50 Models for rosary
beads: The Mocking
of Christ, The
Flagellation and The
Agony in the Garden**
Wax on slate, h.1.6cm
Italian, c.1650–1700
V&A: A.41–1932

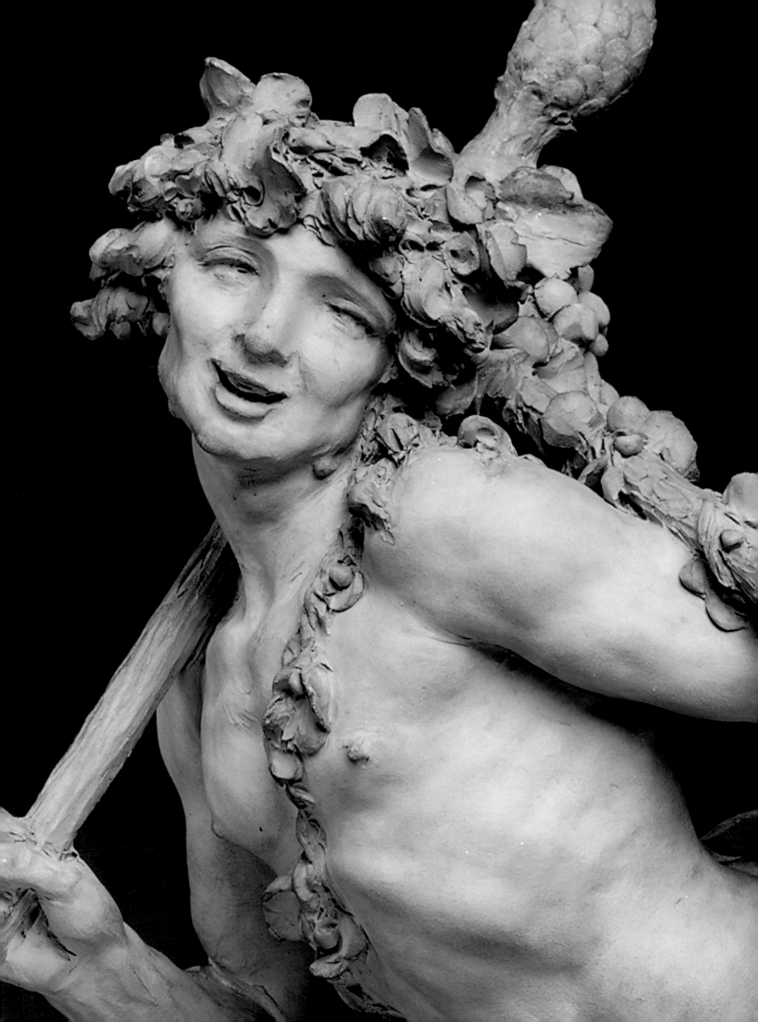

Chapter 3

TERRACOTTA

Now the material in which God worked to fashion the first man
was a lump of clay. And this was not without reason; for the Divine
Architect of time and nature, being wholly perfect, wanted to show
how to create by a process of removing from and adding to material
that was imperfect in the same way that good sculptors and painters
do when, by adding and taking away, they bring their rough models
and sketches to the final perfection for which they are striving.

Giorgio Vasari, Preface to the *Lives of the Artists*

The physical transformation of earth into clay and clay into terracotta by fire
is a process known to have been used for making sculpture since prehistoric
times. This chapter follows that process from the preparation and firing of
the clay through to the application of surface finishes. The V&A's collection
of clay and terracotta sculpture, ranging from the fifteenth century to the
present day, highlights European practice and attitudes.

The advantages of clay for the sculptor are well known. While it is a
relatively widely available material of little intrinsic value, its true worth

**51 The studio of a
sculptor working in
clay**
From Denis Diderot
and Jean Le Rond
d'Alembert,
*L'Encyclopédie ou
Dictionnaire Raisonné
des Sciences, des
Arts, et des Métiers*
Neufchastel, Paris,
1751–65

lies in its ease of handling. After preparation, the clay responds well to the artist's touch in the additive process of modelling (plate 51). The pleasure and physicality of handling clay may be seen as inspirational. By using just fingers and small fine tools, the clay can be rapidly modelled. This ease of handling also has great advantages if it is to be used as a reproductive medium. When pressed into moulds, multiples and series of objects can be formed relatively rapidly. Sometimes both modelled and moulded elements are combined.

Terracotta models and sculpture have been at the heart of the Museum's collections from its inception in the nineteenth century. The renaissance terracotta models from the Gherardini and Gigli-Campana collections, secured for the South Kensington Museum (now the V&A) in 1854 and 1861 by its first curator, John Charles Robinson (1824–1913), are among the great strengths of the collection. These major acquisitions exemplify the importance of preparatory models in the production of sculpture. At the same time, the quality of the terracottas ensured they were appreciated as works of sculpture in their own right.

Preparation of the Clay

Earth clay (a hydrated aluminium silicate) is derived from decomposed igneous rocks, such as granite and gneiss, and is categorized as 'primary' for clay remaining at its original site, and 'secondary' for clay moved elsewhere by natural forces. Both types are ground down by weathering. Secondary clay loses some minerals, and at the same time gains impurities as it is carried along by rivers, ice or seas until deposited in muddy beds (plate 52). Clay minerals, quartz and organic matter will be present in different amounts and affect the make-up of the clay, its colour, plasticity (the extent to which a clay can easily be formed into a shape, and retain it without collapsing under its own weight), shrinkage and strength after firing. These variable factors produce a wide range of different clays.

52 Pits from which clay can be extracted
From *I Tre Libri dell'Arte Vasaio (The Three Books of the Potter's Art)* by Cipriano Piccolpasso

Great skill is required in preparing clay for use, and different processes affect its nature. The recipes for clays were therefore often closely guarded secrets within sculptors' workshops. Ageing the clay in water is an important first step. Solids are broken down by wet-grinding the clay, making smaller grains which give the final clay greater strength. The clay is sieved and stirred thoroughly to distribute the particles evenly in the mix, and

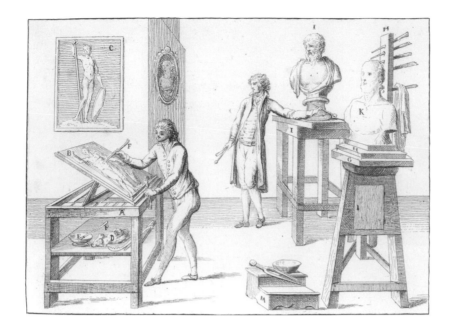

**53 Modelling a clay
relief in a sculptor's
workshop**
From F. Carradori,
*Istruzione elementare
per gli studiosi della
scultura*, Florence, 1802

excess water is then removed by filtration. The correct water content is one factor which affects the workability of clay.

For modelling or casting sculpture, clay must have enough plasticity to allow it to yield readily to pressure and allow fine shaping (plate 53); this can be increased by raising the proportion of a more highly plastic clay. If the clay is too plastic and has insufficient strength to hold a shape, non-plastic material such as sand or ground-up pre-fired clay grog must be added. This non-plastic grog content can also have the function of minimising shrinkage. Air must be driven out of the clay by 'wedging', a process of repeatedly banging the clay down hard onto a surface to ensure no pockets of air remain, since the expansion of these may cause the work to explode in the kiln. Armatures used in the initial modelling must be removed, and the overall thickness of the clay should not exceed about 6cm in order to ensure survival during firing. Many earth clays, when fired, shrink by approximately 10 per cent, and frequently change colour.

Unfired clay

Clay that is merely air-dried and not fired in a kiln is known as 'terra secca' (dry earth). It is extremely fragile, and as a consequence comparatively few works in unfired clay survive. The survival of this mask (plate 54) may well be due to its compact shape, its small size and its origin in Giambologna's workshop, where models were routinely retained. Giambologna's fame meant that the products of his workshop were highly prized by collectors, not least by one of his patrons in Florence, Bernardo Vecchietti (1514–90), who is known to have displayed models in his study. Giambologna designed the façade of Palazzo Vecchietti in around 1578, when this small sketch model was probably made.

**54 Mask
by Giambologna**
Unfired clay, h.7.6cm
Italian, probably 1578
V&A: 4107–1854

55 River God
by Giambologna
(front and back view)
Terracotta, h.30.3cm
Italian, c.1575
V&A: 250–1876

Modelling in Clay

> Modelling in clay is to the sculptor what drawing on paper is to the
> painter.
>
> J.J. Winckelmann, *History of Ancient Art, I*

Drawings can play an important role in the production of sculpture, but
it is the first freely modelled three-dimensional sketch models which often
directly capture the sculptor's intentions, especially if the work is to be
viewed in the round.

Giambologna created a dramatic, active pose in his model of a *River God*
(plate 55), in contrast to the more usual, classical solution of a reclining
figure. The vigour of his composition is given physical substance in the
handling of the clay, where every aspect of the composition, with its
opposing diagonals of limbs, has been captured. The model has been built
up by adding clay to form a mass, worked by the artist's fingers. Although
the clay has been roughly reduced in some areas, there is no demonstrable
concern to achieve the even thickness of clay necessary to ensure a
successful firing. This may be because it was not originally intended to be
fired (test results suggest that firing happened later). The monumentality
inherent in this relatively small-scale model hints at the giant scale of the
final figure, a personification of the mountain-god Appenine created for
Francesco de' Medici's villa at Pratolino.

Antonio Begarelli's mastery of clay is evident in the flying draperies and
carefully handled contrasts of surfaces to represent flesh, hair and fabric
in his highly finished model for one element of his vast composition *The
Deposition from the Cross*, now in the church of San Francesco, Modena
(plate 56). In contrast to Giambologna's *River God*, every aspect of the
composition has been represented, and the degree of detail present is taken
to a high level. This suggests that Begarelli's model may have served as a

opposite (top left)
**56 Virgin and Holy
Women
by Antonio Begarelli**
Terracotta model,
h.42.2cm
Italian, 1530–31
Given by Dr W.L.
Hildburgh, F.S.A.
V&A: A.25–1953

opposite (top right)
**57 Back view of the
Virgin and Holy
Women
by Antonio Begarelli**

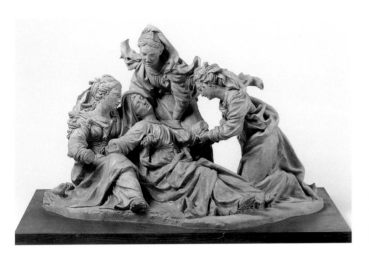
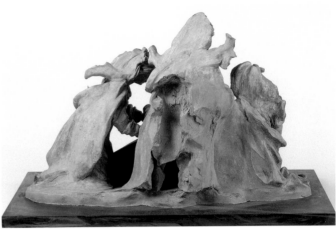

presentation model for the patrons, and formed part of the legal contract for the commission. When viewed from the back, it is evident that this object was intended to be fired, as large amounts of clay have been excavated to reduce the clay mass (plate 57). Its high quality may explain its later acceptance not merely as a model but as a finished sculptural object in its own right.

58 Modern modelling tools

Modelling Tools

Modern tools are similar to those traditionally used by sculptors and their workshop assistants (plate 58). Handled with skill, they help to build forms and add fine detail where fingers cannot. They can also be used to draw in the soft clay (plate 59), as well as for more practical purposes such as removing excess clay; the two tools on the right in plate 58 are designed for this purpose.

Moulded Clay

In addition to its use in modelling, clay can also be pressed into moulds to make multiples of the same object. Most moulds have historically been made of porous materials, such as brick clay or plaster (see *Plaster Models, Plaster Casts, Electrotypes and Fictile Ivories*), which draw moisture from the clay, causing shrinkage and thereby easing the removal of the object from the mould.

The use of moulded terracotta as architectural ornament became popular in Italy during the fifteenth century. It was introduced into England with the building of Cardinal Wolsey's new Italianate palace at Hampton Court, begun in 1514, and soon became fashionable within the court of Henry VIII. Production line methods were needed to meet the demand for projects such as Suffolk Place in London (demolished in about 1568). The soft clay was pressed into a negative plaster mould, producing the raised decoration

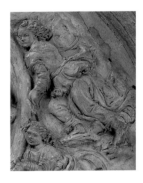

59 Model for Forteguerri monument by Andrea del Verrocchio (detail of upper right-hand angel)
Terracotta, h.39.4cm
Italian, 1476
V&A: 7599–1861

60 Fragment of frieze (front and back view) excavated from the site of Sutton Place, Southwark, London
(now demolished)
Terracotta, h.14.5cm
English, 1518–20
V&A: A.32–1938
Given by Messrs Mosers Ltd

below
61 Science Schools (now Henry Cole Wing of the V&A), upper loggia colonnade
Terracotta columns designed by Godfrey Sykes and modelled by James Gamble, erected about 1870

for the frieze; brick clay often contained small pebbles and natural debris, resulting in a coarse, open structure. The fingerholds visible on this section of frieze (plate 60) indicate that it was removed from the mould at an early stage of drying out.

In nineteenth-century Britain there was a resurgence of interest in Italian renaissance architecture, bringing with it a revival of terracotta decoration. The South Kensington site was developed on its west side and the façade articulated by a round-headed colonnade on the ground floor, and an open-arcaded loggia on the upper floor. The columns for both were embellished with decorative terracotta to enhance the grandeur of the architecture (plate 61).

Modelled and Moulded Portrait Busts

Most portrait busts were modelled but moulded portraits could also be taken from life- or death-masks. In his *Il Libro dell'Arte* (*The Craftsman's Handbook*) of the 1390s, Cennino Cennini describes in detail how to take a plaster life-mask from a sitter. His practical recommendations range from applying rose-scented oil to the subject's face, to inserting metal breathing tubes into their nostrils to ensure their comfort and survival.

The usual method of producing busts for the expanding market was to fix the moulded head to the rather summarily modelled torso before firing. The scale was a vital consideration when producing these more routine portraits, and was not always well calculated, as can be seen in the portrait bust of an old man, where the head is too small for the shoulders (plate 62).

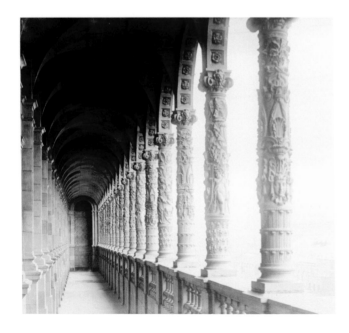

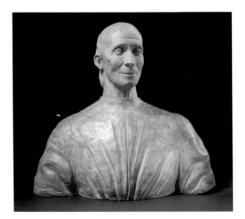

62 Portrait bust of an old man of the Capponi family, based on a death-mask
Moulded and modelled terracotta, h.50.8cm
Italian, c.1450–1500
V&A: 4906–1858

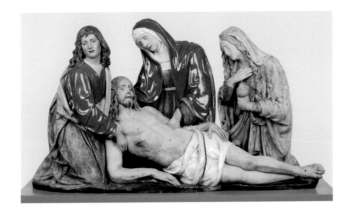

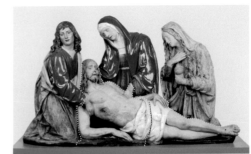

Firing

Earthenware clay for sculpture is fragile and highly vulnerable until it has been fired in a kiln, after which it is known as 'terracotta' (cooked earth). The first ('biscuit') firing (at temperatures up to 1,100°C) irreversibly changes the physical nature of the clay, making it more durable and capable of receiving a variety of surface finishes. Firing is, however, a hazardous operation, and was especially so when conditions were harder to control in wood-burning kilns than in modern gas or electric kilns. Terracotta sculpture over a certain size must be made hollow to withstand firing, although the forms can be modelled or cast.

Andrea della Robbia's workshop overcame the major difficulties of working on a large scale to create a two-thirds life-size group, by modelling the four figures of *The Lamentation* separately from clay no thicker than 3–4cm (plate 63). The individual figures would have been modelled over wooden armatures, later removed when the clay had dried sufficiently to support its own weight. The figures were assembled as a group to form the tableau and then cut into five elements to fit into the kiln. Care was taken about the placing of the cuts, partly to ensure each figure had its own portion of interlocking base to give stability to the finished piece, and also to disguise the fact that cuts had been made (plate 64). The Virgin and St John were separated from Christ just below their sleeves, leaving their hands attached to Christ's chest. The Christ figure was cut into two across his lower half (plate 65), the join disguised by the fold in the loin cloth. All the figures were left open at the back, offering a rare opportunity to see how excess clay was excavated, and how clay bridging walls were constructed across the cavities to support the structures (plate 66).

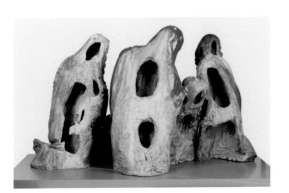

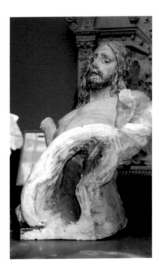

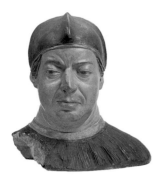

67 Cardinal Giovanni de' Medici (later Pope Leo X) ascribed to Antonio de'Benintendi
Polychromed terracotta,
h.38.5cm
Italian, c.1512
V&A: A.29–1982

Surface Finishes

Terracotta is capable of receiving a variety of surface finishes, ranging from pigment applied with a brush over a gesso base, to more complex finishes involving glazes which require a second firing. *The Lamentation* group (see plate 63) shows both surface treatments. While working on the figure of Mary Magdalene, the Museum's conservators discovered it to be in many pieces and concluded that damage had occurred during or immediately after firing. The damage prevented it from being given the second firing necessary to achieve the tin-glazing. The Mary Magdalene figure is therefore the only one in the group to be entirely hand-painted with pigment.

The portrait of Cardinal Giovanni de' Medici, later Pope Leo X (plate 67), is a rare survival of a strikingly naturalistic image of the sitter, a powerful member of the Medici family. The sculpture was made from a combination of a moulded life-mask and modelled torso. After firing, it was painted with egg tempera to which some oil was added. The oil slowed the drying time,

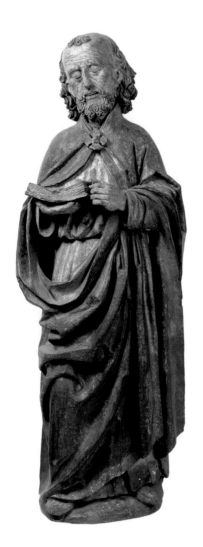

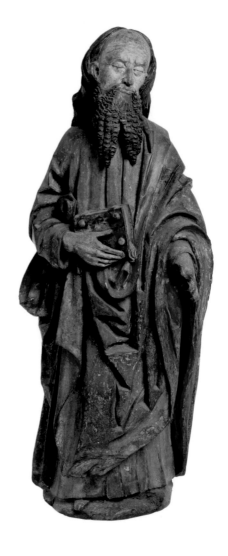

left
68 St Peter
Painted terracotta,
h.109cm
Bavaria, c.1480
V&A: A.37–1910

right
69 St Paul
Painted terracotta,
h.110.5cm
Bavaria, c.1480
V&A: A.38–1910

allowing the colours to be blended with more subtlety to represent different skin tones and, with great precision, the five o'clock shadow of the sitter. The painting of a bust with pigments over a layer of gesso was often subcontracted to a painter's workshop.

Although terracotta sculpture is usually associated with southern Europe, it also flourished in Northern Europe, for example in Landshut, Bavaria, in the fifteenth century. The figures of St Peter and St Paul were modelled from clay and made in sections, and probably formed part of a cycle of Apostles placed high up on piers within a church. The polychromy, together with gilded borders to the robes and traces of raised wax patterns on the cloaks, ensured that the devout would easily recognize these two saints and their attributes (plates 68 and 69).

The clay group *Milo of Croton* (plate 70), probably French and dating from about 1750, is based on a marble group by Pierre Puget, completed in 1682, and was given the appearance of bronze by applying a layer of bronze paint to the fired clay. When set in a French eighteenth-century domestic interior, the material could be mistaken for a more precious bronze.

In renaissance Florence, Luca della Robbia investigated and adapted established potters' polychrome glazing techniques for sculpture. The traditional potters' technique of glazing begins with a biscuit firing of an earthenware pot, which is then dipped in a bath of glaze, the *bianco*, composed of oxides of lead and tin combined with *marzacotto*, a silicate of potash made by mixing and fusing sand with calcined wine lees. This opaque, porous coating was dried before being painted with other metallic oxides. A second firing fused the glaze with the terracotta and the pigments with the glaze, forming an impervious surface. Luca developed a method of suspending pigment evenly within the tin-oxide glaze, which was applied directly by brush to the biscuit-fired sculpture, before being refired at around 900°C to fuse the glaze. This resulted in a solid layer of colour. The glaze penetrates the porous terracotta, thus fusing with it (plate 71).

Although Luca learned basic skills from local potters, his glazes differed in two ways: he used about three times more tin oxide than found in potters' *bianco*, to give a more intense white glaze after firing, and he reduced the amount of sand from the traditional glaze to give greater opacity. Della Robbia glazes still contained the traditional lead, because it has a low melting temperature and therefore acts as a flux, ensuring the glaze runs easily across the surface of the terracotta and penetrates the porous surface during the firing. These glazes also contain a chalky clay, which helps the contraction rate of the glaze on cooling to mirror that of the clay body, thus reducing tensions for a successful result.

70 Milo of Croton
Based on a composition by Pierre Puget
Modelled and painted terracotta, h.28cm
French, c.1750
Given by Dr W.L. Hildburgh, F.S.A.
V&A: A.9–1952

71 Polished section showing the fit of white glaze (right) to the terracotta body (left)
The large particles are tin oxide. Scanning electron microscopy (SEM) photomicrograph image of *Virgin and Child* by Andrea della Robbia
h.160cm
Italian, 1487–8
V&A: 7630–1861

right
**72 Stemma of René
of Anjou**
by Luca della Robbia
Modelled, tin-glazed
terracotta,
diam.335.3cm
Italian, 1466–78
V&A: 6740–1860

left
73 Fish finial
by Gilbert Bayes
Doulton stoneware,
tin-glazed, h.44cm
English, c.1937
On loan from The Gilbert
Bayes Charitable Trust

below
74 Bird finial
by Gilbert Bayes
Doulton stoneware,
tin-glazed, h.50.5cm
English, c.1937
On loan from The
Gilbert Bayes Charitable
Trust

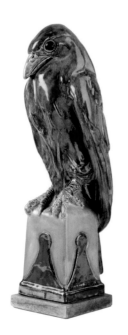

This durable surface finish is put to spectacular use in the vast coat of arms or *stemma* of René of Anjou, originally set high into the façade of the Pazzi family villa at Montughi near Florence (plate 72). Luca della Robbia made the stemma for Jacopo dei Pazzi between 1460 and 1468. The coat of arms consists of at least 18 separate sections, and the border, with its fruit and foliage details, of 14 pieces. All the sections were biscuit fired, given a glaze layer, and fired a second time before being assembled and fixed into an external wall.

More recently, the decorative sculpture of Gilbert Bayes, much of it garden or fountain sculpture, follows the tradition of the techniques first developed by the della Robbia family. Bayes' glazed Doulton stoneware washing post finials (plates 73 and 74) and circular window lunettes for the St Pancras House Improvement Society flats in London of 1937, perfectly marry function, form and material to ensure the survival of brilliantly coloured, decorative pieces in the damp of an English climate.

Dissemination of Ideas through Terracotta Models
In addition to producing fresh ideas, artists often looked at existing works, both contemporary and antique, sometimes adapting them in other materials and on a different scale.

John Michael Rysbrack's *Flora* (plate 75) is based on a reduced plaster replica of the famous Roman statue of Flora. It is a sketch model for a large-scale marble statue, a pendant to *Hercules* for the Pantheon, a temple

erected at Stourhead in Wiltshire, and was commissioned by Henry Hoare the Younger (1705–85). One of Rysbrack's most important patrons, Sir Edward Littleton of Pillaton Hall, Staffordshire, is known to have acquired the model within five years of its being made. Another eighteenth-century sculptor working in Britain, John Cheere, is also known to have made a bronzed plaster version of the Rysbrack *Flora*. The Bow factory's numerous statuettes in porcelain (plate 76) are thought to be based on Cheere's work. (See *Working Practices* for more on the use of terracotta models.)

Terracottas as Finished Works of Art

The French sculptor Claude Michel, known as Clodion, produced terracotta figures and groups which were neither painted nor glazed, but exquisitely modelled and moulded in fine clay (plate 77). They demonstrate high levels of skill throughout the process, from the initial stage of preparing the fine clay, to the expertise of the ceramic factories required to fire the pieces at high temperatures without cracks or flaws, there being no opportunity to disguise any faults with a surface coating. Many small-scale pieces attributed to Clodion are thought to have been cast rather than modelled, a practice which takes sculpture close to ceramics production.

In the later nineteenth century a loosely connected group of French and English artists, influenced by Italian renaissance art, exploited materials and techniques to create sculpture animated by a different sensibility from that of the prevailing classicizing style; their sculptures are often known as the New Sculpture.

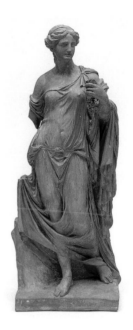

75 Flora by John Michael Rysbrack
Modelled terracotta sketch model, h.57.3cm
English, 1759
V&A: A.9–1961
Purchased with funds from the Hildburgh Bequest

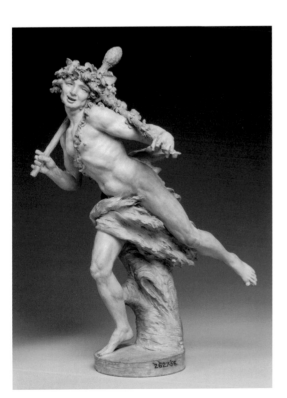

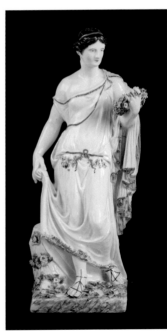

right
76 Flora
Porcelain painted in enamel colours, h.28.3cm
English, c.1760–65
V&A: 533–1868

left
77 A Running Faun by Claude Michel (Clodion)
Terracotta, h.43cm
French, c.1775–1800
V&A: 2627–1856

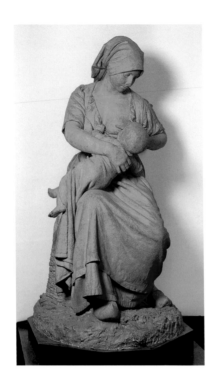
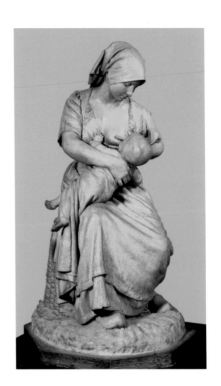

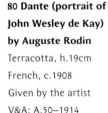
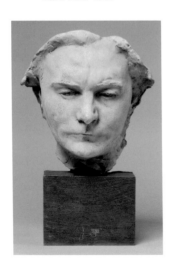

Although the original concept was based on a mythological group, *Juno Suckling the Infant Hercules*, the essence of Jules Dalou's *Peasant woman nursing a baby* (plate 78) is its innovative realism. In his choice of both subject matter and material, Dalou demonstrates his influential role within the New Sculpture. The sculpture was modelled over six weeks (a smaller, cast version (plate 79) is also in the V&A's collection), and the representation of the mother as a peasant gives a new directness to the traditional image of a mother and child. Dalou exerted great influence over the next generation of sculptors in Britain, and his career may be seen as evidence of the importance placed on modelling clay in France and Britain at the end of the nineteenth century.

The small head pictured (plate 80 and cover), called *Dante*, is actually a portrait of the American John Wesley de Kay. Its origins lie in the *Gates of Hell*, the decorative doors commissioned from Rodin in 1880 for the Musée des Arts Décoratifs in Paris, but never executed. The head is cast in clay from a plaster mould; the lines visible in the clay indicate where the piece moulds were joined to complete the mould. Rodin deliberately chose to leave these join lines visible. By leaving evidence in the material of its properties and how the sculpture was formed, Rodin demonstrates the concept of truth to materials, an idea often more closely associated with later twentieth-century sculptors, who carved their own stone sculptures. That Rodin chose this head as one of the works by which he wished to be represented in an important exhibition at Grosvenor House in 1914, indicates that terracotta had become a valid medium for sculpture in its own right.

**81 American Field
by Antony Gormley**
In 1991, Antony
Gormley worked
with a community of
brickmakers and their
families in San Matias,
Cholula, Mexico, who
modelled a field of
35,000 clay figures,
ranging from 8cm to
260cm in height. The
field was installed in
1991 at the Salvatore
Ala Gallery, New York,
before touring America,
Mexico and Canada.
© the artist
Courtesy Jay Jopling/
White Cube (London)

Terracotta remains a viable medium for contemporary figurative sculpture, exemplified at the end of the twentieth century by Antony Gormley's *Field* installations (plate 81): many thousands of individually modelled clay figures raise questions about art, the environment and the collaborative nature of sculpture. Gormley has written: 'Field is part of a global project, in which the earth of a particular region is given form by a group of local people of all ages. It is made of clay, energized by fire, sensitized by touch and made conscious by being given eyes.' (British Council website)

The earthenware group *Mother and Child* (plate 82), made in 1993 by the studio potter Philip Eglin, was acquired by the V&A as a seminal work of the

**82 Mother and Child
by Philip Eglin**
Hand-built earthenware
with white slip, painted
in colour, under and
over a honey glaze,
h.37cm
English, 1993
V&A: C.45–1993

'new figuration' in ceramics. Eglin's large sculptural figure groups echo medieval and renaissance devotional groups, while their surfaces carry boldly applied colour, reminiscent of Staffordshire figures of the eighteenth and nineteenth centuries. As vibrant and colourful to the modern viewer as the work of Luca della Robbia must have appeared in the sixteenth century, Philip Eglin's sculptural ceramics confirm that the worlds of the ceramicist, the sculptor and the viewer are inextricably linked – to one another, and to the history of making sculpture from clay. **WF**

Chapter 4

BRONZE AND LEAD

Bronze has been used to make utensils and tools since about 6000 BCE. In the sixth century BCE, the Greeks started to produce bronze statues using the lost-wax process, but small-scale votive figures survive from as early as the ninth century BCE. The material itself was both expensive and highly prized. In the first century CE, Pliny the Elder wrote evocatively of the hierarchy of metals, placing copper ores as 'next in value' to gold, and described how 'many people have been affected by a mania for it'. Bronze-working in Greece generally came to be associated with statues of the gods, and therefore carried a high status that elevated those connected with it. In 1503, Pomponius Gauricus dedicated his book on the art of bronze sculpture to Ercole d'Este, the Duke of Ferrara, proclaiming that nothing was more noble than this art itself or better suited to accord Ercole immortality. This dedication also hints at the alchemical associations of the material, both in relation to turning base metal into gold and to the search for eternal life.

Though technically an alloy of copper and tin, the term 'bronze' tends to be applied to a variety of copper alloys, including brass (copper and zinc). Bronzes often contain around 5–10 per cent of tin, and a number of other elements, either by accident or design, including zinc, nickel, arsenic, antimony and lead. Lead does not in fact alloy with the other elements, but lowers the melting point of the metal, making it easier to cast. A higher tin content makes the alloy harder and more brittle. High-tin bronzes (above 12–15 per cent) can produce a note ideal for making bells, and this alloy is often referred to as bell-metal.

Bronze is a re-usable commodity, which can be melted down and fashioned into a different form. The reasons were often financial or political, as when Michelangelo's statue of Pope Julius II (b.1443, Pope 1503–13) in Bologna was taken down when the Bentivoglio family regained control of the city in 1511 and recast the sculpture as a cannon dubbed the *Giulia*. This destruction and rebirth was, however, also recommended as part of the making process. Pliny, for example, describes how an alloy

has a seasoned brilliance when it has been tamed by habitual use. Creating bronze statuary is technically challenging, involving the most complicated of all the sculptural processes, combining a variety of approaches and often calling on the skills of different craftsmen.

Bronze casting continued throughout the medieval period, and the twelfth-century technical treatise by Theophilus describes the lost-wax casting of censers and bells. However, it was in the fifteenth century, with a renewed engagement with the classical past, that bronze took on a new life. The city of Florence played a significant role: the Florentine sculptor Donatello increasingly worked with bronze as his life progressed. His sojourn in Padua from 1443–53 had a profound effect, with the city becoming a major centre for bronze production. Even Michelangelo, who was primarily a marble sculptor, made the monumental bronze statue of Julius II cited above (1507–8), and the Florentine goldsmith and sculptor Benvenuto Cellini dramatically described the casting of his statue of *Perseus* (1545–54) in the Loggia de' Lanzi in Florence in both his autobiography and his treatise on sculpture.

The revival of the bronze statuette was no doubt prompted by the enlightened patronage that grew out of a preoccupation with the philosophy and artefacts of the ancient world. The intimacy and expressive possibilities of these objects appealed to artist and owner alike, and they were particularly cherished by initiated collectors, many of whom would have commissioned them to keep alongside their antiques. The pleasure of handling small bronzes not only reflects these intellectual interests, but must surely have been central to the development of techniques which facilitated this intimate relationship.

There was evidently a thriving market for small bronzes in Padua, and the city has been associated with the production of a number of bronzes of crabs, lizards, frogs and other animals that were cast from life. There is, however, no evidence to confirm where exactly they were made, and some appear to have been made in Japan in the nineteenth century. While moulds were sometimes taken for re-use, in many instances the animal itself was invested and burnt out during casting – a method that has been described as the 'lost lizard' process. Life casts were used on the *Baldacchino* that marked St Peter's burial place and the high altar in the basilica of St Peter in Rome by Gianlorenzo Bernini, cast by Ambrogio Lucenti and others in 1624–7. Life casts can also be seen on a mortar by the same artist in the Museum's collection (A.2–1974).

Casting Processes

The most straightforward method of creating a bronze is to make a model in solid wax; this is then transformed through the casting process into solid bronze. The figure of *Hercules* (plate 83) of around 1500 is one such example. However this method was not ideal, as the model is lost in the process and it requires more of the expensive bronze. The outside of the bronze cools more quickly than the inside, which can cause the sculpture to crack, and a solid bronze is heavy and cumbersome to handle.

Hollow casts use less metal and are more technically sound, but they involve a more complex process (plate 84). A clay model is made often using an armature, roughly conforming to the pose of the finished work, which is then dried or baked. Shrinkage of the clay is taken into account and the model becomes the core or *anima* (soul) (plate 84b). Wax is then applied to the core to create a model of the finished sculpture of the same thickness required for the bronze (plate 84c); this will replace the wax in the casting process. In order to prevent the core moving around, it has to be held by metal pins with a higher melting point than bronze that pierce through the wax, connecting the core to an outer mould. The details of the final object are modelled in the wax, and wax rods or sprues – known as runners and risers – are attached both to the model and to a wax cup (plate 84d).

above

83 Hercules
Bronze, h.34cm
North Italian, c.1500
Salting Bequest
V&A: A.137–1910

below

84 Diagram showing the direct lost-wax casting method

a b c d e

f g h i j

The whole model is covered with successive layers of a fire-resistant material, known as the *camicia* or investment (plate 84e). The recipe for the investment as outlined by Cellini consists of the burnt core of ox horns, gesso of tripoli and iron filings for the first three layers, mixed together with a moist solution of dung. This is followed by three layers of clay of varying thickness. When set, the investment is heated and the wax melted out, giving the technique the name of 'lost-wax' or '*cire perdu*' (plate 84f). Cellini warned that all the wax and moisture must be removed from the mould or it could explode during casting. The metal is melted in a furnace or crucible at around 900–1,000°C, and poured into the mould through the cup (plate 84g). The runners carry the molten alloy into the space created by the lost wax, and gases escape through the risers. These sprues have to be placed correctly, so that the molten metal runs into every part of the bronze and to prevent gases from being trapped and potentially causing the mould to explode.

The metal is allowed to cool before the investment is broken off to reveal the bronze inside, together with its tangle of sprues and pouring cup that are also formed in the bronze. The surface of the metal will be rough and covered with a chemical deposit that has to be removed along with the metal sprues. Flaws can be repaired using plugs of bronze or other material, as can the holes left by the core pins if they are removed or have fallen out.

The hole in the knee of the statuette of *David*, for example, was created by the characteristic square core pins of the workshop of Severo Calzetta da Ravenna (plate 85). The removal of the core material made the bronzes lighter and more aesthetically pleasing to handle, and Severo removed the core through a hole drilled between the buttocks of his figures. If the bronze has not run successfully, it may be necessary to remodel an area in wax fixed onto the sculpture and recast in the metal, using a process known as 'casting on'. The underside of the *Venus and Cupid* (plate 86) gives a sense of how pieces can be added and repaired without being visible on the upper face of the sculpture. Details of the finished bronze are usually sharpened in the metal, and the surface working can involve hammering, punching, filing and chiselling before the surface is polished with wet pumice stone and any treatment or patination is applied.

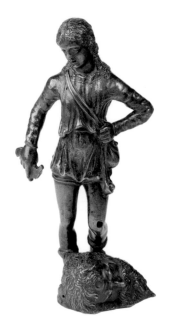

above

85 David with the head of Goliath

From the workshop of Severo da Ravenna
Bronze, h.21.8cm
Italian (probably Ravenna), c.1520–50
V&A: 593–1865

right

86 Venus and Cupid (underside)

Bronze, h.18.5 cm; Italian, c.1600–25
Salting Bequest; V&A: A.86–1910

87 The shouting horseman by Andrea Briosco (Riccio)
Bronze, h.33.5cm
Italian (Padua)
c.1510–15
Salting Bequest
V&A: A.88–1910

The direct method of casting was used by Andrea Riccio, who produced a number of small bronzes for the humanist scholars in Padua in the early sixteenth century. Riccio's bronzes are therefore generally unique, with the original model being lost in the process. His *Shouting Horseman* (plate 87), cast separately as horse and rider, transformed the powerful image of the equestrian monument into an intimate small-scale work that could be handled and admired. This was not an unquestioning copy of an antique precedent, but a vibrant creation in which the adrenalin of horse and rider is virtually tangible. It was both inspired by classical poetry and informed by Riccio's observation of nature. During the War of the League of Cambrai (1509–13), when Imperial and French troops fought the Venetian Republic for control of Padua, the Venetian *stradiotti* or colonial light cavalry would have been a familiar sight.

Replicating Bronzes

While Riccio chose to make direct casts, technical examination of various Paduan bronzes suggests that his followers used an ingenious method of copying his style in replicated bronzes. This involved taking casts from the modelled cores, building individual wax models around them, and thereby creating a unique variant, such as the *Nereid and Ichthyocentaur*, known in a number of different casts of varying quality.

More sophisticated methods of replicating bronzes had already been developed by Antico, the court sculptor to the Gonzaga family in Mantua, and probably in Padua itself by Severo Calzetta da Ravenna, who was active there around 1500–9. In this indirect method, a highly worked model is made, from which plaster moulds are taken. Complex figures require a piece mould that fits together like a jigsaw puzzle, supported by an outer or mother mould. These negative moulds are lined with wax to create a positive replica of the original model, called the inter-model (see plate 88). Antico used a method known as 'slush moulding', in which sections of the plaster moulds are moistened and molten wax is poured in and swilled around. The wax solidifies as it hits the cool walls of the mould, and the excess molten wax is poured out (plate 88c). This process is repeated until the wax forms a shell of the thickness required for the finished bronze. Liquid core material, often a mixture of plaster and sand, is poured into hollow sections of the cast (plate 88d). When the core has set, a hot knife is used to melt the edges of the adjoining sections of wax so that they can be fused together to form the complete model. The core pins, sprues and investment are then added to the inter-model, as described (plate 88f). Severo, on the other hand, used a complex method of interconnected moulds and cast cores, allowing his works to be effectively mass produced by less skilled assistants.

88 Diagram showing the making of the inter-model in the indirect lost-wax casting method showing Giambologna's Mars

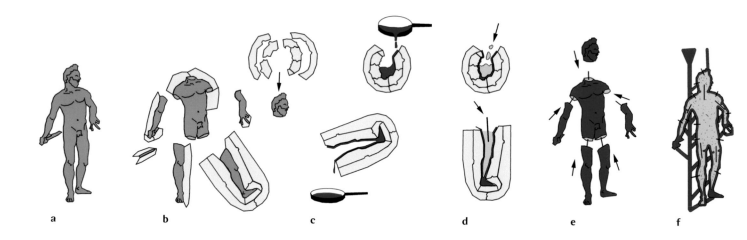

a b c d e f

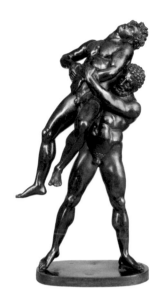

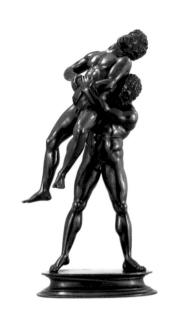

89 (left) **Hercules and Antaeus**
by Pier Jacopo Alari Bonacolsi (Antico)
Bronze with silver inlay, h.40.7cm (with base)
Italian, c.1500
Bequeathed by Dr W.L. Hildburgh, F.S.A.
V&A: A.37–1956
(right) **Hercules and Antaeus**
by Pier Jacopo Alari Bonacolsi (Antico)
Bronze, h.43.2cm (with base)
Italian, c.1519
Kunsthistorisches Museum, Vienna

By retaining the original model and the moulds taken from it, the sculptor is able to replicate his bronze. In fact, Antico made very few replicas of his models, perhaps because the Gonzaga family wished them to remain exclusive. The original version of Antico's *Hercules and Antaeus* (plate 89) was probably created for Bishop Ludovico Gonzaga around 1500. The eyes and teeth are inlaid with silver, doubtless to satisfy the taste of the patron for richly decorated works. The moulds still existed when Antico wrote his celebrated letter of April 1519 in response to a request from Isabella d'Este (1474–1539), the Marquise of Mantua, for versions of some of his bronzes. The *Hercules and Antaeus* now in the Kunsthistorisches Museum, Vienna, is inscribed underneath in the wax before casting, proclaiming Isabella's ownership. While clearly a replica of the original, the difference in surface treatment and detail effectively creates a variant. The giant Antaeus gained his strength from the earth, and Hercules had to kill him by holding him aloft. The tension in the muscles and different treatment of the eyes, which are not inlaid but cast integrally in the bronze, gives the impression in the later version that Antaeus was still struggling for life rather than resigned to his fate, as he appears in the original.

Examination by X-radiography enables us to see inside the bronze (plate 90). In Riccio's *Horseman* (plate 90 above) we see the uneven thickness of the bronze created by the modelled wax over the core. Antico's (plate 90 below), in contrast, has a more even thickness, typical of the slush moulding process, together with tell-tale drip marks that formed when the wax was poured out. A thin line of wax formed where the different sections were joined using a hot knife. While this could be removed from the outside of the bronze before casting, it remained on the interior and appears as a circle of 'flashing', or a thin projection of bronze, visible in the X-ray at the top of the legs, for example.

90 X-radiographs
of (above) Riccio's horseman from *The Shouting Horseman* (see plate 87); (below) Antico's *Hercules and Antaeus*, Vienna (see plate 89)

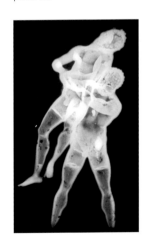

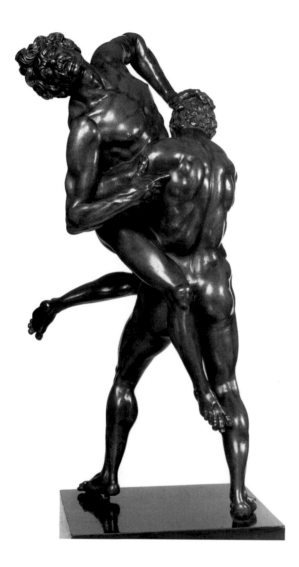

**91 Hercules and
Antaeus by Willem
van Tetrode**

Bronze, h.46.8cm
Netherlandish, c.1562–7
Bequeathed by Dr W.L.
Hildburgh, F.S.A.
V&A: A.92–1956

Northern Sculptors in Italy: Tetrode and Giambologna

Hercules and Antaeus continued to be a popular subject in the sixteenth century. The bronze version by Willem van Tetrode (plate 91), which was cast as one piece, was inspired by a marble group at the Medici villa at Castello by Bartolomeo Ammanati. Tetrode seems to have been an assistant to Cellini in Paris when the latter worked for the court of Francis I in around 1545. He is documented in Cellini's workshop in Florence between 1548 and 1551, and also travelled to Rome before returning to his native Delft around 1566–7. Tetrode was therefore one of the first artists to introduce small bronzes into the Netherlands. We know nothing about his role in their production, but his models were indirectly cast as replicas and were clearly popular. Their varying treatment has led to the suggestion that they were possibly cast by different foundries.

Tetrode was not the only northern artist to venture south. In about 1550, the Flemish sculptor Jean Boulogne, known in Italy as Giovanni Bologna or Giambologna, travelled to Rome to study antiquities. On his way home he stopped at Florence, where he settled and soon became the court sculptor to the Medici, who, despite periods of exile, had long been the leading family in the republic. In 1537 Cosimo I de' Medici assumed the role of Duke, and in 1569 became Grand-Duke of Tuscany.

Giambologna ran a large and successful workshop that created important works in marble as well as high-quality bronze statuettes using the slush moulding method. He made good use of assistants, such as Antonio Susini, a specialist in bronzes who left the studio in around 1600 to set up on his own, and Pietro Tacca, who succeeded him as Grand-Ducal sculptor. The studio attracted a number of others from north of the Alps, including Hubert Gerhard, Hans Riechle and Adriaen de Vries. De Vries, who came from The Hague, may have received his early training with Tetrode in Delft, and worked in Turin, at Augsburg and in Prague for the emperor Rudolf II (1552–1612), whose relief portrait by De Vries is in the V&A (6920–1860). Perhaps surprisingly, given his training, De Vries's bronzes are largely direct casts, created by modelling clay over a wire armature.

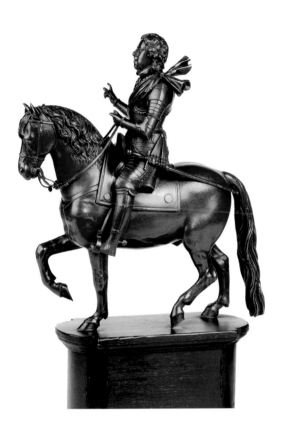

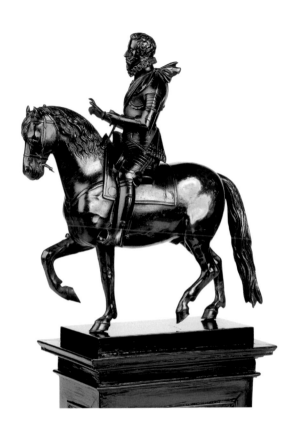

Hubert Le Sueur and Francesco Fanelli: Varying Models

Giambologna's style, which was also associated with the Medici, was disseminated throughout Europe, in part through the movement of his assistants, but also because his monumental and small-scale bronzes were sought after by the élite. Portable statuettes made excellent diplomatic gifts, and even after Giambologna's death, Cosimo II sent several of his models, probably cast by Tacca, to Henry, Prince of Wales (1594–1612) in the hope that Henry would marry Cosimo's sister and thereby unite the house of Medici with the English throne. When Henry died young in 1612, his collection of small bronzes passed into the hands of his brother, Charles, who was later to become king. It was perhaps this early engagement with such works that encouraged Charles's interest in sculpture.

The court failed to lure Tacca to England, but instead welcomed Hubert Le Sueur, the sculptor in ordinary to Charles's brother-in-law, Louis XIII of France (1601–43), who arrived in 1625. In around 1630 he was joined by the Florentine Francesco Fanelli. Described as 'the one-eyed Italian', Fanelli's designs showed more flair, though Hubert, whose father was a master armourer, was praised for his casting. Both artists created variants in their models, Le Sueur by casting the bronzes in several pieces, enabling him to substitute a different portrait head for each rider on his equestrian statuettes (plate 92). The invention of this system of interchangeable parts

92 (left) **Louis XIII on horseback by Hubert Le Sueur**
Bronze, h.21cm
France (Paris), c.1620
Given in memory of L. and R. Lewis
V&A: A.1–1994

(right) **Philip III of Spain on horseback by Hubert Le Sueur**
Bronze, h.21cm
France (Paris)
c.1615–20
Bequeathed by Dr W.L. Hildburgh, F.S.A.
V&A: A.108–1956

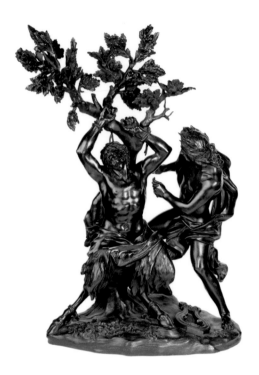

is often credited to Pietro Tacca, though a similar idea had already been exploited in the workshop of Severo da Ravenna in sixteenth-century Padua and Ravenna. The hand-made screw on a statuette of *Tobias* by Severo (now in the V&A; A.22–1960) would originally have held a shell, most likely for use as an inkstand or possibly a lamp. Screws of the same size appear on many of Severo's bronzes, making the pieces interchangeable and allowing clients to customize them. Fanelli, on the other hand, varied his models in wax before casting them in one piece, as seen in the two different versions of *Venus and Adonis* (plate 93).

Seventeenth- and Eighteenth-Century Bronzes

During the seventeenth and eighteenth centuries, intimate collectors' items were replaced by larger, more decorative pieces in the baroque style, such as the *Apollo flaying Marsyas* by Giovanni Battista Foggini (plate 94). Both Foggini and his compatriot Massimiliano Soldani-Benzi were sent to Rome to study by Cosimo III de' Medici (1642–1723). After his time in Rome, Soldani trained as a medallist in Paris before returning to Florence where he spent 40 years in charge of the Grand-Ducal mint. Perhaps due to his training, Soldani cast his bronzes in separate sections that were then expertly assembled using metal-to-metal joints. This enabled each element to be finely worked, and it is usually impossible to see Soldani's joins with the naked eye.

The taste for the antique returned later in the eighteenth century, when reduced copies of classical sculptures became fashionable among Grand Tourists, and an industry grew up in Rome dominated by a few foundries, notably that of the Zoffoli family. These small bronzes were often collected in sets to decorate the mantelpieces of stately homes in Britain.

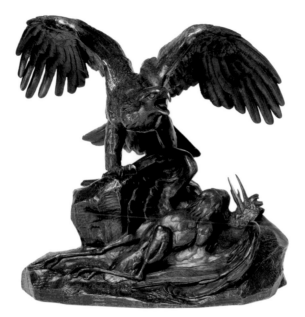

left and below
**95 Eagle seizing a
heron
by Antoine-Louis
Barye** (second version)
Bronze, sand-cast,
chased and patinated,
h.32cm
French, first edition
1857; this cast about
1890 (founder:
F. Barbedienne)
V&A: 112–1890

Nineteenth-Century Bronzes

During the first half of the nineteenth century, social change and new technologies combined to create the favourable conditions in which serially-produced sculpture, often in the form of a bronze statuette, could be acquired by middle-class customers at relatively low cost. The production of sculpture in France was also encouraged by government commissions, public monuments, the annual Salons and a series of Universal Exhibitions.

The development of reducing machines during the 1830s by Frédéric Sauvage and Achille Collas meant that a sculptor's model could be reproduced mechanically in different sizes. This process saved time, effort and expense. A significant partnership for the production of serial bronzes was that of Collas and Ferdinand Barbedienne formed in 1838. Barbedienne pioneered the role of *éditeur fondeur*, issuing editions of sculptors' works cast in his own and other foundries, and on Collas's death in 1859 acquiring the rights to the reducing machine.

For the affluent French middle classes, the high-quality bronze statuette became the ideal form of sculpture to display in their homes, with its associations of classical antiquity and the renaissance.

Antoine-Louis Barye

A new genre developed in which groups of both exotic and domestic animals were often shown in scenes of dramatic conflict, struggling for survival. Animals were no longer subsidiary figures but the main protagonists, and sculptors working in this area have become known as *animaliers*. Antoine-Louis Barye was one of the most famous and earliest of these sculptors, his work being widely reproduced in versions of different sizes. For some

years Barye ran a foundry within his own studio, overseeing every stage of production, from modelling the original through to the final stages of highly skilled chasing and patination of the cast bronze to add vitality and quality to the finished piece.

Barye formed a business partnership with Émile Martin from 1845 to 1857; Martin leased the reproduction rights to founders and took a fee for acting as an intermediary. The bronzes were advertised in a series of printed catalogues, themselves produced in large-scale editions which guaranteed that thousands of bronzes were sold each year. After Barye's death, his models and master bronzes were dispersed at a sale held at the Hotel Drouot, Paris in 1876. Barbedienne acquired many of them and produced posthumous editions of some compositions well into the twentieth century.

Sand Casting

The lost-wax method of bronze casting, favoured by earlier sculptors, was too costly for nineteenth-century founders striving to meet the voracious demand for small-scale bronzes. They turned instead to sand casting (for more on sand casting see *Medals and Plaquettes*). As already noted, hollow casts are preferable, partly to minimize cost, but also to ensure an even rate of cooling. These are achieved by using a sand core, similar in shape but slightly smaller than the original model. The difference between the two will be the space occupied by the molten metal, and it determines the thickness of the bronze cast. The hollow cast of Barye's bronze group *Theseus Combating the Minotaur* (plate 96a) is a variation of the first version modelled in 1843, most likely cast in 1855, and shown that year at the Paris exhibition. It was an important early purchase by the Museum.

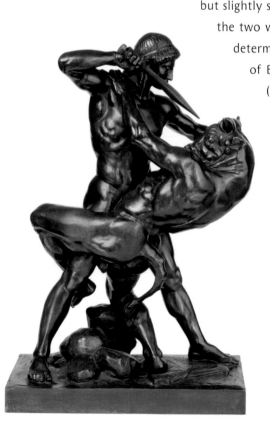

A *chef modèle* or master bronze was cast from the original model and finely finished before being cut into the distinct elements required to replicate the complex composition (plate 96b). This could serve as the model for future plaster piece moulds, from which further models could be taken, or it could simply be pressed directly into the moulding sand. Barye

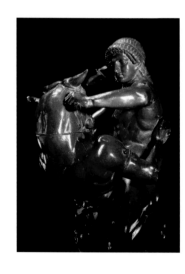

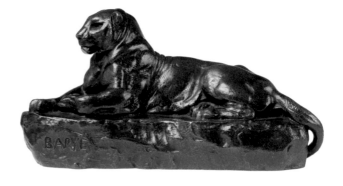

evidently used the latter practice, since both fired and unfired sand has been found inside some of his other bronze models. The core was also modelled from damp French sand, into which metal pins were inserted in order to hold it away from the outer sand mould. After the cast was released, the core and all evidence of the core pins were generally removed. The *Panthère de l'Inde* (plate 97), however, purchased by the Museum direct from Barbedienne, still carries evidence of its facture. A small metal plug (plate 98) is visible in the back of the Panther, and the underside reveals that the plug has not been trimmed. The darker areas inside the figure are the remains of core sand, charred by the molten bronze as it flowed into the mould.

In serially-produced sand-cast bronzes, careful design of the individual elements ensured that the final composition could be readily assembled. Some elements were cast with integral flanges, allowing them to be set into recesses in the base, while other parts were cast with male and female keying elements to ensure correct positioning and a secure fit. Animal hooves were cast in order to receive securing screws from underneath the base, and tails were frequently cast separately. Varieties of Roman (mortice and tenon) and sleeve joints ensured separate elements, such as limbs, fitted securely together. Joints were brazed – a method of joining the bronze elements using a filler metal and flux under heat but below the temperature at which bronze melts – and then cleaned off to disguise their presence. The aim of nineteenth-century foundry techniques was to reduce the amount of finishing work. Even so, the sand core had to be removed, and evidence of core pins and mould lines disguised. Physical joints also needed painstaking peening (hammering) and chasing to disguise their presence after the elements had been assembled.

97 Panthère de l'Inde by Antoine-Louis Barye (second version)
Bronze, h.10cm
French, first edition 1857; this cast c.1890
(founder: F. Barbedienne)
V&A: 97–1890

98 (above) **Detail of back of the panther showing the plug** (see plate 97)
(below) **The underside of the panther showing the untrimmed plug**

Auguste Rodin

Bronze casting is by nature a collaborative process, and like many before him, Auguste Rodin depended on the skills of other specialists. While he modelled the original clay, expert mould-makers, plaster or bronze casters and patinators were needed to complete the finished work. There are, however, essential differences between Rodin's artistic values and practice at the end of the nineteenth century, and those of his earlier compatriots, such as Barye. Rodin initially favoured lost-wax casting techniques over sand casting, as he thought they most

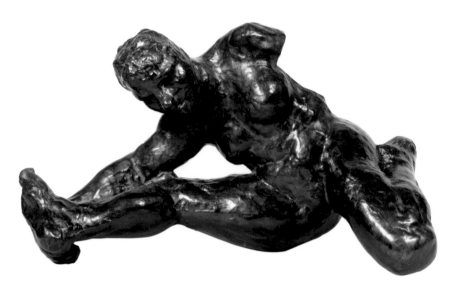

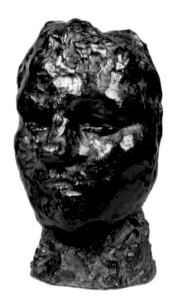

above left

99 The Crouching Woman
by Auguste Rodin
Bronze (founder: Alexis
Rudier), h.53cm
French, c.1855–90
Given by the artist
V&A: A.40–1914

above right

101 Camille Claudel
by Auguste Rodin
Bronze (founder: Alexis
Rudier), h.36.9cm
(including base)
French, 1882–99
Given by the artist
V&A: A.43–1914

right

100 The Head of Iris
by Auguste Rodin
Bronze (founder: Alexis
Rudier), h.58.4cm
French, c.1908
Given by the artist
V&A: A.41–1914

faithfully recorded the artist's intentions. But after receiving estimates for the proposed bronze door, *The Gates of Hell*, in 1884–5 from Eugène Gonon and Pierre Bingen, he realized that lost-wax methods were also prohibitively expensive. The artist later enjoyed a long working relationship with the firm of Alexis Rudier, which specialized in sand casting and could meet Rodin's exacting standards.

Sand casting was employed for *The Crouching Woman* (plate 99), an assemblage of several pre-existing plaster moulds. These were used to cast in bronze the separate elements of limbs, torso and head from other compositions in order to create a new sculpture (see *Plaster Models, Plaster Casts, Electrotypes and Fictile Ivories* for further discussion of Rodin's use of plaster). The intentionally piecemeal approach to its creation, together with its truncated form and apparent physical instability, imbue the final work with a sense of imbalance and unease, anticipating later developments in twentieth-century sculpture. Rodin later had the head of *The Crouching Woman* cast on a much larger scale, and called it *The Head of Iris* (plate 100); this was one of many examples of Rodin's practice of rethinking and reusing certain motifs and themes.

Although Rodin studied zoological drawing briefly with Barye in 1896 at the Museum of Natural History in Paris, and greatly admired the older artist, his intentions when creating bronze sculpture were vastly different. In contrast to the meticulous finish of a true Barye bronze, Rodin's concept of what constituted beauty is evident in his intimate bronze study of his pupil and lover, *Camille Claudel* (plate 101). Evidence of the facture remains in the bronze: the surface is enlivened by the preserved marks of Rodin's fingers, and is actually enhanced by what a nineteenth-century critic might have called its 'unfinished' state.

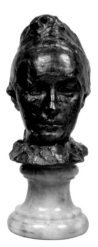

Patination

The surface finish is one of the key elements of bronze production, usually involving the application of colour or gilding. This finish could reflect the taste of the patron, though it has frequently been lost to us when later collectors repatinated their bronzes. The luxurious inlay and gilding seen on Antico's bronzes must have appealed particularly to his Gonzaga patrons.

The most durable means of gilding, as often used by Antico and seen in Hubert Gerhard's Fugger altarpiece (plate 102), was fire or mercury gilding, a technique which goes back to ancient China and was described in antique sources. Two methods are described in surviving recipes – one involves applying an amalgam of mercury and powdered gold leaf, and in the second mercury is applied to the surface of the bronze and gold on top. By heating the bronze the mercury is driven off and the gold is fused to the surface of the bronze. This process was extremely dangerous, and only became safe when modern methods of extraction were developed. Documents relating to the Fugger altarpiece describe how butter was given to the gilders, as it was thought to counteract the poisonous effects of the mercury. It doubtless had little effect. These fascinating accounts also outline the elaborate process of cleaning the surface before gilding that was carried out by two women using wire brushes and tartar before they washed the bronzes down with beer and water.

Various recipes survive for patinas of different colours, including Gauricus's suggestion that black is produced by a coating of varnish or liquid pitch or by using the smoke of wet straw. The results of tests on Venetian bronzes with blackish, opaque patinas confirm the use of a drying oil – walnut in some cases – but also a conifer resin, sometimes larch or Venice turpentine. A recipe for green is given by both Gauricus and Vasari, who advocate the use of vinegar. The colour associated with Florentine bronzes of the sixteenth century and later is usually a golden varnish, generally considered as Giambologna's invention. The patination of his extended workshop has been identified as falling into three basic groups: a deep chestnut-brown, a more yellow-brown which can be startlingly golden and transparent (plate 103), and a deep red, verging on oxblood in the shadow. Tests have shown a varied content, and include a brown organic patina of Venice turpentine, pine pitch and linseed oil.

An intriguing document mentions that when the studiolo of Francesco I de' Medici (1541–87) in the Palazzo Vecchio

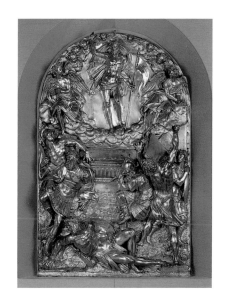

102 Resurrection relief from The Fugger altarpiece by Hubert Gerhard
Bronze gilt, h.96.5cm
German (Augsburg), 1581–4
Bequeathed by Mr George Weldon
V&A: A.20–1964

103 Florentine boar associated with Antonio Susini
Bronze, h.16.5cm
Italian, 1600–1700
Salting Bequest
V&A: A.153–1910

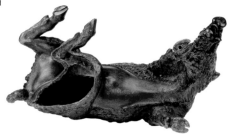

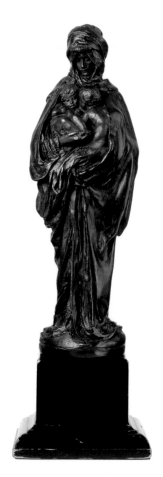

104 Charity
by Alfred Gilbert
Bronze (founder:
Alessandro Parlanti),
h.38.1cm
English, c.1899
V&A: A.8–1972

was dismantled in 1586, Antonio Susini polished six large bronzes with pumice and was provided with 1lb of '*matita rossa*' – red lead, pencil or chalk – with which to varnish them. This fits with a description in a late seventeenth-century treatise by André Félibien (1619–95), who refers to the application of oil and sanguine, the name given to a type of red clay or earth that was used for making crayons or chalks and consisted largely of ferric oxide. This could equally be hematite, an iron oxide found in red sandstone.

Colour in sculpture was also a topic of interest for sculptors in the nineteenth century, as reflected in Alfred Gilbert's experimentation with alloys and patination. Gilbert was a leading figure in the New Sculpture movement, a loosely connected group of artists who did much to revive sculpture in Britain in the late 1800s. Gilbert's interest in metals and casting techniques are well documented. The alloy used to cast *Charity* (plate 104), and known as *shakudo,* originated in Japan. It has gold in place of the tin more usually found in bronze, and could be given a purplish tone by the application of a caustic solution. In addition, a pickling solution was applied selectively to the bronze to induce a reddish-purple for the face and hands of Charity and the infants' bodies. Sometimes the process of patination was speeded up by the use of a torch to heat the chemicals that were painted onto the surface. Barye's *Eagle Seizing Heron* (see plate 95 detail) shows how a green patina has been induced in this way, and then rubbed back in certain areas to reveal the warm tones of the bronze beneath.

Foundries

Not every bronze sculptor was capable of casting his own works, and many collaborated with specialist foundries, including Donatello and even Cellini and Giambologna, who also cast their own works. Antico, who was trained as a goldsmith, still delegated the casting of Isabella d'Este's bronzes to a founder called maestro Johan, who he advised would work for the low rate of 50 ducats, or even at a salary of only six ducats a month and free board for himself and three assistants. Expert founders were not always successful in their results. Michelangelo berates maestro Bernardino for the initial failure of his cast of the over-life-size statue of Julius II, and Cellini both complains of and praises the foundrymen he used while in Paris.

On occasion, local regulations governed practice. In Venice, for example, the role of the marble carver or *tagliapietra* was separated from that of the specialist bronze caster, who belonged to a separate guild. The foundrymen, including members of the great bronze-founding dynasties of the Alberghetti and di Conti, occasionally cast works from sculptors' models.

They also created decorative and functional bronzes based on marble and bronze originals by the leading sculptors of the day, including Alessandro Vittoria, Girolamo Campana and Nicolò Roccatagliata. Roccatagliata, who is credited with a number of small bronzes, is said to have lost an eye while casting. However, little is known of the actual production of his works, and the inscription on the bronze altar frontal in the church of San Moisè in Venice, designed by Nicolò and his son Sebastian, states that it was cast and finished by the Frenchmen Jean Chenet and Marin Feron.

In the nineteenth century Rodin's relationship with foundries was similarly fundamental to his production of bronzes. The first bronze version of his life-size figure *The Age of Bronze* was cast using the lost-wax technique by the Thiébaut Frères foundry in 1880. Yet in a letter of 1900 to Roger Marx (1859–1913), a French civil servant as well as a writer and collector, Rodin wrote that he thought a later sand-cast version of this figure was better than the first lost-wax version. The Museum's version of *The Age of Bronze* was sand cast (plate 105) by the Alexis Rudier foundry. Rodin did not, however, abandon lost-wax casting, and also employed Montagutelli Frères to make the two lost-wax bronze portrait busts of the Duchesse de Choiseul, and that of Eve Fairfax, which he later gave to the Museum. But he severed connections with this foundry after discovering in 1913 that illicit casts of his work had been made.

The revelation that Montagutelli was still producing unauthorized casts after Rodin's death created a huge scandal. Illicit casts are problematic: rogue versions are usually, though not always, smaller in size and of lower quality, and the provenance of a cast bronze is a vital factor in determining its commercial value. Certain practices, legal in France, allowed for a large number of casts to be produced from an original model before the edition was closed. However a law of 1968 set a limit of 12 casts, each of which must be numbered. In some cases descendants of sculptors have set up new editions by combining moulds in ways never envisaged by the original sculptor.

Sculptors and founders have always worked closely together, and a number of different factors are taken into account when deciding how to cast. In some cases it appears that the sculptor made a deliberate choice. Riccio's and De Vries's preference for the direct lost-wax cast highlights that sculptors continued to choose this risky but more immediate method, even when replication was an option. The needs of the market doubtless also had a role to play in determining the nature of the bronzes produced. **WF and PM**

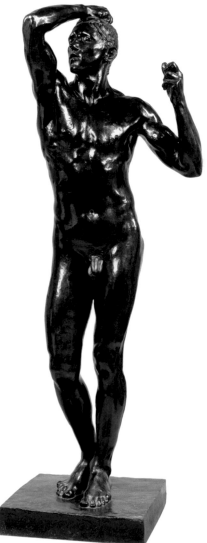

105 The Age of Bronze by Auguste Rodin
Bronze (founder: Alexis Rudier), h.180cm
French, c.1876
Given by the artist
V&A: A.33–1914

**106 Ornate pipe head
bearing the initials
P.B.S.**
Lead, cast, h.51cm
English, 1698
V&A: M.83–1921

**107 The blessings
of peace**, signed by
the monogrammist
H.G. (perhaps Hans
Jamnitzer)
Lead, cast, diam.16.8cm
German, c.1580
Given by Mrs R. de
L'Hopital
V&A: A.38–1936

Lead

Since its discovery over 5,000 years ago, the chief application of lead has been architectural, ranging from solely functional items, such as pipes for plumbing, to those merging the useful with the decorative, such as ornate pipe heads (plate 106). But despite being less commonly employed for works of art than bronze, lead nonetheless occupies a noteworthy role in sculpture. The V&A possesses a varied collection of lead sculpture, comprising coins, plaquettes, statuettes, busts and garden sculpture.

The Material and its History

Predating the Bronze Age, lead is thought to be one of the first metals discovered by man, since it was easy to extract from its mineral ores and is relatively widespread. Chiefly found along with silver in the mineral galena, or variously combined with copper or zinc, such ores were mined and then crushed, before being smelted down into their constituent parts. This process often left the lead with many impurities, a problem now overcome by modern distillation methods, but as a natural element unmixed lead is a rare occurrence.

The earliest known use of lead dates from about 3000 BCE in Egypt and Asia Minor, where it was applied in column fortifications, before being employed in the making of small statuettes and votive figures. However, lead works of art were only sporadically produced until about 500 BCE, when the Greeks began using it for small sculptures and market weights, followed by the Romans, who used it for household ornaments, as well as for water pipes (or plumbing, a term derived from the Latin for lead, *plumbum*) and architecture. By the early Middle Ages, lead was being employed in masonry, roof coverings, fonts and cisterns, and from the fifteenth century onwards, was additionally used for coins and plaquettes (plate 107).

During the sixteenth and early seventeenth centuries, the use of lead in the fine arts was rare, and it was not until the late seventeenth century that it was more widely employed in sculpture, in decorative relief panels and garden sculpture (plates 108 and 109). By the eighteenth century this latter application flourished, not only because of lead's relative resistance to corrosion, but also because its colour and texture allowed it to blend well with the outdoor environment. Since then lead has been used for a wide range of objects, including busts, tobacco boxes, sundials and statuettes.

Physical Properties

In its purest form, lead is a silvery-grey metal renowned for its softness, ductility, high mass and low melting point. Throughout its history, and

as relevant expertise has evolved, these physical properties have very much determined how the metal has been fashioned and formed, and its varying applications in sculpture.

Lead can be fashioned in one of two ways. Its high malleability permits it to be cold-worked and beaten into form, while its low melting point facilitates its use as a plastic material that can be melted and poured into negative moulds. Sometimes these two methods can be combined: a piece can be cast in the rough, and then refined by hammering; it is then normally referred to as wrought lead, rather than cast or beaten.

Casting

With an approximate melting point of 327°C, lead can be cast with simpler facilities than those required for some other metals. Unlike bronze, it does not call for exceptionally high melting temperatures, nor does it need to be entirely free from metallic impurities, since these in fact often impart additional structural strength. As such, one of the earliest techniques to be employed in lead sculpture was casting, as it could be executed in fairly small workshops when refining methods were still inexact.

The V&A's collection of renaissance lead plaquettes illustrates how casting methods evolved during the fifteenth and sixteenth centuries in Europe. Originating in Italy in the 1440s, and reaching Germany and the Low Countries by the 1520s, plaquettes were small-scale relief sculptures that emulated coins and stone engravings from the ancient world. Made as surface ornaments by cabinetmakers and goldsmiths, or as collector's items for those wanting to partake in the intellectual and visual world of antiquity, they often depicted Christian or classical subjects, and helped to visually spread the designs of many major renaissance artists including Peter Flötner and Andrea Riccio (Briosco).

108 Meleager by Andrew Carpenter (Andries Carpentière)
Lead, cast, h.161cm
English, c.1720–30
Purchased with the assistance of The Art Fund
V&A: A.5–1985

**109 Venus, Adonis and
Cupid attributed to
Andrew Carpenter
(Andries Carpentière)**
Lead, cast
English, c.1720–30
Wrest Park,
Bedfordshire
By permission of English
Heritage, NMR

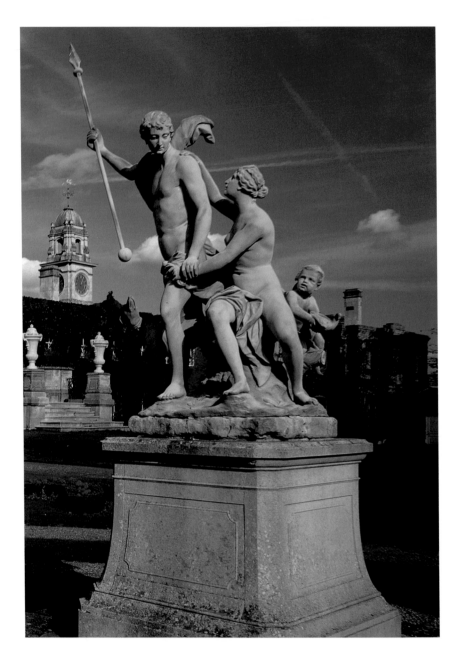

**110 Coriolanus
receiving the Roman
women attributed to
Jonas Silber**
Lead, cast, diam.16.5cm
German, c.1580
V&A: 1646–1856

The Blessings of Peace (see plate 107) and *Coriolanus Receiving the Roman
Women* (plate 110) were both produced in South Germany during the 1580s,
in Nuremberg and Augsburg respectively. These two cities were particularly
important casting centres at this time, specializing in exporting the latest
designs to many parts of Europe. Before being cast in lead, the plaquettes
would have originated from models carved in soft stone or wood, or, as was
common in Italy, slate or wax. Two basic methods of casting were employed
at this time: the sand casting technique, employed since antiquity, and
the lost-wax process, also used since antiquity and particularly during the
renaissance.

The sand casting technique, probably used for the production of *The Blessings of Peace*, begins with the making of a model, usually round in shape, and in this case carved in soft stone and depicting the figure of *Peace* with imagery of abandoned armour and weaponry. From this a negative mould is made by pressing the model into a bed of fine, yielding, moist casting sand (enclosed by close-fitting metal frames) to obtain an imprint of the design. The sand is densely packed down around the model and trimmed clean with a knife, before the model is removed and the negative cast placed into an oven to bake. Once this sand-baked negative has hardened and dried, molten lead is poured into the resulting matrix and, on cooling, the solid plaquette is removed (for a more detailed description of sand casting, see *Medals and Plaquettes*).

At this stage, finishing touches by hand may be required, including refining the surface detail by filing or chasing, or applying metal oxides or thin coats of lacquer. The oxides create a thin layer of oxidation, usually brown, grey or blue in colour, called the patina, which adds lustre and depth to the relief and is often used selectively to accent chosen areas.

The lost-wax process, possibly employed in the making of *Coriolanus Receiving the Roman Women*, is more suitable for producing small numbers of high-relief plaquettes, or those heavily undercut or of unusual shape. Unlike sand casting, which can often generalize form, the lost-wax method reproduces the minute detail and fine modelling, visible on this plaquette, to enable a greater variation of texture and clarity. It similarly begins with a model, this time carved in wood to depict the Roman general Coriolanus swayed by his wife and children not to attack Rome, being placed into a bed of soft material to produce a negative mould of the design. This mould is used to make a positive model in fireproof clay, which is pared down on the back to reduce it by the desired thickness of the final lead. The negative mould is then encased around the fireproof clay model before molten wax is poured into the space between the two. On removal of the negative mould, the wax reproduction is hand-finished to perfect its design, before a finely granulated sand mixture is gradually applied thickly to its surface. This is called an investment mould (from the French verb *investir*, 'to surround'). It is dried and heated to melt the wax, which flows out through specially made channels, known as sprues, before molten lead is poured into the cavity between it and the fire-resistant clay. Once the lead has cooled and hardened, the clay mould is broken and the finished plaquette remains.

While the latter process is more time-consuming and rarely employed for large batches, lead itself casts well using either method, as its low molten viscosity prevents it sticking to its moulds. This means that on casting, the

transfer of relief details is easier, as the lead comes away cleanly from its negative.

However, these methods were not only employed in small-scale sculpture. As artists became more proficient in casting lead, they grew bolder in its applications. By the late seventeenth century, large-scale garden sculpture was highly popular, not only for its aesthetic suitability for outdoor environments, but also because of its relative resistance to corrosion compared with other metals. Celebrated for its superficial tarnishing on exposure to air, the surface of lead forms a thin oxide layer which protects the rest of the dense body from any further decay. But despite its relatively protective veneer, lead suffered increasingly from the corrosive effects of acid rain, which would have damaged the surface patination, leaving it more open to corrosion.

Given lead's high density, garden sculptures made of the metal were hollow, usually ranging from about 1–1.5cm in thickness. One example in the V&A's collection is a life-size figure of *Meleager*, the mythical hero famous as the huntsman who killed the Calydonian boar. This was made by Andrew Carpenter (Andries Carpentière) in the 1720s, probably to surmount a gate-pier (see plate 108). As one of the most prolific makers of lead garden sculpture for many of the great country houses of the 1720s and 1730s, Carpenter was used to producing large-scale pieces. Seen here with his hunting dog, *Meleager* would have been produced according to the lost-wax method. A full-size model would first have been made out of clay, from which various hollow piece moulds would have been taken; with so many projecting parts it was necessary to make a number of these moulds.

To create the initial model, Carpenter would have begun by assembling an iron armature on which to gradually build up and support the clay figure. The core clay figure would then have been marked up on the surface with metal shims to delineate where the model would be later divided. At this point, layers of liquid plaster would have been applied to the clay core which would harden to form a thick shell around the figure, enabling it to be cut into pieces. Each piece would then be prised apart along the shim lines, with the clay core and armature removed, before being reassembled for the liquid wax to be poured in. With numerous hollow wax pieces of the divided figure now made, Carpenter would have carefully redetailed each one to ensure their replication in the final lead. Sprues would then be attached to each of the wax pieces, before they were coated in layers of a liquid plaster (the investment mould), capable of withstanding the heat and pressure of the molten lead. These shells were fired in a flashout kiln to melt the wax away, before the molten lead was poured into the resulting

matrix. Once cooled the shells would be knocked off, the sprues would be removed, and the various sections would be pieced and welded together around a supporting iron armature, before being worked on so that no seam lines were visible on the finished figure. At this point, such figures were often painted either for visual effect or to imitate marble or stone.

In addition, while the hunting horn in Meleager's right hand would have been part of the original mould, the spear held in his left would have been modelled and cast separately, as would the dog. By moulding them individually, Carpenter made it easier for any part to be cast again, be it to melt down and recast a first attempt, or to replicate them for other purposes. The latter seems to have been the case with one of the four lead garden sculptures at Wrest Park in Bedfordshire, made by Carpenter for the Duke of Kent in the late 1730s. In the group representing *Venus, Adonis and Cupid* (see plate 109), the nude male figures with swathes of drapery around their midriffs are analogous to *Meleager*, while the hound in the group with its upturned head is akin to the one at his side. This illustrates how artists could take multiple casts from individual models and use or adapt parts in other compositions.

Another reason for making multiple casts might be for a sequence of pieces, where various studies derive from an original model. This is seen in a series of lead character busts by Franz Xaver Messerschmidt, made between 1775 and 1783. In a study to illustrate different human emotions and temperaments as revealed by facial expressions, Messerschmidt designed 69 different character heads, many of which he cast in lead. One of this series, held at the V&A, is known as *The Strong Smell* (plate 111), and shows the head and neck of a bald man (probably a self-portrait) thrust forward with his eyes tightly shut and a pursed mouth, sniffing heavily. A number of these busts display distinct similarities, the artist again almost certainly portraying himself, merely varying the facial poses. This suggests the sculptor made an original model of his face at rest, and worked from it as a uniform base to follow through and model various other facial expressions.

At 49cm high, *The Strong Smell* was cast from a wax model, similar to the process described on pages 70–71, but in a single piece rather than in sections. Despite being hollow, it has thicker walls than Carpenter's *Meleager* (see plate 108), as the weight to height ratio is less, and its distribution is more stable at a lower centre of gravity. However, due to lead's density of 11.34g/cm³, and its tendency to sag over time, natural sinking can pull and distort sculpted detail. Thus, in an attempt to avoid focusing too much weight in one place, Messerschmidt kept the mass to a minimum by omitting overly solid areas such as the lower shoulders and back, and the sides of the upper

111 The Strong Smell by Franz Xaver Messerschmidt
(character study)
Lead, cast, h.49cm
Austrian, c.1775–83
Purchased under the
Murray Bequest
V&A: A.16–1948

chest. By casting the bust in this way, he has strategically counter-balanced the weight of the protruding head, but also added internal support by leaving the armature and core material inside.

On the rare occasions that lead was cast as a solid mass, the sculpture would have needed to be small enough in scale so that the weight and natural sinkage of the medium would not have been a problem. One such example is *Reclining Figure* by Henry Moore, a lead sculpture made in 1939 (plate 112). Although originally known for his carved stone sculpture, Moore briefly turned away from this in the late 1930s to cast a large quantity of his work in metal. As one of the easiest metals to work due to its low melting point and its ability to stay molten for longer compared with other metals, Moore cast approximately 11 solid lead statuettes between 1938 and 1940, omitting the early stages of casting and working directly from small-scale wax models. In doing so he was not only able to cast solid pieces which were less likely to crack on cooling, but also make the shapes and forms much thinner and more open than would have been possible directly in clay or plaster. *Reclining Figure* is an example of this, where Moore moulded plaster around the small solid wax original, flash-fired it to melt the wax, and poured in the lead, end on, using only one runner and riser to channel it and release the vapour. Like the *Meleager*, these left marks where they were attached to the figure, and so had to be chased with metal files after casting, before being polished for a more delicate finish.

112 Reclining Figure by Henry Moore
Lead, cast, h.15cm
English, 1939
On loan to the V&A
from the Tate

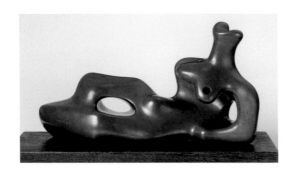

Cold-Working

Sheet lead is usually cold-worked by hammering. It is best shaped within a thickness range of 0.3–1cm for general work and 0.15cm for smaller, low-relief pieces. But unlike the lead used in casting, hammered lead needs to be relatively free from metallic impurities. This is because lead becomes more prone to hardening and cracking with repeated blows as the ratio of impurities increases. Since early users of lead found its purification difficult to monitor and carry out, the technology had to advance in order to enable its fashioning in this way. As such, it was not until the early eighteenth century, when purification methods had improved, that such direct sculpting was possible.

The relief of *The Entombment* (plate 113), made by Jakob Mollinarolo in the late eighteenth century, aptly demonstrates this later handling of the material and the tools required to chase it. On beginning the relief,

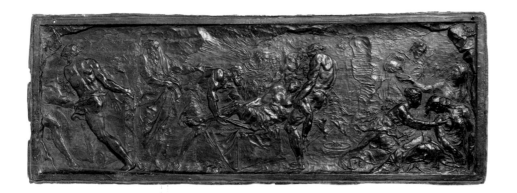

113 The Entombment by Jakob Gabriel Mollinarolo
Lead, hammered,
h.26cm
Austrian, c.1770–80
Given by Dr W.L.
Hildburgh, F.S.A.
V&A: A.75–1951

Mollinarolo would have first cleaned the surface of the lead with soap and water before drawing an outline of his design lightly upon the sheet in chalk. In fact, artists often made a wax model of large-scale reliefs as a guideline from which to work, and Mollinarolo's version for this one can be seen in the Kunsthistorisches Museum in Vienna.

To carry out the design, various ball pein hammers were probably used: one side of the hammerhead section of such hammers is flat for levelling the lead, and the other, known as the pein, is rounded and used more for shaping. Ideally, given lead's softness, the best way to work the design was to hammer the sheet from both the front and the back. This was done by placing the sheet on a cushioned sack of fine sand for the initial rounding out of the forms, before the relief was worked up to a higher depth. In general, the greater the thickness of the lead, the higher the relief possible. Mollinarolo's composition, at over 1cm deep, enabled him to fashion his heads and figures, such as the man's foot and calf on the left hand side, to a level where they are approaching the full round. But while lead's high malleability makes it easily fashionable in sheet form, its lack of elasticity requires a delicacy of handling, as it has a tendency to crack when hammered too thin. As such, Mollinarolo has kept his forms fairly simple, with sharp protruding shapes, like noses, subdued and compact, and figurative detail achieved through texturing rather than fashioning them too finely. Finally, to prevent stresses on internal surfaces or separated areas on the back, the artist applied small quantities of soft lead-based solder to ensure that any finer areas were sufficiently reinforced.

As a relatively inexpensive material that is easily worked and fairly permanent when correctly treated, lead has enjoyed a wide-ranging use in sculpture since ancient times. From plumbing and plaquettes, to busts and garden sculpture, the lead sculpture in the V&A's collection shows that when it is employed by a sculptor with an understanding of its physical properties and limitations, its distinctive qualities can be fully appreciated. **MH**

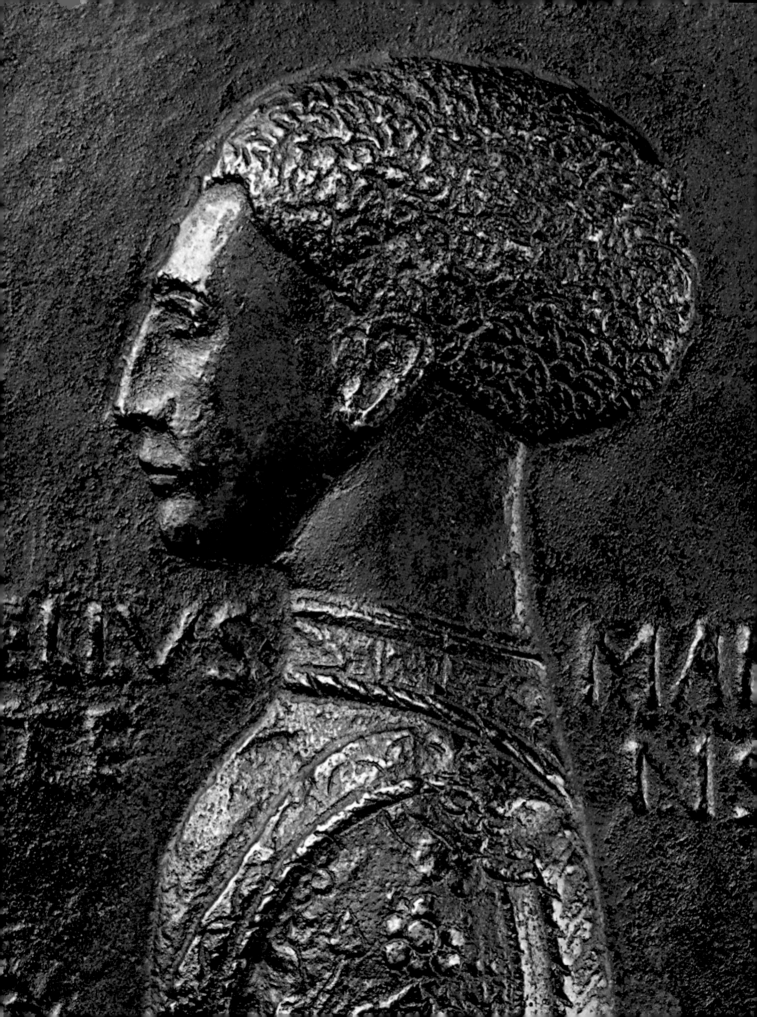

Chapter 5

MEDALS AND PLAQUETTES

Medals give a great light to history in confirming such passages as are true in old authors, in settling such as are told after different manners, and in recording such as have been omitted. In this case a cabinet of medals is a body of history.

Joseph Addison (1672–1719)

Distinct in their purpose from military medals or coins, European commemorative medals mark significant events, people or places, and can also be intended as propaganda. Unlike coinage, which is commissioned by the state and subject to controls of design and weight, medals are often made for private individuals and can embrace any subject. This broad scope and independence from utilitarian constraint mean that they have developed more as small-scale sculptures than their workaday counterparts, coins, and medallists often rank among the most respected artists of their day.

The commemorative portrait medal made its first appearance in northern Italy in the early 1400s. The background was the prevailing fascination with ancient Greece and Rome, but the medal also owes its existence to the emerging European emphasis on the importance of the individual. During the fifteenth century, medal production spread throughout Italy, and coins and medals were often buried in the foundations of buildings, such as the Tempio Malatestiano in Rimini, for future generations to find. As the ideas of the renaissance spread from Italy across Europe and trade routes opened up, they carried with them the enthusiasm for medal-making, and by the beginning of the sixteenth century medallists were already working in Germany and the Netherlands. After an early start under the patronage of Jean, Duc de Berry (1340–1416), French medal production began in earnest in the late sixteenth and early seventeenth centuries, as did the work of British medallists.

The earliest medals were laboriously cast in small numbers, and are now known only in a handful of examples. The first known medal by Antonio

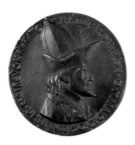

114 John VIII Palaeologus by Antonio Pisano (Pisanello)
Bronze, cast, diam.99mm
Italian, after 1438–9
V&A: 7711–1863

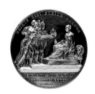

115 Coronation of Queen Victoria by Benedetto Pistrucci
Silver, struck, diam.37mm
English, 1838
Given by the Deputy Master of the Royal Mint
V&A: A.6–1916

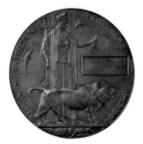

116 Next of Kin memorial plaque by Edward Carter Preston
Bronze, cast, uniface, diam.120mm
English, c.1919
Given by the War Office
V&A: A.10–1920

Pisano (Pisanello), often cited as the first medal of the Italian renaissance, and commemorating the visit of the penultimate Byzantine Emperor John VIII Palaeologus (1392–1448) to Ferrara in 1438–9 (plate 114), exists in only 11 recorded copies. At the other end of the scale, in the nineteenth century Benedetto Pistrucci's official medal for the Coronation of Queen Victoria (plate 115) was mass-produced. Around 4,500 copies were struck in various metals, and large numbers were thrown into the crowd on the day as souvenirs. In 1918 the British Government, in one of the biggest medallic productions ever undertaken, issued over a million memorial plaques, to become popularly known as 'The Dead Man's Penny', to relatives of those lost in the First World War (plate 116).

Manufacture

Although usually larger than coins, medals are similar to them in form, and can also be made of copper alloy (bronze), silver, gold, lead or a variety of other metals and alloys. They can be worked on both sides, or just one. A two-sided medal will normally have an obverse – the primary face on which the main subject is depicted – and a reverse – the secondary face that bears images or inscriptions which add to or enrich the information given on the obverse. Reverse images are often allegorical scenes, or emblems alluding to the qualities of the main subject. Single-sided medals are referred to as uniface.

The manufacture of medals can be carried out in two different ways: casting or striking. Each method results in a finished object with different characteristics. Due to the processes involved, cast medals often demonstrate a greater individuality and freedom of design, and medals from the same basic model can vary widely in detail and finish. Die-struck medals tend to be shallower in relief, more uniform and mechanical in form and feel; they can be produced in larger numbers without losing any of the crisp detail of the original design.

Casting

Until the mid-sixteenth century, most medals were produced by casting. Thereafter die-striking and casting existed alongside each other, with large editions of identical struck medals becoming increasingly popular. In the early nineteenth century, with an impetus which began in France, some artists reacted against the monotony of machine-manufactured medals, and engaged once more with the skills needed to make individual pieces by hand. The so-called art medal was born out of this climate, and casting is still practised among medallists today.

Cast medals are made in small numbers from a modelled original by pouring hot, molten metal into a mould and allowing it to cool. The process often begins with a preparatory drawing, from which a model is developed using a material that is easy to work with and alter – early ones being a form of plaster or beeswax worked up on a slate or wooden disc (plate 117) – although in Germany during the sixteenth century it was usual for models to be carved from fine-grained fruitwood or stone (plate 118).

Sand Casting and Lost-Wax Casting

Variations of the ancient method of sand casting were used in the renaissance. From an initial drawing, the maker produced a separate model for each side of the medal. Practices varied slightly, but once these models were complete, including any inscriptions, negative moulds were usually taken from them in a fine-grained material such as plaster, and from these further positive moulds were made, again in plaster. The models were placed at the bottom of two 'flasks' – separate wooden frames that could be fitted accurately together – and these were then filled up with fine damp sand which was tamped down firmly in several layers on top of each model, so that the compressed sand nearest to the model took up as much as possible of the detail.

Once this was done, the flasks were turned over, the bottoms taken off and the models carefully removed, leaving a precise negative impression in the sand. A 'sprue' was made, connecting the space left by one of the models to the surface, and lines traced in the surrounding sand to allow gases and molten metal to flow and escape to the edges. The flasks were then put together carefully so that the two hollows left by the plaster models were positioned exactly one on top of the other, and the molten metal was poured into the funnel of the sprue. As soon as the metal stopped glowing the flasks could be taken apart and the cast removed.

To make a mould which could, with care, be used several times, medallists would work direct from their initial model, using a hardened mixture of ash, salt, tufa, pumice and a bonding agent. For a two-sided medal, two moulds would be needed, which would be joined together for the casting, with vents and channels cut first, to allow the molten metal in and the escaping gases out during the process.

In either case, once the rough cast medal had cooled, it was cleaned of the stalks of metal which had solidified in the various runnels and sprues, and chased with metalworking tools to remove imperfections or add detail. The raw appearance of the freshly cast metal was toned down or patinated with lacquer and other substances.

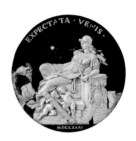

117 Model for the reverse of the medal of Pope Clement XII by Massimiliano Soldani-Benzi
Wax on slate model, diam.82.5mm
Italian, 1731
Given by G.F. Hill and formerly in the collection of the medallist L.C. Wyon
V&A: A.39–1932

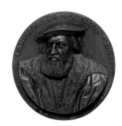

118 Charles de Solier, Lord of Morette by Christoph Weiditz
Boxwood, diam.57mm
German, around 1530
Salting Bequest
V&A: A.507–1910

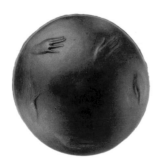

**119 Model for reverse
of the John Charles
Robinson medal
by Felicity Powell**
Wax, diam.120 mm
English, 2002
Given by the artist
V&A: A.11–2004

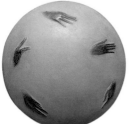

**120 John Charles
Robinson medal
by Felicity Powell**
Bronze, cast,
diam.116.5mm
(cast by Alan Dunn)
English, 2002
V&A: A.5–2002

The lost-wax process for casting bronzes (described in *Bronze and Lead*), in which the original wax model is left inside the outer mould and is melted and expelled during casting, is not thought to have been widely used for the making of cast medals. One reason for this might be that whereas a sacrificial wax model could be used in the one-off production of a uniface medal or relief, the making of a single wax model worked on both faces to cast a two-sided medal would present greater difficulties, the soft material on one side being vulnerable to damage while the other side was being worked on.

The main stages of modern casting can be seen in a twenty-first century medal by Felicity Powell, commissioned by the V&A in memory of John Charles Robinson (1824–1913), the first curator of the South Kensington (later Victoria and Albert) Museum, and an important figure in the formation of its collections. Many of the steps are similar to the earlier processes, but the casting itself uses the ceramic shell technique developed in the 1950s (plates 119 and 120). The wax model is surrounded by a shell of ceramic particles; as this is porous there is no need to construct vents for the gases given off during casting. Once cast, this medal was given an unusual green patina – a chemical alteration to the surface of the metal – by the application of copper nitrate solution under heat.

Striking

Striking a medal involves impressing images under force on a metal blank, known as a planchet or flan, using stamps or dies made of a harder metal, using either a hammer or a press. Struck medals can be made in large numbers without the dies degrading or the finished result altering. Early currencies such as Greek and medieval coins were made by a crude form of striking, the rough blank of metal being placed between two dies engraved with the required images or devices and the whole assemblage being hit with a hammer, the obverse and reverse being impressed simultaneously, sometimes with uneven results (plate 121). The upper die was known as the trussel, and the lower one the pile. The first mechanical striking apparatus, the screw press, was invented around 1506 in Italy, and following that the process became increasingly mechanized.

As with casting, the starting point for the artist might be a sketch or wax model. From this a plaster model would be produced and the metal dies then cut by the engraver into the surface of the dies or stamped into them by a hardened punch. As the process of producing dies became ever more technically sophisticated, so the artist became distanced from the realization of his design. By the mid-nineteenth century, many stages

had been introduced, and because of the forces exerted on them during striking, dies and punches had to be hardened between each one. The first, or master punch, when hardened, was used to sink a matrix or master die, with features incuse. This, hardened in its turn, was used to raise a further working punch from which the working dies were finally made. The product of each stage would be minutely examined and worked on by an engraver to remove any defects.

The illustrations, representing nineteenth-century striking techniques, show a model and a working die used in the production of one of the five official medals of the Great Exhibition of 1851 (plates 122, 123 and 124). During the actual process the die for the obverse would traditionally take the bottom position on the press table. A steel collar was placed over the neck of this die, and the weighed bronze blank – the future medal – placed inside the collar. The upper die, with the design for the reverse, was then set on top of the blank inside the collar. The collection of assembled parts was then hit by the steam-powered ram of the press. At impact the bronze of the blank, restrained all round by the collar, was forced into the cavities of the upper and lower dies. The medal could be taken out, examined, and heated if necessary so that the metal relaxed and it could be replaced for further blows.

A further technological advance, the reducing machine or pantograph, with which the contours of a design on a large model could be followed at one end and simultaneously reduced in scale and copied onto a punch at the other, was introduced during the mid-nineteenth century.

121 Tetradrachma of Demetrius Poliorcetes, King of Macedonia
Silver, struck,
diam.55mm
Greek, 294–288 BCE
Salting Bequest
V&A: A.626–1910

122 Model for the reverse of the Council Medal for the Great Exhibition of 1851 by Pierre Antoine Hippolyte Bonnardel
Plaster, diam.226mm; English, 1851; V&A: A.2–2004

123 Die for the obverse of the Council Medal for the Great Exhibition of 1851 by William Wyon
Steel, diam.160mm; English, 1851
Given by the Royal Commissioners for the 1851 Great Exhibition; V&A: A.80–1921

124 Council Medal for the Great Exhibition of 1851 by William Wyon
Bronze, struck,
diam.89mm
English, 1851
Given by the Royal Commissioners for the 1851 Great Exhibition
V&A: 6028–1852

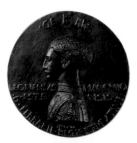

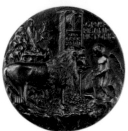

**125 Leonello d'Este
by Antonio Pisano
(Pisanello)**
Bronze, cast,
diam.95mm
Italian, 1444
V&A: 7130–1860

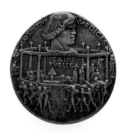

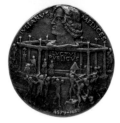

**126 The Pazzi
Conspiracy
by Bertoldo di
Giovanni**
Bronze, cast,
diam.65mm
Italian, 1478
V&A: 4579–1857

Italian Renaissance Portrait Medals

While it is generally accepted that Roman coins and their commemorative editions played a part in the origins of the portrait medal, their initial success was largely due to the Italian artist Pisanello. First produced for aristocratic and humanist patrons in the North Italian courts, such as the Este of Ferrara, they were used as diplomatic gifts or tokens of friendship, and often commemorated events such as marriage, military victories or the taking of office. The basic form was established by what is thought to be the first portrait medal, made by Pisanello in 1438. This depicts John VIII Palaeologus (see plate 114), and is circular in shape and two-sided. A portrait in profile and identifying Latin inscription was normally displayed on the obverse, while the reverse showed an emblem or motto of the sitter. Divorced from the restrictions of weight and value placed on coinage, and almost exclusively celebratory in nature, this new type of work of art led to many more commissions for both Pisanello and his contemporaries.

In the early 1440s, while working for the Este, Pisanello was commissioned to make one of the first series of portrait medals, commemorating the marriage of Leonello d'Este, the Marquis of Ferrara (1441–50), to Maria of Aragon (1482–1517), the daughter of the King of Naples. Leonello was a fervent collector of ancient coins and a cultured follower of humanist philosophies. Pisanello's series of eight medals with portraits of Leonello and allegorical reverses reflect the erudition of the court. Aimed at asserting Leonello's strength as a ruler, and preserving his fame for the future, one of this series shows Love in the form of a Cupid teaching a lion (Leonello) how to sing (plate 125).

Portrait medals were produced by sand casting until the later sixteenth century. Preparatory drawings or existing paintings provided the basis for their designs, and it was common in Italy to then fashion a model out of wax. Having worked the images for the obverse and the reverse, lettering and other ornamental details were added to the model before casting. The placing of the letters on the obverse of the medal of Cupid and the Lion (see plate 125) has a measured dignity, while the portrait is both sensitive and idealized.

Bronze medals are normally given a patina, which is a lacquer or chemical treatment. The effects of the patina, which involve changing the tones of the metal to soften and distinguish the surface relief, can be seen on the portrait medal made by Bertoldo di Giovanni to commemorate Giuliano and Lorenzo de' Medici, following the Pazzi conspiracy in 1478. The conspiracy, led by Pope Sixtus IV and his nephew Salviati, and backed by members of a rich rival family, the Pazzi, aimed to overthrow the Medici in Florence and

enlarge papal territory (plate 126). But the plot failed, as the Florentines rose up against the perpetrators. The added tones of the patina, which is probably original, enhance the expression of the two Medici portraits on the obverse, and vibrantly emphasize the murder of Giuliano in the Duomo and Lorenzo's swift escape from his attackers on the reverse.

Jacopo da Trezzo, a trained sculptor and gem-engraver, enjoyed the patronage of the Medici in Florence from the late 1540s, and entered the service of Philip II of Spain in 1555. His large cast medals show the influence of the renowned Milanese sculptor and medallist Leone Leoni. Da Trezzo's medal of Philip II (plate 127) portrays the Spanish king on the obverse. Using a fine-pointed tool to build up and define his dress meticulously in wax beforehand, da Trezzo has been able to capture the detailed folds on his sleeves and the ruffled lace trim of his shirt. By chasing the medal's surface after casting he has introduced ornate embroidery to his doublet. The reverse shows Helios driving the chariot of the sun, implicitly comparing Philip to the sun god.

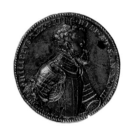

127 Philip II of Spain by Jacopo da Trezzo
Bronze, cast,
diam.67mm
Italian, c.1555
V&A: 6759–1860

Plaquettes

Renaissance plaquettes likewise frequently depicted mythological stories (see also *Bronze and Lead*). Much like portrait medals, which could be easily reproduced and widely distributed, the durability and portability of cast plaquettes meant they were highly popular as small-scale sculptures, regardless of their function. They began to be produced in the later fifteenth century in Rome and Florence by goldsmiths, such as Moderno (Galeazzo Mondella). Plaquettes were [generally] one sided and their shapes varied considerably depending on their function. They could, for instance, serve as hat badges, pendants or furniture decoration but were also admired as miniature works of art in their own right. Plaquettes depicting religious subjects could also be made into paxes, or set into portable liturgical objects and candlesticks for altars.

One such plaquette, depicting St George and the Dragon, and attributed to Gianfrancesco Enzola (plate 128), is now in the V&A's collection. The legend, while somewhat obscure in origin, was first recorded in the late sixth century, and may have been an allegory of Emperor Diocletian's persecution of the Christians (he was often cited as 'the dragon' in ancient texts), or a version of the Greek myth of Perseus, believed to have rescued the virgin Andromeda from a sea monster near Lydda, where the cult of St George first took root. Produced in much the same way as medals, but less lengthy as only one side of the plaquette was in relief, a model would first have been made in wax, with a negative mould of just the obverse taken

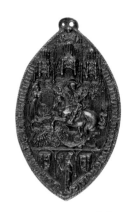

128 St George and the Dragon attributed to Gianfrancesco Enzola
Bronze, cast, h.86.5mm
Italian, c.1475–1500
Purchased under the Salting Bequest
V&A: A.457–1910

in sand, before molten bronze was poured into the cast and enhanced on cooling if necessary. Channels are often visible on the reverse showing how the material ran into the cast.

This particular plaquette has been cast from an impression of the episcopal seal of Lorenzo Roverella, the Bishop of Ferrara between 1460 and 1474, and shows St George on a horse facing the left, as he spears the dragon with the Princess Sabra looking on. As a renowned goldsmith and medallist from around 1455, Enzola enjoyed the patronage of Ercole d'Este, the Duke of Ferrara, and was Master of the Mint there from 1471–3. Testament to his skill, Enzola's meticulous carving can be seen on the plaquette's background of gothic tracery, surmounted in detail by a triple canopy and two shields of arms. His subtle treatment of the bronze, with its lush brown patina, gives the finished piece a rich and lustrous surface and beautifully highlights Enzola's mastery of the active human figure in a difficult and spatially complex pose. The two holes at the top of this plaquette suggest that it was probably once attached to the front of a cabinet or furniture piece decoratively to enhance the surface, while the subject matter would have concurrently demonstrated the erudition of the owner.

Not all plaquettes were overtly religious or mythological in subject matter, but they were often inspired by classical antiquity. One plaquette, for example, shows five putti at play (plate 129), recalling representations of the infant Bacchoi, seen on second-century Roman sarcophagi. At once learned in their formal sophistication, but also immediately accessible, such subjects were highly popular, particularly as decorative ornaments. In this instance, the rectangular composition was probably intended to form an ornate side panel of a casket or inkstand (plate 130).

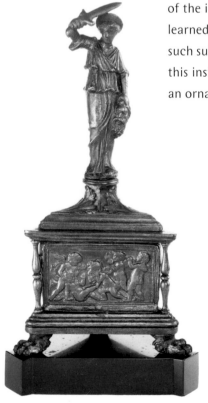

left

130 Triangular inkstand or sand-box with side plaquettes of cavorting putti
Bronze, cast, each side h.8.5cm
Italian, c.1575
© The Collection of the Frick Art and Historical Center, Pittsburgh, Pennsylvania

right

129 Five putti at play
Bronze, cast, h.49mm
Italian, c.1475–1500
V&A: 81–1891

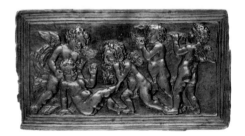

Netherlandish and German Medals

Medal production flourished in the Netherlands in the sixteenth and seventeenth centuries. An early masterpiece is this cast bronze medal by Quentin Matsys of the great humanist scholar Desiderius Erasmus (c.1469–1536), made for the sitter in 1519 (plate 131). It is both a sensitive portrait and a meditation on mortality, and many copies were made in bronze, lead and bell metal from 1524 onwards. Matsys, who had painted Erasmus two years previously, has created a naturalistic portrait in low relief, complemented by both the inscriptions and the allegorical reverse, on which Erasmus himself advised. The Greek and Latin wording on the obverse testifies that the portrait was taken from the life, and can be translated as: 'His writings will present a better image: portrait executed from life'. Erasmus himself said that his best portrait was to be found in his books. The reverse shows the pagan god Terminus (denoting death), with another classical inscription, to be translated as: 'Consider the end of a long life – death is the ultimate limit of things'. The Latin legend running across the field means: 'I yield to no one' (as if spoken by the god).

Medals were made in Germany from the early sixteenth century onwards, the main centres of production being Nuremberg and Augsburg, where existing foundries, goldsmiths and metalworkers provided a good foundation for the new art of the medal. Many German medals of the sixteenth century were made from wood or stone models, some of which have survived.

Friedrich Hagenauer's cast lead medal of Augustin Loesch, Chancellor of the Duchy of Bavaria (1471–1535), is dated 1526 (plate 132). Hagenauer was active mainly in Augsburg, and frequently depicted his sitters in profile, wearing prominent hats, which assisted in the composition of the portrait within the round format of the medal. This lead was probably taken from a wood model. The medal is uniface, the Latin inscription giving the name and title of the sitter, and the date.

Boxwood or fruitwood medallions made in Germany in the sixteenth century are among the finest examples of the art of the portrait medal. Some, such as a pearwood model of a young man by Hagenauer, could have been models for medals, although no medals in metal are known to have been cast from them, and they may have been considered small-scale sculptures in their own right (plate 133). A hole has been drilled at the top of this piece, suggesting that at one stage it may have been displayed in a collector's cabinet, the large turned mount acting as a frame.

A lead medal by the Nuremberg artist Matthes Gebel of Bartholomaeus Haller von Hallerstein (1486–1551), dating from 1537, is bent around the

131 Desiderius Erasmus by Quentin Matsys
Bronze, cast, diam.10.5cm
Netherlandish, 1519
V&A: 4613–1858

132 Augustin Loesch by Friedrich Hagenauer
Lead, cast, diam.7.1cm
German, 1526
V&A: 150–1867

133 Portrait of a man by Friedrich Hagenauer
Pearwood, diam.6.1cm
German, c.1530–40
Salting Bequest
V&A: A.509–1910

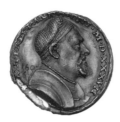

**134 Bartholomaeus
Haller von Hallerstein
by Matthes Gebel**
Lead, diam.3.2cm
German (Nuremberg),
1537
V&A: 160–1867

**135 Pact of Malice
by Karl Goetz**
Bronze, cast, diam.8.2cm
German (Munich), 1915
Given by Richard Falkiner
V&A: A.2–1998

edge (plate 134). Lead is a soft metal and fairly easily damaged; in this case the medal may once have been fixed to a book cover and then removed, causing this irregularity. Gebel's medals are often small (this one measures only 3.2cm across), and the portraits are more naturalistic than the medals of some of his contemporaries, such as Hagenauer (see plate 133). They are often based on stone models, which can allow for more subtle modelling than wood.

Karl Goetz's cast bronze *Pact of Malice* was made in Munich during the First World War (plate 135). It is signed and dated 1915, and was produced shortly after the Treaty of London between the Allies and Italy. On the obverse a winged lion with six hydra-like heads represents the Allies, with a legend in German meaning 'Pact of Malice'. God the Father is depicted on the reverse holding a sickle in his right hand, along with the apocalyptic words of the great German poet Heinrich von Kleist (1777–1811), 'Smite him dead! The Day of Judgement will not ask your reasons!' Goetz produced 175 satirical medals during the First World War, which were above all politically motivated.

French Medals

The history and development of the French medal from the fifteenth to the nineteenth century was closely controlled by the State; the fame of virtually all French political and military leaders was celebrated through the medal. Initially linked to the production of coinage, the medal's dual functions of commemoration and reward, together with its portable nature, made it an ideal medium for state propaganda. Dynastic claims were advanced by repeating the iconography of earlier medals, or indeed repeating entire series of medals – *histoires metalliques* (histories in metal) – issued in honour of the head of state.

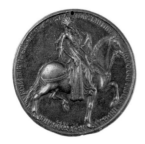

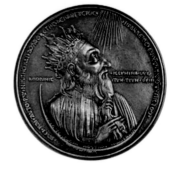

left
**136 Constantine the Great
Possibly by the Limbourg brothers**
Bronze, cast, diam.8.9cm; French, c.1402
V&A: 4492–1858

right
137 Heraclius
This is a 19th-century bronze electrotype by Ferdinand Liard after the fifteenth century medal by the Limbourg brothers
diam.9.9cm; French
V&A: 1890–122

The first two French medals owe their existence to the art of the goldsmith. They depict the Roman emperors Constantine (plate 136) and Heraclius (plate 137) and are by one or both of the Limbourg brothers, Jean and Paul. The *Constantine*, described in the accounts of Jean, duc de Berry (1340–1416) as being made of gold and decorated with jewels, was bought by the Duke on 2 November 1402 from an Italian merchant, Antonio Mancini. The Duke subsequently had one copy of each of these two medals made in gold, and it is from these that later versions descend. The clarity and sophistication of design in both medals was due to the Limbourgs' early training as goldsmiths, and their skill as graphic artists. But they appear in France without directly recognizable precedents, and had no immediate influence on French medal design. For example, the struck silver medal commemorating Charles VII's expulsion of the English in 1454 is closer to contemporary coin design (plate 138). It is thought, however, that copies of these prototype medals travelled to Italy, and knowledge of them in the later 1430s informed Pisanello's portrait medal of John VIII Palaeologus, himself a Roman emperor, setting the format for the development of the portrait medal (see plate 114).

The medal of Louis XII and his consort Anne of Brittany (plate 139), commissioned by the city of Lyon on 18 March 1499 to be given to the Queen, was produced by local artists. The style of this medal remains predominantly medieval, with its adherence to heraldic devices, but the idea of a bronze portrait medal derives from Italy and the work of Pisanello.

As early as 1547, Henri II, seeking to control coin counterfeiting, instituted an official post governing the production of the tools for striking coins. In 1551 new machinery developed in Augsburg enabled the Paris Mint (*La Monnaie*) to manufacture perfectly circular metal blanks of an even thickness for mechanical striking of greater accuracy and speed. In the late

138 The Expulsion of the English
Struck silver,
diam.6.15cm
French, c.1454
© Trustees of the British Museum

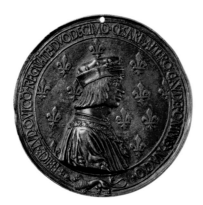
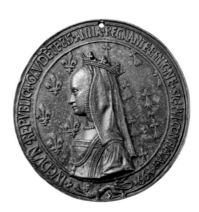

139 Louis XII and Anne of Brittany by Nicolas Leclerc and Jean de Saint-Priest
Cast by Jean and Colin Lepère
Bronze, diam.11.5cm
French, 1499
V&A: 661–1865

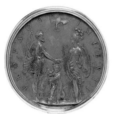

**140 Henry IV of France
and Marie de Medici
by Guillaume Dupré**
Bronze, cast,
diam.19.05cm
French, 1605
V&A: 5779–1859

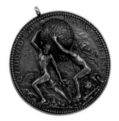

**141 Antoine Coeffier
(Ruzé), Marquis
d'Éffiat by Jean Warin**
Bronze, cast and
chased, diam.6.94cm
French, 1629
Salting Bequest
V&A: A.362–1910

**142 Antoine Coeffier
(Ruzé), Marquis
d'Éffiat by Jean Warin**
Detail of medal
above: the left arm of
Hercules is fully three-
dimensional and clear
of the field of the medal

sixteenth century the appointment of Germain Pilon to the newly created post of *Controleur Général des Effigies* gave him the sole right to model the King's portrait for the coinage, and led to greater centralized control over the design and production of both coins and medals. In 1604 Guillaume Dupré was elevated to the same post, with additional responsibilities, by Henri IV (r.1589–1610) in recognition of his medallic work, including a medal commemorating the birth of the Dauphin (plate 140). The reverse of this medal represents the King as Mars, and his consort Marie de Medici (1573–1642) as Minerva, with their son, the Dauphin, standing between them. Dupré was the first French medallist to exploit fully the tradition of medallic portraits that had been perfected in Italy.

An early cast medal of 1629 by Jean Warin (plate 141) depicts Antoine de Ruzé (1581–1632), Superintendent of Finances and Commander of the French Army, as Atlas, helping Henri IV, represented as Hercules, carry the burdens of state. The raised left arm of Hercules is entirely free of the medal, having been modelled almost in the round and then pierced through when the medal was chased during finishing (plate 142). Warin, influenced by Dupré's classicizing style, displays at the same time a vigorous naturalism. He was appointed *Controleur Général* in 1647, and achieved a virtual monopoly for the striking of coins and medals at the Paris Mint. His struck medals were designed above all to glorify the state.

Jean-Baptiste Colbert (1619–83), Chief Secretary of State for Louis XIV, further centralized state control in 1663 by establishing the Petite Académie, later called the Académie des Inscriptions et Belles-Lettres, which inaugurated a series of medals to immortalize and glorify Louis XIV, the Sun King. Many of the best medallic artists were employed, though they were strictly controlled by the Petite Académie, which determined the subject of each medal, its composition and the inscription. These medallic histories, of which there were four, were enormously influential on medal design throughout Europe, and remained the norm in France as cultural propaganda until the French Revolution of 1789.

A semi-official medallic history, begun by Napoleon Bonaparte (1769–1821) as early as 1797, continued under the charge of Dominique Vivant Denon (1749–1825) from 1803. By 1815 the Paris Mint records show that Denon, Director of both the Mint (1804–15) and the Musée Napoléon (the Louvre), had created 141 medals, all of which were minted in vast numbers for official distribution. A second great medallic history for Napoleon was begun in 1806 by the Classe d'Histoire et de la Littérature Ancienne of the Institut Impérial, a revival of the Académie des Inscriptions et Belles-Lettres, but was never completed. By copying the earlier medallic history of Louis

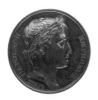

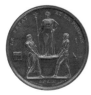

XIV, Napoleon sought to be legitimized as emperor. One of these medals, *The Coronation of Napoleon* (plate 143), shows Napoleon standing on his shield, an image symbolizing his heroic status.

The early years of the nineteenth century saw a reaction against the conformity and conservatism of the struck medal. Sculptors working independently of state-controlled medal-making became much more interested in the expressive possibilities of the cast medal. Modelling their designs in wax, rather than handing them over to a die-engraver, allowed them direct control of their compositions, which were more lively. The intention of the Galerie des Contemporains by David d'Angers, begun in 1827, was to break the state monopoly of medallic portraiture. The Galerie asserted the entitlement of individuals to this form of commemoration by including likenesses of the artist's personal friends, alongside more famous subjects (plate 144).

In the second half of the nineteenth century a series of national and international exhibitions held in Paris gave artists and manufacturers unrivalled opportunities to exhibit their finest work. French medal-makers were commissioned to design the official prize medals awarded to manufacturers, as well as the official commemorative medals, and the Paris Mint sold thousands of contemporary struck medals at the 1889 and 1900 exhibitions.

In addition, the nineteenth-century development of reducing machines, though controversial, enabled artists who were not skilled die-engravers to make medals, and French medal design flourished under their more innovative approach. Official bodies such as the Direction des Beaux Arts, and the medal collection formed at the Musée du Luxembourg (1860–1940), underpinned this resurgence in the art of the medal. And in the 1880s Louis Oscar Roty revived the rectangular renaissance plaquette format (see plate 129), often additionally including a scene on the reverse (plate 145), which proved hugely influential on French medal design (plate 146).

opposite

**143 The Coronation of Napoleon
by Romain-Vincent Jeuffroy**
Bronze, struck,
diam.4.1cm
French, 1804
Given by James W.
Fleming, F.R.C.S.E.
V&A: 1944–1877

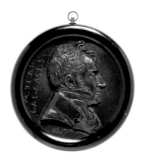

**144 Emmanuel-Augustin-Dieudonné-Martin-Joseph, Comte de Las Cases
by David d'Angers**
Cast by Eck and Durand
Bronze, sandcast,
uniface, diam.12.6cm
French, 1830
V&A: A.4–1971

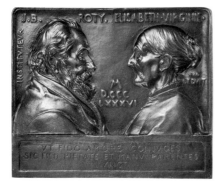

**145 Portrait of Louis Oscar Roty's parents
by Louis Oscar Roty**
Bronze, cast, uniface
h.13.7cm
French, 1886
V&A: 668–1894

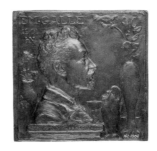

**146 Emile Gallé
by Henry Nocq**
Bronze, cast, uniface,
h.11.6cm
French, 1901
V&A: 162–1906

French medal production declined during the early twentieth century. However an influential force for stylistic change was the International Exhibition of Modern Decorative and Industrial Arts held in Paris in 1925, from which Art Deco derives its name. Pierre Turin's commemorative medal exemplifies one such style (plate 147). In the early decades of the twentieth century, as a result of the changes in production and purpose, medals were no longer so closely tied to their traditional functions of commemoration and reward, and French medals could now be decorative objects in their own right (plate 148).

British Medals

With notable exceptions, the contribution of Continental artists can be seen as a thread running through the history of the British medal. The impact of the Italian renaissance on the arts in Britain was comparatively late and muted, although a tradition of humanism in literature and philosophy had been established by scholars such as John Colet (1466–1519) and Thomas More (1477–1535). The earliest medals commemorating British subjects were either produced abroad, such as the portrait of Mary Tudor (1516–58) by Jacopo da Trezzo (plate 149), or were the work of visiting Italian, French, German and Netherlandish artists working for the Royal Mint.

One of the first British artists known to make medals was the great limner (painter of miniatures), seal designer and goldsmith Nicholas Hilliard, who worked at the courts of Elizabeth I (1533–1603) and James I (1566–1625). Few medals can be definitely attributed to Hilliard, who allowed other artists to use his designs, but this medal of James I (plate 150) may be based on a design by him. It recycles a reverse first found in 1588 on a medal of Elizabeth I, celebrating the defeat of the Spanish Armada, but here symbolizing a country stable after the upheavals of the Reformation. In contrast to the worldly splendour of James's portrait, the sombre likeness of the parliamentarian Sir John Hotham (executed in 1645), by Thomas and Abraham Simon (plate 151), cast during the Commonwealth, is puritanically austere. The Simon brothers collaborated, Abraham modelling in wax and Thomas chasing and often signing their exquisitely cast medals, in producing a series of portraits of anti-royalist figures which are some of the best British medals of any period.

Dating from around 100 years after the Simon medal, and presenting a total contrast to it, the splendid parcel-gilt portrait of Frederick, Prince of Wales (1707–51) (plate 152) is one of another series, intended to include 13 'portraitures of famous men living in England'. This was the work of the Swiss medallist Jacques Antoine Dassier, who lived in Britain from 1741 to 1757,

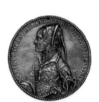

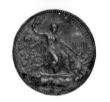

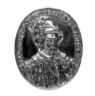

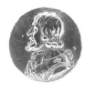

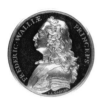

and worked as an engraver at the Royal Mint. Dassier's medals, modelled in the most understated of low relief, manage to convey on a small scale the monumental quality of some full-scale sculpture of the period, such as the work of Louis-François Roubiliac (see *Working Practices*).

Fifty-seven years after the death of Dassier, in 1816, another European artist began work at the Royal Mint. Benedetto Pistrucci, the gifted but temperamental Italian gem-engraver, medallist and sculptor, who was to live out the rest of his life in Britain, was a man whose career brought controversy. As an ambitious if talented foreigner, eager to occupy a place at the very heart of the British coin and medal-making establishment, he was attacked by a xenophobic press. Appointed Chief Engraver at the Mint in 1817, he was subsequently demoted in 1828, and a new post of Chief Medallist created for him. A delay of 30 years in the production of dies for his most prestigious commission, the Waterloo Medal, which was begun in 1819 but never struck, did little to improve his image.

His work on the coinage of George III (1738–1820) and George IV (1762–1830) and the small number of medals that Pistrucci did produce, however, raised the standard of both coinage and medals to a new level, with its neo-classical elegance and technical skill. His portrait of George III for the half-crown coin was considered one of his masterpieces. Pistrucci had powerful supporters, one of whom is represented here in a work of peerless, pared-down simplicity: the celebratory medal for the career of William Wellesley-Pole (1763–1845) (plate 153), struck on the occasion of his retirement from the post of Master of the Mint. Pistrucci's work as a gem-engraver is discussed in the chapter on semi-precious materials.

The younger rival who was to take Pistrucci's place as Chief Engraver at the Mint was William Wyon, a member of an established family of British medallists whose ancestors began working in the early eighteenth century. Second Engraver at the Mint from 1816, Wyon was a hard worker who resented his wages being lower than those of the less reliable and less productive Pistrucci. In 1828 the tables were turned and Wyon rose to the post of Chief Engraver. His output was enormous. He worked on the British and colonial coinages of four monarchs, and designed hundreds of medals, including one for the Royal Academy of Art (plate 154) which carries his early portrait of Queen Victoria (1819–1901), used on many other medals and also as the model for the head on the first postage stamps, including the Penny Black. Clear, bold and balanced, Wyon's style echoes the work of the neo-classical sculptor John Flaxman, whom he admired; it was hugely influential, and represents the best of mainstream nineteenth-century British medal design.

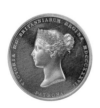

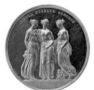

opposite

152 Frederick, Prince of Wales by Jacques Antoine Dassier

Bronze, partly gilt, struck, diam.55mm

English, c.1750

V&A: 310–1880

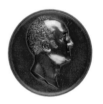

153 William Wellesley-Pole, 3rd Earl of Mornington and 1st Baron Maryborough by Benedetto Pistrucci

Bronze, struck, diam.51mm

English, 1823

Given by Mrs. J. Hull Grundy

V&A: A.100–1980

opposite

154 Patron's Medal, Royal Academy of Arts by William Wyon

Gold, struck, diam.55mm

English, 1837

Bequest of H.L. Florence, Esq

V&A: A.44–1917

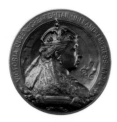

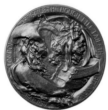

**155 Golden Jubilee of
Queen Victoria
by Alfred Gilbert**
Bronze, struck,
diam.64mm
English, 1887
V&A: A.94–1970

**156 Mond Nickel
Company Medal
by Percy Metcalfe**
Nickel, struck,
diam.45mm
English, 1925
V&A: A.51–1934

opposite

**157 23rd FIDEM
Congress Medal
by Ronald Searle**
Bronze, struck by the
Royal Mint, diam.5cm
English, 1992
V&A: A.3–1993

The Art Union of London, founded in 1837 to promote interest in 'British artists and manufacturers of decorative wares', commissioned a series of 30 medals by British medallists recording the history of British art, which were offered annually to subscribers. Wyon designed the first medal, issued in 1843, commemorating the sculptor Francis Chantrey. The changes that were to take place in British sculpture towards the end of the nineteenth century are encapsulated in the contrast between this and the last medal in this series, designed some 40 years later by the innovative modeller and sculptor Alfred Gilbert, to mark the 50th anniversaries of Queen Victoria's reign, and of the Art Union itself in 1887 (plate 155). One of a group of young British artists in the late nineteenth century whose work is known as the New Sculpture, Gilbert was influenced by the Arts and Crafts movement, and by certain contemporary French and British sculptors. The dies for his medal, one of the few he produced, were made directly from Gilbert's original wax model using a reducing machine, and the finished result retains much of the freshly modelled feel of the original.

Thirty-five years after the Gilbert medal, the way forward into the new century is uncompromisingly shown in Percy Metcalfe's medal for the Mond Nickel Company (plate 156). Metcalfe, who worked for the Royal Mint designing coins and medals, has created a latter-day Britannia for the machine age. Delineated in broad planes and knife-edge profiles, and stripped of all extraneous detail, elements such as the crest on her helmet and the arc of her shield fill the field with almost abstract shapes.

Contemporary Medals
Contemporary art medals, or perhaps those small-scale sculptures that conform to traditional medallic values, have flourished since the mid-twentieth century. Medal-making has been taught within art academies in Eastern European countries from this time, while the British Art Medal Society (founded in 1982), with its innovative Student Medal and New Medallist Projects, actively supports medallists and commissions new medals. In addition, international contacts between artists, collectors and historians have been forged through the work of FIDEM (Fédération Internationale de la Médaille), founded in 1937.

Artists more famous in other spheres have been enticed by this favourable climate into designing medals. The cartoonist Ronald Searle designed a FIDEM conference medal in 1992 (plate 157). His portrait medal wittily quotes the format of Pisanello's renaissance portrait medals. When the medal is turned in the hand the viewer can fully appreciate the artist's humour: instead of a symbolic representation of the sitter's fame or glory,

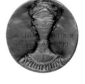

as one would find on a traditional medallic reverse, we are presented with the back of his head. Searle connects the viewer directly with the medal and its history.

In contemporary art medals the artist often questions the traditional concept of format, appearance and purpose. In *Leda and Hatpin* (plate 158), Linda Crook takes her inspiration from classical myth, but reworks it to free women from the role of victim. In the original story, the god Jupiter in the guise of a swan violates Leda, but here Leda has transformed him into a fancy hat, which she secures with a hatpin. The reverse suggests that the hatpin might be a feather plucked from the swan, further subverting the traditional perception of this myth.

Punks by Danuta Solowiej-Wedderburn (plate 159) records in bronze an artist's view of a particular time. The artist arrived in London from Poland in 1987 when punk was a huge phenomenon. The projecting spikes at the lower left of the plaquette embody the aggressive nature of punk style and behaviour, while the image on the reverse refers to the fashion designer Vivienne Westwood (b.1941), one of the founding spirits of punk style.

Artists who engage with the medal also bring to it their knowledge of technological innovations. Peter Musson's design, showing the DNA double helix against a background of concentric circles reminiscent of a fingerprint, another method of establishing identity, was created using computer-aided design technology. The data was sent to a computerized rapid-prototyping machine which cut the master models with fine precision. Only the casting of the medal was done in the traditional way (plate 160). **LC, WF, MH & MT**

158 Leda and the Hatpin by Linda Crook
Silver, cast, diam.7.5cm
British, 1999
V&A: A.6–2003

left, above
159 Punks by Danuta Solowiej-Wedderburn
Both sides: bronze, lost-wax cast in ceramic shell by David Reid
h.10.4cm
English, 1987 (obverse, originally sand cast, part of an edition) and 1992 (reverse, modelled in wax)
Given by the artist
V&A: A.10–2001

left, below
160 50th anniversary of the discovery of DNA (Deoxyribonucleic Acid) by Peter Musson
silver cast, diam.7cm
English, 2002
V&A: A.9:1–2003

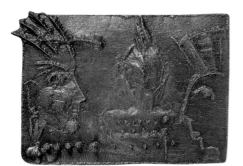
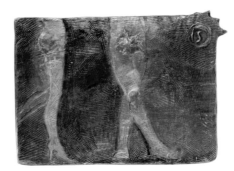
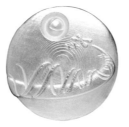

Chapter 6

MARBLE AND STONE

Marble is often thought of as the primary material for sculpture, mainly due to the seminal influence of Greek and Roman marble sculptures, and its subsequent importance in Italian renaissance and baroque sculpture. Statuary marble is usually white or near-white, and is generally unpainted, though it was often given a surface finish to tone down the brightness of the material; Antonio Canova applied dirty water or wax to the surface of Carrara marble to give it a yellowish stain, in imitation of Parian marble. Some ancient Greek marbles were partly painted, although the pigments have rarely survived, except in microscopic quantities, and so the sculptures are now not seen to have any surface colouring. Similarly, some medieval marbles were painted, and some today still show traces of polychromy. But these are exceptions, and in general marble from the fifteenth century onwards is unpainted. Stone sculptures are likewise frequently not painted, although those of the Middle Ages were generally polychromed.

Lack of polychromy gives marble and stone sculptures a visual purity, allowing the viewer to concentrate on the carved forms, the nuances of surface polish and texture, and the shadows and highlights created by the light (daylight or artificial) playing on the surface. While some marble and stone sculpture may be carved in a highly naturalistic fashion, the viewer is rarely deceived into thinking the figure represented is real; any illusionistic qualities are balanced by an awareness of the substance from which the sculpture is carved. The nineteenth-century writer Richard Ford (1796–1858) commented acerbically about polychromy: 'The essence of statuary is *form* ... a marble statue never deceives; it is the colouring that does, and a trick beneath the severity of sculpture.' This chapter will examine sculptures carved in marble, as well as in limestone, steatite and porphyry. (See also *Alabaster*.)

161 Haggai
by Giovanni Pisano
Marble, h.63.8cm
Italian, c.1285–97
Purchased with the
assistance of The Art
Fund
V&A: A.13–1963

162 Chisels used for
working marble and
stone (20th century)

Marble: Quarries and Tools

Geologically, marble is a metamorphosed form of limestone (calcite or calcium carbonate), or dolomite (magnesium calcium carbonate), which has been crushed and heated over time. Ancient Greek sculpture was generally made from Parian marble (from Paros, one of the islands in the Cyclades), or Pentelic marble from Mount Pentelikon near Athens. Marbles from these locations were sometimes quarried for later sculptures, but generally the marble used for post-classical European sculpture comes from Carrara in the Apuan Alps in northern Italy. The quarries there were used by the Romans, and were reopened in the twelfth century, when marble sculpture started to be incorporated into architecture. In recent times marble has been quarried in China for use in sculpture, and marble quarries are also in operation elsewhere, including Turkey, Brazil and the USA.

Giovanni Pisano's bust of the prophet Haggai, from the west front of Siena Cathedral (plate 161), dating from 1285–97, is one such Carrara marble sculpture. Its weathered surface indicates that it was placed outside for a long time. It was in fact on the exterior of the cathedral until it was taken down in 1836, along with other external sculptures, as part of a restoration programme, since the marble was friable and prone to split horizontally. It was apparently kept for some time in one of the storerooms of the cathedral, but its later history is unknown until it was acquired by the Museum from a London dealer in 1963. It is a fragment of a complete figure, one of 14 full-length statues of prophets and sibyls all originally on the cathedral façade. The figure has a long neck, leans forward, and exhibits deeply carved features; the features needed to be emphasized and the head had to crane forward because it was once positioned high up on the building, far from the spectator. The drill has been used extensively, for example on the hair, beard and collar.

The drill was just one of the tools used to sculpt marble, which was also worked with hammers and chisels (plate 162). Initially a block would be quarried, and then rough-cut with a point chisel; this would not be undertaken by the sculptor himself, although he would have agreed the size and quality of the marble in advance with those working at the quarry. Different types of punches and claw chisels could then be used to give the initial shape to the sculpture, and flat chisels were employed for the final cutting. The sculptor, or his assistants, would carry out this work.

For details such as the hair, drills might be used, as mentioned above. Drill marks are also visible on the beard of Orazio Marinali's *Bust of a Man*, made in about 1700 (plate 163). Following the cutting, chiselling and drilling, the marble would be polished using a powdered abrasive stone, such as pumice. The pumice would be combined with water in a slurry, and this mixture applied to rags or leather; the marble surface would then be rubbed down with these. Pumice or another abrasive powdered stone must have been used to achieve the smooth surfaces of the Marinali bust.

On occasion chisel marks can be seen, whether intentionally or not. Rodin's *Cupid and Psyche*, dating from about 1908 (plate 164), deliberately flaunts the working of the marble. The figures seem to emerge from a quarried block, and there is a fine contrast between the idealized, highly polished nudes and the roughly textured marble base, replete with choppy marks made by the chisel. Rodin's treatment of the marble foreshadows later developments in sculpture.

In the twentieth century many sculptors wanted to stress truth to materials in their work, drawing attention to the texture of the raw block of stone or marble, both because of its inherent beauty as a natural material, and to make the viewer aware of the artist's skill in transforming it into a figurative, or indeed abstract work of art. Leon Underwood's *Mindslave: the Mind's Abject Subordination to the Intellect* (plate 165) exemplifies this movement. Dating from 1934, its sinuous, semi-abstract forms evoke Michelangelo's *Young Slave* (see plate 27), and symbolize the struggle to escape the mental repression prevalent in much of Europe in the 1930s. At the same time, the hardness of the stone and its smooth surface are readily apparent. At the base of the torso some of the marble has been deliberately left rough and unworked, reminiscent of Rodin's *Cupid and Psyche*, as well as the unfinished *Young Slave*, which inspired the piece.

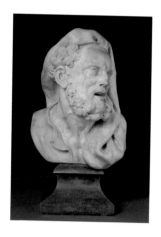

163 Bust of a man by Orazio Marinali
Marble, h.46.5cm (with socle); Italian, c.1700
V&A: A.45–1983

164 Cupid and Psyche by Auguste Rodin
Marble, h.66cm
French, c.1908
Given by the artist
V&A: A.49–1914

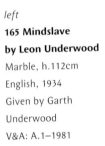

left

**165 Mindslave
by Leon Underwood**

Marble, h.112cm

English, 1934

Given by Garth
Underwood

V&A: A.1–1981

right

**166 Leda and the Swan
by a follower of
Michelangelo**

Marble, h.138.4cm

Italian, c.1535

V&A: A.100–1937

below left

**167 Lord Cobham
by Peter Scheemakers**

(front and back view)

Marble, h.84.5cm

English, c.1740

Given by W.L.
Hildburgh, F.S.A.

V&A: A.1–1942

Also like Michelangelo's Slaves, *Leda and the Swan* (plate 166), by a follower of Michelangelo and dating from about 1535, is unfinished. In this case the tool marks evident on the left leg, parts of the drapery and elsewhere would have been concealed by further working and polishing if the piece had been completed. Here the claw chisel marks can be clearly discerned. Unlike the *Mindslave*, this was not intentionally left incomplete, and therefore reveals the sculptor's work in progress. Similar marks can sometimes be seen on the back of portrait busts, which were left in a less finished state because the reverses of busts are not normally viewed. The way a sculptor chose to finish the back of a bust (or directed his workshop to finish it) is often distinctive and can even help to identify the sculptor. The reverse of the portrait bust of Lord Cobham, commissioned in about 1740 from Peter Scheemakers, displays chisel marks on the roughly worked marble (plate 167).

Imports of Marble: Northern Europe and Italy

Marble sculpture is understandably associated above all with Italy, because supplies of the material are so plentiful there; in France, the Netherlands and Britain, marble had to be imported. Moreover, many northern European sculptors went to Italy in order to acquire the skill necessary to carve it. Because of the importance of Italian marble, as well as the thriving artistic communities in Rome, Florence and elsewhere, and the attraction of the classical remains, Italy was a goal for many artists in the seventeenth, eighteenth and nineteenth centuries.

Marble was generally imported to northern Europe via Amsterdam, a major trading centre from which the raw material could be sent on to Britain or elsewhere, the stone often being used as ballast for the ships. Some British sculptors, such as Nicholas Stone and Grinling Gibbons, trained in the Netherlands, where they learned the art of carving marble; thriving marble sculpture workshops, such as that of the Quellin family, existed in Amsterdam. Much unworked Italian marble imported to Britain in the seventeenth and eighteenth centuries was in fact used for architectural details, such as columns or floor tiles, and possibly for chimneypieces. Only a proportion was used for figurative sculpture, such as tombs or busts.

Marble sculptors from the Continent often travelled to find work, as well as to train. François Dieussart was from the Netherlands and trained partly in Rome, but worked in Britain from 1636 to 1641, specializing in marble portrait busts for the royal family and the Earl of Arundel. His skill in carving marble was in demand, because at that time few British artists had had much experience in sculpting it. Dieussart's bust of Elizabeth of Bohemia, the Winter Queen (1596–1662), dated 1641 (plate 168), exemplifies the sculptor's skill in carving marble. He evidently used a drill for the ringlets of the hair, while the rippling silk bodice is evoked through subtle chiselling. The inscription on the socle identifies the sitter (who was married to Frederick V, Elector Palatine, and was also the sister of Charles I), and gives the date of the bust. This inscription might well have been carved by one of Dieussart's assistants, or could even have been subcontracted to a specialist carver. This also commonly occurred in the production of church monuments: a sculptor would sculpt the figurative elements, while a specialist carver would be responsible for the inscription.

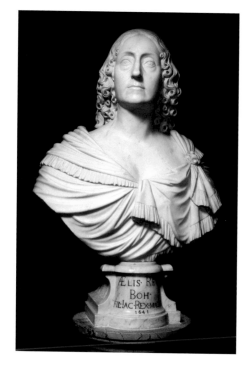

168 Elizabeth of Bohemia, the Winter Queen
by François Dieussart
Marble, h.81.6cm (with socle)
Netherlandish, 1641
Purchased with the assistance of The Art Fund
V&A: A.8–1967

**169 Youth leading
a rearing horse
by Benedetto Cervi
(also called Pavese)
subcontracted from
Agostino Busti (also
called Bambaia)**
Marble, h.41.3cm
Italian (Milan), c.1531–2
V&A: 7260–1860

170 Detail of plate 169
Small bridge of marble
connecting the tail of
the horse to the wall
behind

right
**171 Diana
by Joseph Nollekens**
Marble, h.124cm
English, 1778
V&A: A.5–1986

Carving and Finishing

Marble reliefs can allow the sculptor the opportunity of demonstrating his virtuoso technique of carving and finishing. Benedetto Cervi, also called Pavese, carved the small-scale high relief *Youth Leading a Rearing Horse* in about 1525 (plate 169). The delicate, elegant figure of the youth attempting to control the rearing horse with its flickering mane suggests the vigorous and unpredictable action of the animal through the medium of the hard marble, the attenuated moving limbs of both horse and man being conveyed in a masterly way. The toes of the youth and his cloak are particularly fine examples of this sensitive carving. Marble can fracture if carved too thinly, and the tail of the rearing horse is joined to the wall behind by a small bridge of marble to prevent breakage (plate 170).

Joseph Nollekens's *Diana*, dating from 1778, which is just under life-size, (plate 171), has a similar marble support. The right arm is bent to pull at the bowstring (the string is not included in the sculpture, but must be imagined), and this vulnerable marble limb is supported by a small bridge between the two arms. The tree trunk between the goddess's legs performs a similar function, acting as a support for the whole figure. This sculpture has always been displayed indoors, and exhibits what must have been its original finish; in the 1830s it was in the sculpture gallery at Wentworth Woodhouse in Yorkshire, the country seat of Lord Rockingham. Marbles which have not suffered weathering, and equally have not been accidentally damaged or strenuously over-cleaned, can retain their pristine surface.

Marble sculptures are frequently carved life-size, or even bigger, in part because large marble blocks can be readily obtained, and because it can be worked and carved with finesse. The very nature of marble – its hardness, and arguably its colour

(if white) – means that it works well on a large scale. Monumental works in marble are admired due to their often dominating presence, whether placed on the exterior of a building, in a public place or garden, or indoors.

Giambologna's *Samson and the Philistine* (plate 172) is one such monumental marble sculpture. Giambologna carved the group in Florence in about 1562 for Francesco de' Medici (1541–87), and it was originally set up on a fountain. In 1601 it was given to the Duke of Lerma, chief minister of Philip III of Spain, as a diplomatic gift, and was briefly in the royal gardens in Valladolid, but in 1623 Philip IV presented it to Charles, Prince of Wales (later Charles I); it came to the Museum in 1954. The spiralling group of figures means that there is no single front view; the spectator has to move around it in order to understand the whole. Such a monumental and complex composition clearly requires virtuosity of a different kind from that seen in Bambaia's intricate relief. The sculptor must beware of any faults in the marble which could cause fracturing, but also has to ensure the work is stable. The base of the group has to support the whole, and any protruding elements, such as Samson's upraised right arm, have to be soundly placed or supported by other parts.

Like Pisano's *Haggai*, Giambologna's work shows signs of weathering, having been outdoors for over three centuries, and has lost some of its original polish, but the strength and subtlety of the carving are immediately apparent despite this. Although marble can withstand weathering, it does absorb moisture on the surface and reacts to changes in temperature and humidity. Such vicissitudes lead in time to the loss of the original polished surface and the wearing down of details; sometimes parts of the sculpture become so damaged that they have to be replaced. The ass's jawbone, for example, is a replacement of the original missing one, while Samson's right leg has been repaired above the kneecap.

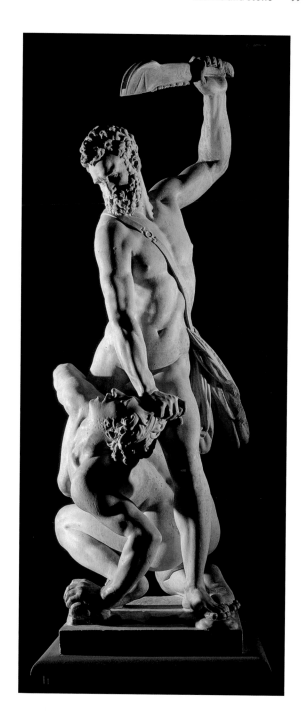

**172 Samson and the Philistine
by Giambologna**
Marble, h.209.9cm
Italian, c.1562
Purchased with the
assistance of The Art
Fund
V&A: A.7–1954

**173 Sir Mark Pleydell
by Louis François
Roubiliac**

Marble, h.55cm

English, 1755

The National Trust (on

loan to the V&A)

**174 Thetis Dipping
Achilles in the River
Styx
by Thomas Banks**

Marble, h.85cm

English, 1790

Given by C.F. Bell

V&A: A.101–1937

Louis François Roubiliac (1702–62) was famed for his treatment of the surface of marble, and his *Sir Mark Pleydell* (plate 173) illustrates his skill in distinguishing the different surfaces of flesh and hair, and the animation of the facial features, conveyed through hard marble. A contemporary remarked of his carved marble drapery that it was 'really more like silk than marble'. Roubiliac was French in origin and trained on the Continent, but spent almost all his working life in Britain. He perfected his ability in carving marble in France and Dresden, before arriving in London in about 1730.

Some of the other marble sculptures made for indoor settings and now in the V&A's collection are more or less in the condition in which they left the sculptor's studio. *Thetis Dipping Achilles* by Thomas Banks (plate 174) was commissioned in 1790 by Thomas Johnes, probably for the conservatory in his house at Hafod in North Wales. The infant Achilles, held by his heels, is being dipped by his mother Thetis in the River Styx in order to protect him from harm (his heel was not submerged, and he was later to be killed through a wound there, hence the expression 'Achilles' heel'). The figure of Thetis is styled on the patron's wife, while the face of his baby daughter served as the model for the infant Achilles. The sculptor has provided a broad base for the composition through the kneeling form of Thetis's body and her outstretched arm; the child is in fact adjoined to the base. The surface polish survives, and the composition cleverly unites a story from classical myth with contemporary portraits. The apparent stains visible in the marble are in fact natural discolourations or veins, rather than damage. This sculpture is unusually still on its original mahogany plinth, which also seems to have served as a cupboard.

Limestone, Steatite and Porphyry

Along with marble, limestone was one of the most common stones used for carving sculpture in Europe. This is calcium carbonate, which is sedimentary, and fossils can often be discerned in the surface. Some polishable limestones are loosely called marble, such as Purbeck

marble, a limestone quarried in Somerset; in fact, as mentioned above, marble does not occur naturally in Britain. Limestone is frequently used as a building material: most medieval cathedrals and churches are built in this stone, and many of the capitals from the cloisters or interiors of these buildings are carved with fine decorative or figurative sculpture. A capital with angels from the abbey church of Mozac (Puy-de-Dôme) in the Auvergne in France, dating from about 1135–50, is adorned with four angels holding scrolls (plate 175). This was originally one of eight capitals in the choir of the abbey church, three of which remain in situ. Although the surface of the stone is slightly worn, the carving of the folds of drapery, wings and lettering is well defined.

Because limestone weathers well, it has also been employed for garden sculptures. Additionally, because it is readily available in Britain it was an obvious alternative to marble in this country. Its more textured surface and warmer colouring were also valued, and again perhaps seen as appropriate for garden sculpture. Caius Gabriel Cibber's *Bagpiper* of about 1680–90 (plate 176) functioned as a garden sculpture for much of the eighteenth and early nineteenth centuries. It was formerly at Stowe in Buckinghamshire, and may have been at the great country house at Canons in Middlesex (subsequently demolished) prior to that, although its original setting is uncertain. It is made from Portland stone, a fine limestone from Dorset much favoured by sculptors.

below left
175 Capital with angels
Limestone, h.69cm
French, probably
1135–50
V&A: A.7–1937

below right
176 Bagpiper by Caius Gabriel Cibber
Portland stone
h.108cm
English, 1680–90
V&A: A.3–1930

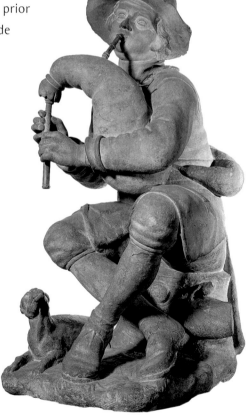

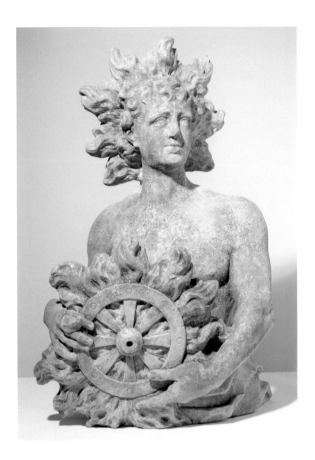

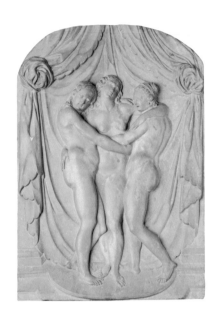

above

**177 Sunna
by John Michael
Rysbrack**

Portland stone,
h.88.3cm
English, 1728–30
Purchased with the
assistance of the
Heritage Lottery Fund,
the Whiteley Trust, the
Hildburgh Bequest and
an anonymous donor
V&A: A.2–1997

above right

**178 The Three Graces,
circle of George
Schweigger**

German (Nuremberg),
c.1650
V&A: 366–1864

A series of seven Saxon gods representing the days of the week was similarly made in Portland stone by Rysbrack for Lord Cobham at Stowe in the late 1720s. *Sunna* (Sunday) was one of these (plate 177). Its mottled surface, which has intensified over time due to weathering, and the fact that fossils can be discerned in the stone, must have been particularly appealing in the garden setting, and the subject matter, redolent of ancient Britain, would have been appropriate for such a material. This limestone work is exceptional for Rysbrack, who generally sculpted in marble or terracotta, indicating that here the material must have been actively chosen, perhaps by the patron, because of its intended outdoor setting. Fine details cannot be carved as easily in limestone, but again the broad treatment must have been considered suitable for both the subject and the setting. Another of these Saxon gods, *Thuner* (Thursday), is also in the collection (V&A: A.2–1997).

Limestone was not just used for large, outdoor sculpture. A fine limestone quarried in Solnhofen in Germany, and hence known as Solnhofen stone, was used to carve small-scale reliefs during the sixteenth and seventeenth centuries. *The Three Graces*, made in Nuremberg in the second half of the seventeenth century, is a good example of the subtle low relief carving of this material on a small scale (plate 178).

Steatite, or soapstone, is a metamorphic stone, magnesium silicate, and is used only rarely for European sculpture. Its strong colours are immediately apparent, while its hardness means that it is difficult to work in detail. The two small busts of *Heraclitus* and *Democritus*, the so-called laughing and

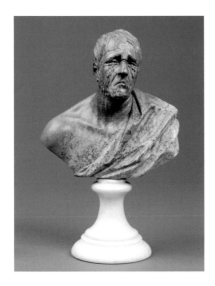 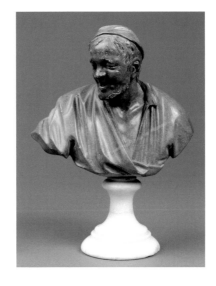

179 Democritus and Heraclitus by Johann Christian Ludwig von Lücke
Steatite, h.13.9cm and 13cm
German, 1757
V&A: A.201 and A.202–1946

weeping philosophers, by the eighteenth-century German sculptor Johann Christian Ludwig von Lücke, are carved in this material (plate 179). Their sculpted forms are complemented by the rich surface colour. They were probably made for a collector, perhaps to be placed on a desk or writing table.

Porphyry is an extremely hard igneous stone, and can only be worked with emery or hardened steel. It was highly prized for sculpture in Roman times. This small head of a warrior, possibly from the sarcophagus of St Helena in Rome, dates from the early fourth century (plate 180).

Coloured marbles and porphyry were on occasion used to contrast with white marble. The profile portrait of Cosimo I de'Medici, Grand-Duke of Tuscany, by Francesco del Tadda, signed and dated 1570, is worked in porphyry set against a green serpentine, known as verde di Prato, with an incised inscription marked out in gold (plate 181). A process for tempering steel so that tools could be made to work porphyry was discovered in the mid-sixteenth century in Florence, and subsequently a number of sculptures, such as that by Tadda, were carved in this material. The strong natural colours of both the porphyry and the serpentine play an important part in the effect of the sculpture. **MT**

above
180 Head of a warrior
Porphyry, h.15.5cm
Roman, c.300–350 CE
Bequeathed by Dr W.L. Hildburgh, F.S.A.
V&A: A.102–1956

left
181 Cosimo I de'Medici, Grand-Duke of Tuscany by Francesco del Tadda
Porphyry and green serpentine, h.71.5cm
Italian, 1570
V&A: 1–1864

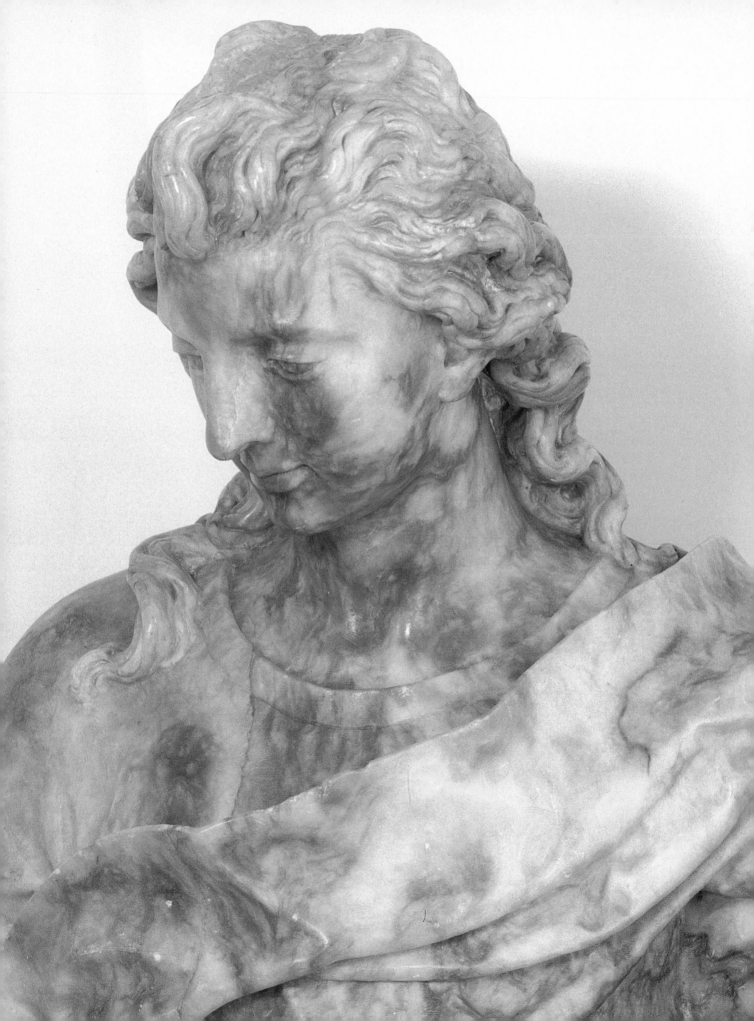

Chapter 7

ALABASTER

Alabaster is a rare, fine-grained form of gypsum (hydrous calcium sulphate), a stone found in large solid masses beneath the ground. It resembles marble, but is a softer, semi-translucent stone. The most highly prized alabaster has always been the whitest, but it varies in colour; as a fifteenth-century English poem tells us: 'Alabastre, owther [either] white or redde'. It is just as often a creamy yellow or ochre, usually streaked with other colours. Once quarried across Europe, alabaster actually takes its name from the Egyptian town of Alabastron, where a similar looking, but geologically quite different, stone had been quarried since ancient times.

The Assyrians, Egyptians, Greeks and Romans all used alabaster, often on a colossal scale, but most of the alabaster sculpture that survives today dates from the Middle Ages. Indeed, the Greeks and Romans kept their costly ointments in what ancient writers call *alabastra*. This 'alabaster', sometimes called 'calcite alabaster', is an entirely different mineral (calcium carbonate), really a form of marble, which, while similar in appearance to gypsum, is much harder, heavier and water-resistant. This was not the alabaster used by sculptors, although it is occasionally used to this day for the carving of small trinkets and vases.

From the start, alabaster was recognized as a cheaper alternative to white marble. Easier to work and less costly than marble, it responded well to the sculptor's tools, and to painting and gilding. It was quarried in the English Midlands, in Germany, France, Italy, Catalonia and the Netherlands. Although classical sculptors were familiar with the stone, skills in the working of the material must have been lost, since at least one example of a medieval alabaster carving in the twelfth century was in an unsuitable setting. A decorated arched doorway dating from about 1160, at Tutbury Priory Church in Staffordshire, is the earliest known use of the material in England (it appears never to have been used in Scotland or Wales), indeed one of the earliest instances in Europe. However, alabaster is very soft – it can even be scratched with a fingernail when freshly dug from the earth

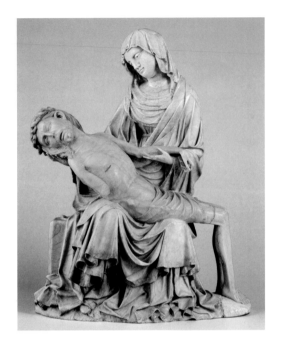

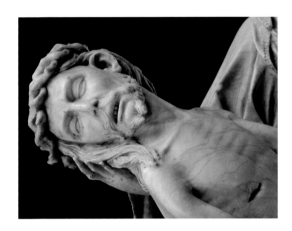

above left
**182 Virgin with the
Dead Christ
by Rimini Master**
Alabaster, h.38.4cm
Netherlandish, c.1430
Given by Sir Thomas
Barlow
V&A: A.28–1960

above right
**183 Detail of Christ's
face** (see plate 182)

– and although it hardens on contact with air, it remains fragile and in fact partially dissolves when it comes into contact with water. The doorway in the wet English Midlands weathered badly, and much of the finer work has been blurred over time. But by the end of the thirteenth century alabaster was being used for interior sculptures, mainly devotional statues and reliefs, and funerary effigies for aristocrats.

In the Netherlands, alabaster became a popular alternative to marble, and was used with outstanding skill. In particular, the work of a fifteenth-century master craftsman dubbed the 'Rimini Master' exemplifies the artistic prowess of Netherlandish sculptors. This superlative artist appears to have been from the southern Netherlands, but his modern sobriquet is derived from the fact that one of his finest works is an alabaster Crucifixion scene from the church of St Maria delle Grazie in Rimini-Covignano, now in the Liebieghaus, Frankfurt. The Rimini Master and his workshop were responsible for intricate works of great delicacy, such as a Pietà group of about 1430 (plates 182 and 183). Painstaking attention has been paid to hair, drapery and the working of eyelids and lips. It was this kind of frank naturalistic depiction that characterized the best of Netherlandish alabaster working.

The Rimini Master's skill was evidently appreciated in his own lifetime, since his work was exported to north-east Italy (hence his alias), among other places.

Claus Sluter, a Burgundian sculptor, also worked extensively in alabaster. His last commission was for the alabaster tomb of Philip the Bold (1342–1404), Duke of Burgundy, at the Charterhouse of

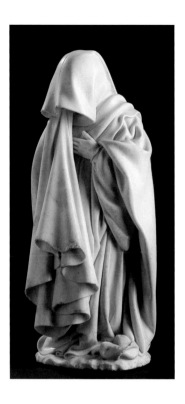
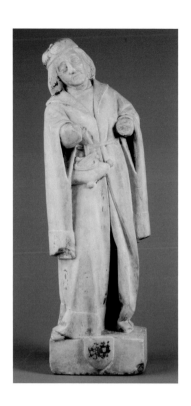
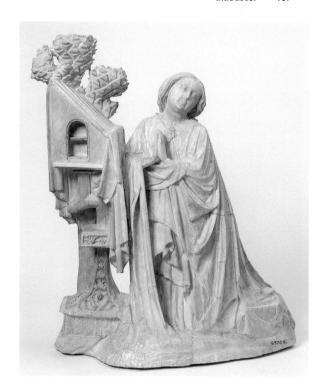

Champmol, Dijon (now in the Musée Archéologique, Dijon), dating from 1391. For the harrowing figures of mourners adorning the sides of the tomb chest (plate 184), Sluter used the finest white alabaster. It is interesting to note that English alabaster was held in particularly high regard, as it is relatively free of the veins of colour that occur in most alabaster, and several surviving contracts for Netherlandish commissions insist that English alabaster be used. The alabaster used here, however, came from Vizille, near Grenoble, and a year later in 1392 the artist travelled to Paris to collect an alabaster block for the effigy of the Duke himself.

The alabaster tomb figures, or *pleurants* ('weepers'), by Sluter and others were fashionable in Burgundy in the fifteenth century, but another surviving alabaster tomb figure, made by a Burgundian or French sculptor, is quite different (plate 185). This figure is much less solemn than Sluter's hooded weepers, showing a cheerful nobleman out for a day's hawking.

An alabaster figure of the *Virgin Annunciate* (plate 186) is a further example of the level of Flemish craftsmanship. This statuette, made in Flanders or Hainault in about 1440–60, probably formed part of an altarpiece or tabernacle. Here can be seen the changes at work within late medieval alabaster sculpture: the folds of the Virgin's robes, though finely and delicately executed, are less sharply angular and much more Italianate than the work of the Rimini Master of two decades earlier.

The Netherlands was one of the greatest centres of alabaster production in the later Middle Ages. England, however, produced many more

above left
**184 Mourner from base of tomb of Philip the Bold, Duke of Burgundy
by Claus Sluter**
Alabaster, h.41cm
Netherlandish,
1390–1406
Photo: François Jay
© Musée des Beaux-Arts de Dijon

above middle
185 A man hawking (tomb figure)
Alabaster, h.55.3cm
Burgundian or North-East French, c.1440–60
V&A: 4084–1857

above right
186 The Virgin Annunciate
Alabaster, h.51cm
Netherlandish,
c.1440–60
V&A: 6970–1861

187 The Swansea altarpiece

Alabaster, h.83cm

English, c.1460–90

V&A: A.89–1919

alabasters, albeit often of lesser artistic quality, since English alabaster carvers generally catered for a different market, dominating the lower end of the price scale. They exported their works to customers across Europe who could not afford to spend as much as wealthy aristocrats, but who were eager to furnish their homes and local parish churches with religious imagery. The English workshops thus presided over the most developed alabaster industry in Europe. While alabaster sculptures made in this country seem sometimes rudimentary and repetitive in comparison with their Netherlandish counterparts, the impressive scale of the industry warrants attention.

In England, alabaster was quarried in South Derbyshire and parts of Staffordshire. The main quarries were situated in the ridge south-east of Tutbury in Staffordshire, some 20 miles from Nottingham, and at Chellaston Hill, about four miles to the south-east of Derby. The English alabaster industry began in earnest with tomb effigies. During the period from about 1330 to 1380, sculptors, or 'alabasterers' or 'alabaster men', as they were often called, worked on costly funerary effigies for royalty and the aristocracy. These early alabasters were sophisticated and of a high standard, alabaster being the ideal choice of material for detailed figurative work. The earliest known commission for an alabaster tomb is for no less a personage than King Edward II (r.1307–27) at Gloucester Cathedral. This was probably completed in around 1330, and was followed by the similarly prestigious order for a tomb for one of the King's sons, Prince John of Eltham (d.1336), at Westminster Abbey.

Nottingham and Burton-on-Trent emerged as the leading English centres of alabaster production, because of their close proximity to where the stone was found. But London, and also York, where eight 'aylblasterers' are mentioned in the city Freeman's Roll between 1457 and 1524, were

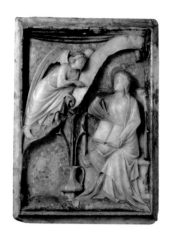

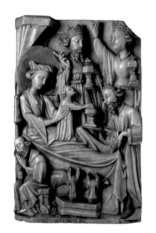

important areas of activity. The mainstay of the medieval English alabaster industry was the altarpiece. Most English alabaster carvings formed part of altarpieces, set in a wood ('tre' or 'stok' to medieval writers, ie 'tree' or 'stock') framework, brightly painted and gilded, and designed in the form of a hinged triptych to stand on the altar in a church (plate 187). Such altarpieces usually represented a series of dramatic scenes from the life of Christ (plates 188 and 189). They were cheap and easy to produce, and from the 1380s onwards workshops began manufacturing them in large numbers, at which point a thriving export industry began.

Merchants were employed by the alabasterers to sell their wares and hawk them across Europe. Relations between craftsman and salesman were not always amicable, as illustrated by the case of Nicholas Hill of Nottingham, who sued the merchant William Bott in 1491 for not giving the payments due for 58 heads of St John. The trade reached its zenith around 1440, with alabasters shipped abroad in great numbers from ports such as Hull, Southampton, Dartmouth, Bristol and London. These shipments were not without hazards: in 1390 the *George* left Dartmouth for Seville only to be captured en route; among her cargo were '*ymagez d'alabastre*'.

From the 1340s onwards, English alabastermen had also been producing individual devotional figures of saints in alabaster. Queen Isabella, the consort of Edward II, had among her private chapel furnishings an alabaster figure of the Virgin, and a broken one of St Stephen. During the fifteenth century, many alabaster sculptures of the decapitated head of St John the Baptist were made in the southern Netherlands and Westphalia, and as a genre *Johannesschüsseln* ('John dishes') were especially popular in the Holy Roman Empire. With its translucent gleam, alabaster is forcefully reminiscent of the waxy skin of a corpse (plate 190). The heads were attached to plates made of wood, silver or alabaster, and often kept in wooden boxes with shutters, which gave them an even stronger dramatic presence. These heads were later copied by Nottingham-based sculptors in the second half of the century; the piece in the V&A is a powerful example of this subject (plate 191).

German alabastermen of the fifteenth century, like those in the Netherlands, focussed their energies on the sculpting of finely finished pieces. The range of sculptures produced was also similar to that of the

left (top)

188 The Annunciation
Alabaster, h.41.1cm
English, c.1390
Given by Dr W.L.
Hildburgh, F.S.A.
V&A: A.28–1950

left (bottom)

189 The Adoration of the Magi
Alabaster, h.39.7cm
English, c.1420–40
Bequeathed by Dr W.L.
Hildburgh, F.S.A.
V&A: A.98–1946

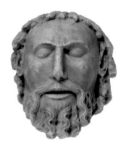

190 Head of St John the Baptist
Alabaster, h.23cm
German, c.1430–50
V&A: A.31–1950

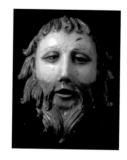

191 Head of St John the Baptist
Alabaster, h.19cm
English, c.1470–90
Given by Dr W.L.
Hildburgh, F.S.A.
V&A: A.79–1946

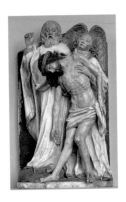

**192 Holy Trinity
by Hans Multscher**
Alabaster, h.28.5cm
German, c.1430
Liebieghaus, Frankfurt

right top
**193 St John the Baptist
before Herod**
Alabaster, h.39.2cm
English, c.1480–90
Given by Dr W.L.
Hildburgh, F.S.A.
V&A: A.124–1946

right
**194 St Christopher
with the infant Christ**
Alabaster, with traces
of gilding, h.95cm
English, c.1450
Given in memory of
Cecil Duncan Jones by
his friends
V&A: A.18–1921

far right
195 St Michael
Alabaster, h.75.6cm
English, c.1430–70
Given by Viscountess
D'Abernon in
accordance with the
wishes of the late Lord
D'Abernon
V&A: A.209–1946

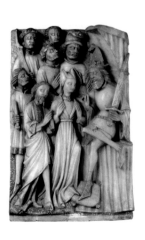

Netherlands, with delicate and sensitively observed Pietà groups, funerary sculptures and reliefs of Christian subjects. For example, Hans Multscher of Ulm was responsible for a scene of the Trinity (plate 192), dating from about 1430. Multscher ran a large workshop, and also practised as a painter, but like most alabaster carvers he only partially painted his work.

Alabaster was certainly considered attractive in its own right, and paint was only used selectively to enhance and pick out details. Eyes, hair and landscapes were highlighted with strong, thick pigments, while crowns, jewellery, details on clothing and rays of divine light were finished with gold leaf ornamentation. On English alabaster reliefs, teardrop-shaped gilded knobs of gesso were added and spread across the background to represent dazzling, divine light. Polychromy was also used on English alabasters to emphasize morality and the workings of men's souls. For instance, on an English panel of *St John the Baptist before Herod* (plate 193), the faces of Herod and his pagan attendants have been painted a deep brown to indicate the Godless darkness in which they exist. Conversely, the face of St John has been left as naked polished stone to suggest his moral state.

But the English alabaster carvers could be occasionally careless and crude when compared to their Netherlandish and German counterparts. Although it has sometimes been conjectured that alabaster was more than a cheap substitute for marble, and that it was actually regarded as a precious stone in medieval times, this is emphatically not the case. Alabaster was employed primarily because it was readily available, and was relatively inexpensive to source.

Nevertheless, the English alabaster men also produced works of great quality, equal to, though very different from, the bold naturalism of German and Netherlandish work, such as a figure of *St Christopher* (plate 194). This imposing piece was carved in

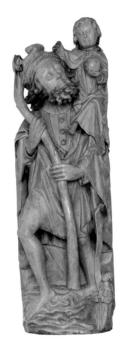

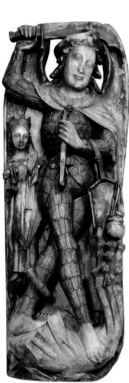

about 1450, and is one of a series depicting the giant Christopher carrying Christ across a river. It is clear that this subject was made in standard sizes: small, medium and large, because Christopher was one of the most popular saints in later medieval England. Of similar size is a figure of *St Michael* (plate 195), shown weighing the souls of the dead. This sculpture was produced between about 1430 to 1470, at the height of the English alabaster export industry. For the best English alabasters, enormous fees were charged. Peter the Mason, for example, was paid the princely sum of £200 in 1367 by Edward III for an alabaster altarpiece 'to be placed upon the high altar within the free chapel of St George at Windsor'. To put this in context, during the same period one could have lived comfortably for a year on £20. In 1374, an alabaster tomb for John of Gaunt was ordered at a cost of £486.

At the other end of the market, it seems that by the mid-fifteenth century a complete alabaster altarpiece could be bought for as little as £1, and a rudimentary head of St John the Baptist for only a shilling (5p). Because alabasters could be bought so cheaply, they were sold successfully across Europe. As the English export industry grew, the overall quality of craftsmanship declined from about 1400, but this has to be seen in the context of greatly increased output: there were many more pieces being made than before.

One of the chief destinations for exported English alabasters was Spain, but Spain also had her own alabaster carvers; two Castilian effigies survive that were carved in alabaster in about 1500 (plates 196, 197 and 198). As well as funerary monuments, Spanish alabaster devotional relief

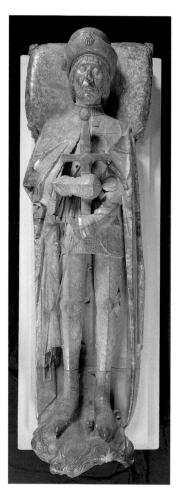
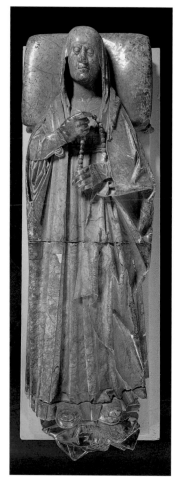
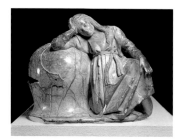

left
197 Detail of plate 196
Helmet and female figure at feet of Don Garcia de Osorio

above left
196 Effigy of Don Garcia de Osorio
Alabaster, h.40cm
Spanish, c.1500
V&A: A.48–1910

above right
198 Doña Maria de Perea
Alabaster, h.31cm
Spanish, c.1500
V&A: A.49–1910

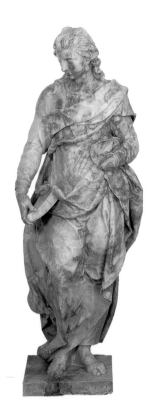

**199 St John the
Evangelist, from the
's Hertogenbosch
rood-loft
by Hendrik de Keyser**
Alabaster, h.156cm
Netherlandish, 1613
V&A: 1046:11–1871

right
200 Altarpiece
Alabaster. h.81.9cm
Netherlandish,
c.1550–60
V&A: 587–1883

opposite (top left)
201 The Crucifixion
Alabaster, h.41cm
German, c.1550–1600
Given by Forbes
E. Hallet Esq.
V&A: A.10–191

panels depicting the Trinity also survive. Although smaller alabaster reliefs were not produced in such numbers in Spain as in England, it was clearly a material used frequently by Spanish sculptors throughout the fifteenth and sixteenth centuries. In the same way as English alabasters have sometimes been misidentified as Flemish or Italian, so also have Spanish alabaster sculptures on occasion been mistakenly called English. Alabaster was also worked in France and Italy, where there were native supplies of the stone.

In England, the Reformation and Henry VIII's break with Rome in 1531 killed off the trade in alabaster altarpieces and devotional figures that had been flourishing vigorously for the previous 200 years. The Reformation led to a fundamental change in religious practices and outlook, and workshops shipped their remaining stock out of England to Catholic areas of Europe. In doing so, an important part of England's medieval artistic heritage was saved from destruction. Much other religious art was destroyed in England, and alabaster sculptures in particular were fragile and vulnerable to fire.

Thereafter, English sculptors concentrated instead on tombs, but fewer artists showed an interest in using alabaster and it became increasingly employed for decorative surrounds on tombs, and decorative details of no great artistic value, partly because England's own supplies of alabaster were running out. The use of alabaster for works of fine art continued on the Continent, however, particularly in the Netherlands and Germany. Alabaster, albeit intriguingly quarried in England, was Hendrick de Keyser's choice of material for his *St John the Evangelist* for the *rood-loft* at 's Hertogenbosch in the Netherlands in 1613 (plate 199).

During the sixteenth and early seventeenth centuries, a productive industry in small alabaster reliefs was operating in Malines (Mecheln) in the Netherlands. These fairly cheap religious alabasters were made from about 1540 onwards, just about the same time that the English alabaster industry disappeared, and production continued until around 1630. One such fruit of this industry is an altarpiece of around 1550–60 (plate 200), made for a mercantile domestic interior and depicting the *Crucifixion*, *Entombment*, and at the top, *God the Father and the Holy Spirit*. The flamboyant Italianate manner in which these three reliefs have been rendered contrasts with the angular, sensitively restrained modelling of Netherlandish alabasters of the medieval period. Gilding highlights the details, and the reliefs are surrounded by an oak frame, made in Antwerp, again

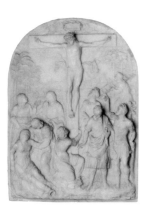

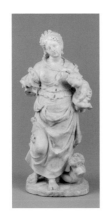

gilded, and covered in gesso grotesques, putti, trophies and other classical motifs. Similar reliefs were produced in Germany during the same period. One representation of the *Crucifixion* (plate 201), made some years after the Malines altarpiece, is indeed very similar. Here, though, the figures in the foreground have all been carved almost completely in the round.

From the eighteenth century onwards, few artists worked in alabaster. One exception was Lazar Widmann, from Pilsen in Bohemia, an artist best remembered for his small-scale alabaster figures. One of these figures, a damaged but delicately worked allegorical statuette (plate 202), dating from about 1740–5, shows Charity as a classically dressed woman, her partially veiled head tilted gently to one side. But thereafter alabaster was little used, falling out of favour as a mainstream and important medium. Some alabaster continues to be worked in Volterra in Tuscany, where decorative trinkets and small sculptural works, mainly for a tourist market, are made. Overall, however, alabaster is today comparatively forgotten. Jacob Epstein made his *Jacob and the Angel*, now at the Tate, in alabaster in 1940–1 (plate 203), but this was a rare gesture. Today, Fauld mine in Staffordshire is the only commercial source of alabaster in England.

Alabaster sculptures can be of extraordinarily high quality, the colours and texture of this translucent material being particularly well suited to small-scale and larger figurative sculptures. Their popularity across Europe from the end of the thirteenth century to the eighteenth century is testimony to the attractiveness and artistic appeal of the material. **FC**

left
202 Charity
by Lazar Widmann
Alabaster, h.35cm
Bohemian, c.1740–5
Purchased under the
bequest of Capt. H.B.
Murray
V&A: A.24–1933

below
203 Jacob and the
Angel
by Sir Jacob Epstein
Alabaster, h.214cm
British, 1940–1
© Tate, London 2007

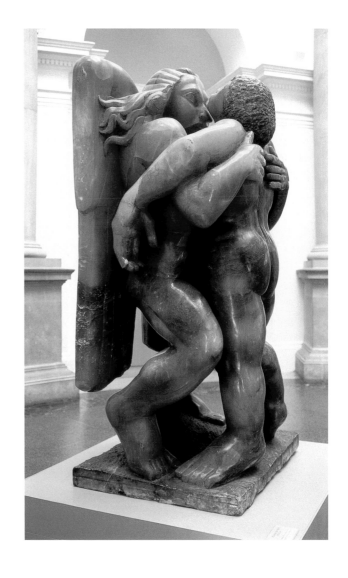

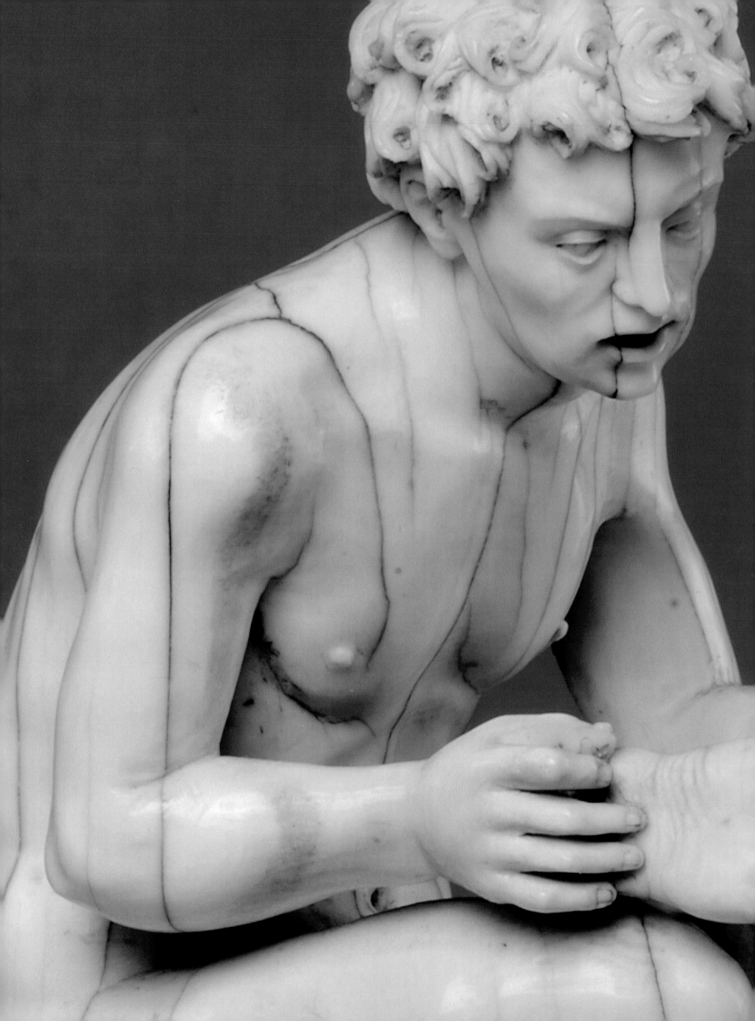

Chapter 8

IVORY AND BONE

Ivory is a dense, creamy white substance which forms part of the tusks of mammals such as elephants and walruses, as well as the teeth of hippopotami; the ivory tusks of extinct mammoths have also been excavated and used for sculpture in the past. Other similar materials are sometimes used for small-scale sculpture, including bone, and the tagua nut ('vegetable ivory') from South America.

For centuries ivory has been highly valued by craftsmen and patrons alike for creating both religious and secular objects. Its structure and density varies from one species of animal to another. The main sources of ivory are elephant tusks from North Africa and India. Elephant tusks grow outward in successive layers and have an interior hollow conical cavity (the pulp cavity), through which a small nerve runs along the length of the tusk (plate 204). African ivory tusks can grow as long as two metres, while Indian tusks are somewhat smaller. The tusks of the Atlantic walrus, and whalebone from the Finner whale, have also been used for works of art in northern Europe since the tenth century. Animal bones (mainly horses and cattle) were employed by the Embriachi workshop in northern Italy to make caskets and reliefs during the fifteenth century.

Elephant and walrus ivory are prepared for carving by removing the outer layer, known as the husk or cementum. The tusk is then sawn into the appropriate shape for a figure or relief (plate 205). The carver uses small knives, chisels, gouges and files, similar to those used for wood carving. After polishing, ivory can be stained or partially painted and gilded, although it is often left unpainted. The Benedictine monk Theophilus Presbyter (c.1070–1125) described the process of working ivory in his treatise *On Divers Arts*, written in the early twelfth century:

When you are going to carve ivory, first shape the tablet of the size you want, put chalk on it and draw figures with a piece of lead according to your fancy. Then mark out the lines with a slender tool so that they are clearly

204 Diagram of an elephant tusk

205 Diagram of an elephant tusk cut vertically

**206 Leaf of a diptych
(the Symmachi Panel)**
Elephant ivory,
h.29.5cm
Italian, c.400 CE
V&A: 212–1865

**207 Consular diptych
of Rufus Gennadius
Probus Orestes**
Elephant ivory, h.34cm
Italian, 530 CE
V&A: 139–1866

visible. Next cut the ground with various tools as deeply as you wish and carve figures or anything else you like according to your skill and knowledge. If you want to ornament your work with gold leaf, put an undercoat of glue from the bladder of the fish called the sturgeon, cut the leaf into pieces and lay them on as you wish.

The V&A houses one of the most comprehensive collection of ivory carvings, ranging from an Egyptian game piece of a crouching lion from the time of the Old Kingdom (2575–c.2008 BCE), to figures and reliefs dating from the twentieth century.

Ivories from Late Antiquity

Two ivories from late antiquity convey the expertise and skill of ivory carvers or *eborarii* in the Mediterranean world. The first is one of the most striking ivories in the collection: a relief of a pagan scene, the so-called Symmachi panel, which was made in Rome in about 400 CE. It depicts a priestess beneath a tree, sprinkling incense onto the fire of an altar, with the inscription 'Symmachorum' (plate 206). Originally it was one of two panels hinged together to form a diptych; the other half of the diptych, inscribed 'Nicomachorum', depicts a similar figure, and is now in the Musée National du Moyen Âge in Paris. Such diptychs seem to have been presented as gifts in commemoration of family events, in this case probably the marriage between a member of the Symmachi and one of the Nicomachi families. The carver has rendered both priestesses in an elegant manner, recalling the slightly earlier neo-attic style of the time of the emperor Hadrian (117–138 CE).

Consular diptychs were produced in ivory in both Rome and Constantinople from the beginning of the fifth century onwards. This one, dated 530 CE, portrays the western consul Rufus Gennadius Probus Orestes (plate 207). The two hinged panels were carved on the outside, while the wax fields on the inner faces were used for inscribed messages. They were sent by newly appointed consuls to members of the Senate and to friends to announce their accession. With the abolition of the consulate in 541 by the emperor Justinian (527–65), the production of Consular diptychs ceased and the main centres of ivory production in Rome and Constantinople declined, although some fine early Byzantine ivories continued to be produced in Constantinople.

Many Consular diptychs survived, however, in church treasuries, where they were reused for commemorative purposes, when prayers were said for the individuals' names inscribed on the wax. Others were recarved to depict Christian subjects. One such, a relief depicting the Crucifixion

209 Reverse of plate 208

and scenes from the Passion, was carved in Metz in the late ninth century (plate 208), and was intended to adorn a book cover, like many other ivories of this date. The reverse (plate 209) shows the upper part of a sixth-century Consular diptych partly shaved down; the palmette design resembles the border decoration on the front, and was evidently added by the ninth-century carver.

Carolingian, Ottonian, Byzantine and Romanesque Ivories: 800–1200

From Roman times up to the reign of Charlemagne (768–814), the art of ivory carving almost disappeared in Europe because of the disruptions caused by the spread of Islam, which prevented the import of the material. But ivory carving flourished again under Charlemagne and his successors. Carolingian ivories were probably carved in a workshop at the court in Aachen in about 800 (the so-called Court School), such as this square plaque depicting an eagle, the symbol of St John the Evangelist (plate 210). It originally formed the upper part of a diptych, with three other panels showing the symbols of the other Evangelists, together with a bust of Christ (the latter and the symbol of St Matthew are now in the Museo Nazionale in Ravenna), and perhaps a plaque (now lost) depicting the Virgin. The eagle and the acanthus border are shown in the naturalistic manner of the Carolingian renaissance, which revived certain stylistic aspects of classical art, as well as early Christian prototypes. During the ninth century, many ivories were produced at episcopal seats such as Rheims and Tours, as well as Metz, where the most productive workshops flourished, and where the relief of the Crucifixion depicted in plate 208 was produced.

After a brief cessation of the craft in the first quarter of the tenth century, ivory carving prospered once again under the powerful Ottonian dynasty, from Otto I to Henry II (926–1024). The Museum houses an outstanding Ottonian ivory, a holy water bucket known as the Basilewsky Situla, which was probably made in Milan in around 980 for Otto II for ceremonial purposes (plate 211).

From the middle of the ninth to the twelfth century, the eastern empire of Byzantium became a great centre of ivory carving. The workshops of Constantinople produced highly decorated caskets in the late tenth and early eleventh

left (top)

208 The Crucifixion and scenes from the Passion

Elephant ivory, h.17cm
Carolingian (Metz),
c.890
V&A: 266–1867

left (bottom)

210 An eagle, the symbol of St John the Evangelist

Elephant ivory, h.12cm
Carolingian (Court School), c. 800
V&A: 269–1867

below

211 The Basilewsky Situla

Elephant ivory, h.46cm
Ottonian, c.980
Purchased with the funds of the Vallentin Bequest and with the aid of a contribution from The Art Fund
V&A: A.18–1933

212 The Veroli casket

(lid)

Elephant ivory,

h.11.5cm

Constantinople,

c.980–1020

V&A: 216–1865

213 Christ in Majesty

Walrus ivory, h.9.6cm

English, c.1000–1050

V&A: A.32–1928

**214 The Adoration of
the Magi**

Walrus ivory, h.21cm

German (Lower Rhine),

c.1150–60

V&A: 145–1866

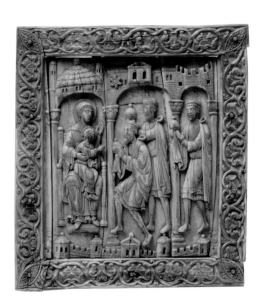

centuries, and a number of these have survived, among them one which was formerly in the cathedral treasury in Veroli and thus now known as the Veroli Casket. This incorporates lively and intricately carved reliefs depicting scenes from classical mythology (plate 212).

Throughout the eleventh century, ivory carving blossomed all over Europe, including England. One example of the long-standing tradition in this country is the plaque of *Christ in Majesty*, made from walrus ivory and dating from the first half of the eleventh century (plate 213). Its style is comparable to contemporary book illuminations from Canterbury. It was originally polychromed, as traces of gold, red, blue, green and pink reveal, and it was probably originally mounted on an item of church furniture or book cover.

During the twelfth century, the main continental centres of ivory production were located in cities such as Cologne and Liège on the rivers Rhine and Meuse. The Museum houses several reliefs from Cologne, such as the walrus ivory *Adoration of the Magi* (plate 214), which was made in about 1150–60. Together with two other walrus ivories depicting the *Nativity* and the *Ascension of Christ*, this relief originally formed part of a larger ensemble, perhaps an altar frontal. A striking idiosyncratic technical feature seen on all three ivories are the lines of punched dots on the drapery.

Thirteenth- to Fifteenth-Century Ivories

During the thirteenth century Paris became one of the most prominent cities in Europe, and from the mid-thirteenth century until the end of the fourteenth century it was a highly productive centre for gothic ivory carvings. These were produced by sculptors who belonged to the guild of the *ymagiers tailleurs* (image-makers and carvers). The guild members were allowed to work in a variety of materials, such as 'bone, ivory, wood and any other kind of material, whatever it may

be', according to Etienne Boileau's *Livre des Métiers* (Book of Trades), written about 1250–75. Many different types of ivory objects were produced for religious and secular purposes; devotional statuettes, particularly those of the Virgin, and diptychs and triptychs with scenes from the life of Christ and the Virgin, were made in great numbers. The stylistic vocabulary of these ivories is often closely related to that of monumental Parisian sculpture. The leaf of a diptych (plate 215) of about 1250–70 is one of the earliest gothic ivories made in Paris. Many ivory ateliers apparently specialized in the production of secular objects, such as combs, knife- and dagger-handles, and caskets and mirror-backs with scenes from medieval Romances (plate 216).

By the beginning of the fifteenth century the prolific production of both secular and religious ivory reliefs and statuettes had slowed down, probably because the material was unavailable. However, a new class of micro-carvings in ivory of religious subjects emerged, their surfaces originally entirely painted (plate 217), apparently in imitation of precious enamels (*émail en ronde bosse*). These were inserted in monstrances, reliquaries or pendants.

Ivories from the Sixteenth Century Onwards

Following the great flourishing of European ivory carving during the medieval period, there was a comparative lull during the fifteenth and sixteenth centuries, partly because supplies of the raw material were disrupted after the fall of Constantinople to the Turks in 1453, and partly because ivory itself seems to have gone out of fashion. One exceptional sixteenth-century piece in the Museum's collection is the statuette of *Hercules Plucking a Thorn From His Foot* by the German sculptor Christoph Weiditz (plate 218). This small-scale sculpture, based on an antique prototype, *The Spinario*, dates from about 1540–50, and may have formed part of a cabinet of curiosities (*Kunstkammer*).

above left

215 Scenes from the Passion
Elephant ivory,
h.32.5cm
French, 1250–70
Salting Bequest
V&A: A.546–1910

above right (top)

216 Storming of the Castle of Life
Elephant ivory,
diam.13cm
French, c.1350–60
V&A: 9–1872

above right (bottom)

217 The Deposition
Elephant ivory,
diam.8.5cm
French, c.1400–20
V&A: 605–1902

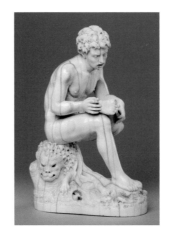

218 Hercules plucking a thorn from his foot by Christoph Weiditz
Ivory, h.15.5cm
South German,
c.1540–50
Given by Dr W.L. Hildburgh, F.S.A.
V&A: A.35–1949

219 Women in a bath house by a follower of Leonhard Kern
Ivory, h.20cm
South German, c.1650
Given by Dr W.L.
Hildburgh, F.S.A.
V&A: A.42–1949

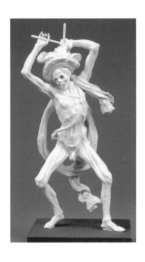

The next important era for the working of ivory was the seventeenth and eighteenth centuries, when artists in the Netherlands, Germany, France and Britain produced virtuoso pieces for princes and wealthy collectors all over Europe. The raw material was imported through major ports such as Antwerp, Genoa and Dieppe, and centres of ivory carving grew up at the courts of Salzburg, Prague, Dresden and elsewhere.

Many northern European sculptors specialized in ivory carving in the seventeenth century, such as the South German sculptor Leonhard Kern. *Women in a Bath House* (plate 219) of about 1650, probably carved in his workshop, exemplifies the distinctive qualities of the material. The shape of the relief still shows the curvature of the tusk, while the colour of the material seems especially well suited to the subject matter of naked, rather fleshy women bathing. Kern also worked in boxwood, which is of a similar density to ivory.

As well as depicting flesh, ivory could of course be used to represent bone. The *Dance of Death*, probably by the North German sculptor Joachim Henne, and dating from about 1670–80, is a skeletal figure banging on a drum, a *memento mori* or remembrance of death (plate 220). Such reminders of mortality were commonly produced in Germany and were frequently seen in popular engravings from the fifteenth century onwards, as well as in sculpture. The virtuoso carving of the anatomy would have been admired at the time, and this piece could well have formed part of a cabinet of curiosities.

Ivory was relatively easy to carve and could be worked in fine detail, unless there was a hidden fault that caused damage during carving. An exquisite relief showing the Virgin swooning at Christ's entombment probably dates from about 1677–80, and is by the German sculptor Balthasar Permoser, who is more renowned for his large-scale sculptures in sandstone in Dresden (plate 221). This ivory may have been carved while he was working in Florence. Although it is only just over 24cm high, it has a monumental, baroque quality.

Throughout this period ivory was highly valued, and was sometimes combined with other precious substances by court artists to enhance its qualities. Its creamy white colour could be contrasted with, for example, dark wood or amber (plate 222; and see plate 257). The large figure group of *The Judgement of Solomon* of about 1741 is by Simon Troger, an Austrian sculptor, active in Innsbruck and Munich in the first half of the eighteenth century. Troger specialized in combining walnut with ivory, continuing a long tradition of carving wood in the Tyrol and South Germany. Here, as in some of Troger's other works, the eyes of the figures are of glass.

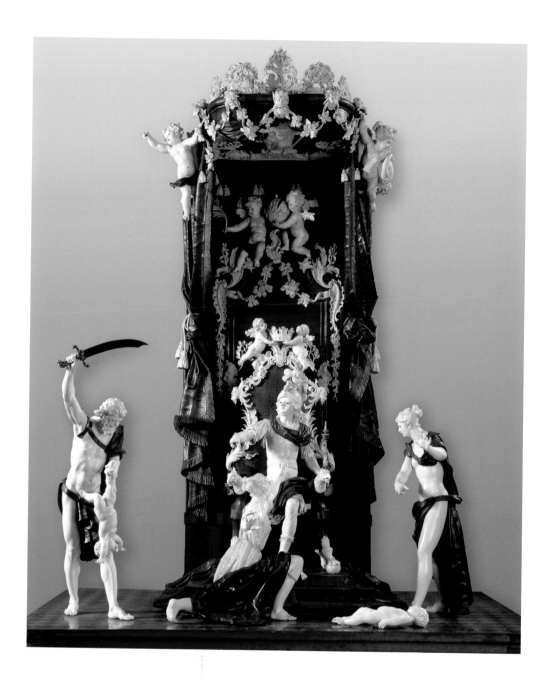

opposite (middle)
**220 The Dance of
Death
by Joachim Henne**
Ivory, h.23.5cm
German, c.1670–80
V&A: 2582–1856

opposite (bottom)
**221 The Entombment
by Balthasar Permoser**
Ivory, h.24.1cm
German, c.1677–80
Given by Dr W.L.
Hildburgh, F.S.A.
V&A: A.30–1949

left
**222 The Judgement of
Solomon
by Simon Troger**
Ivory, walnut and glass,
h.122cm
German, c.1741
V&A: 1009–1873

below
**223 Cup and cover
by Philip Senger**
Ivory, h.32.5cm
German, 1681
V&A: 74–1865

Ivory was not only carved but could be turned on a lathe. Ivory-turning became fashionable in European courts from the sixteenth to the eighteenth century, and some rulers practised it themselves, including Duke Francesco de'Medici, Grand Duke of Tuscany (1541–87) in Florence, and rulers at the Danish court in Copenhagen and at the Habsburg court in Vienna. However, most turned ivories were worked by professional artists, often attached to the court. One of these was the German sculptor Philip Senger, who was turner for Cosimo III, Grand Duke of Tuscany (1642–1723), and who also instructed the Gran Principe Ferdinando (1663–1713) in the art of turning. The elegant shape of this cup and cover by Senger, signed and dated 1681 (plate 223), recalls silver vessels, but it was designed as a work of art and was not destined to function as a goblet.

**224 George I
by David Le Marchand**
Ivory, h.38.5cm (with
socle)
English, c.1714
V&A: A.12–1931

**225 George II
by Johann Christian
Ludwig von Lücke**
Ivory, h.18.8cm
German, 1760
V&A: A.18–1932

In the eighteenth century portraits in ivory became popular in wealthy circles and amongst royalty. David Le Marchand's signed bust of King George I (1660–1727) of about 1714 depicts the monarch both realistically and monumentally (plate 224). Even though it is only about half life-size, it has a presence comparable with a marble bust. Le Marchand was a specialist ivory-carver, and had arrived in Britain from Dieppe by 1696, when he was 22. This northern French city was a major centre for the production of ivories, since so much ivory entered the port, and continued to be so until the late nineteenth century. Le Marchand spent the rest of his life in Britain, at first in Edinburgh, but then mainly working in London, and his portrait busts and reliefs are among the finest European ivories of their time.

Johann Christian Ludwig von Lücke's relief of King George II (1683–1760), signed and dated 1760 (plate 225), is another example of a striking royal portrait in ivory, again by an artist from the Continent, although Lücke, a German sculptor, was an itinerant artist and spent only three years in London from 1757 to 1760. This ivory was exhibited in London in 1761, and was probably based on life sketches, either drawings or wax models, which were then used in the studio to create the finished ivory.

Some ivories were made in Asia for the European market. In the Indian city of Goa, and in Sri Lanka, local sculptors carved ivories for Portuguese patrons. These were either exported to Portugal, or used by missionaries to convert the indigenous population to Christianity. Such ivories are almost invariably anonymous, but their style of carving reflects the confluence of Asian and European styles. A crucifix from Sri Lanka of about 1600 (plate 226) exemplifies this union of cultures: the sinuous linear carving and the facial features of Christ are typical of Sri Lankan styles, while the Christian iconography would have been dictated by the Portuguese client, who may have been a priest. The comparatively large size of this piece, as well as the fact that it is partly painted, is also typical of colonial ivories. Ivory was in more plentiful supply, although it was probably an African rather than an Indian elephant's tusk, as African tusks were larger and more suitable for carving. Many Sri Lankan and Goan ivories were partly painted and were sometimes partly gilded to enhance the natural colour of the material.

Although some sculptures were carved in ivory in the nineteenth century, it was not in great demand as a sculptural material during this period, although as mentioned above, Dieppe remained an important centre for ivory carving. One British artist who exceptionally worked in the material was Benjamin Cheverton. His ivory of Thomas Slingsby Duncombe MP (1796–1876) is a miniature portrait bust after a marble by Alfred Hone, exhibited at the Royal Academy in 1848 (plate 227).

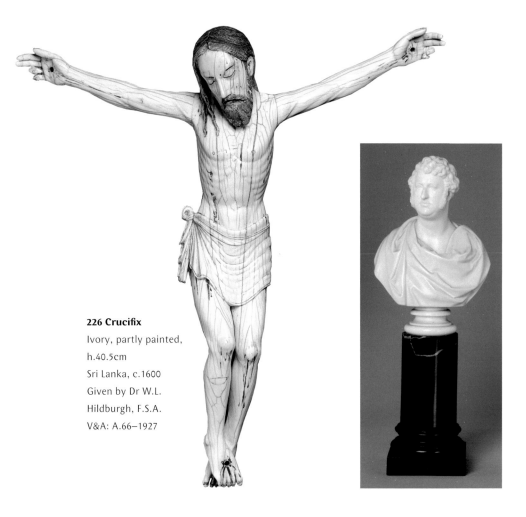

226 Crucifix
Ivory, partly painted,
h.40.5cm
Sri Lanka, c.1600
Given by Dr W.L.
Hildburgh, F.S.A.
V&A: A.66–1927

Cheverton specialized in producing these portable portraits, which were made with his own reducing machine from life-size versions.

A few artists in the twentieth century, notably in Britain, found an affinity with ivory, perhaps because of the dictum of 'truth to materials' and the belief in direct carving. Sculptors often chose substances with particular qualities of surface, colour and texture to be appreciated in their own right, and wanted to carve the materials themselves. Richard Garbe's *Young Woman*, dating from 1946 (plate 228), is a striking example of the way the ivory could imitate smooth flesh, and the simplified forms of the whole seem in accord with the material. Garbe deliberately used the shape of the tusk, thereby avoiding any excessive waste, and exploiting the expressive curves of the ivory to imitate the female form.

Ivory is rarely if ever used for contemporary sculpture, due to the concern about endangered species and the consequent illegality of most ivory exports today. The works of art in ivory from the medieval period to the twentieth century in the V&A's collection testify, however, to its distinctive qualities as a material for small-scale sculpture in earlier times.

NJ and MT

above middle
**227 Thomas Slingsby
Duncombe MP
by Benjamin
Cheverton**
Ivory, h.13.5cm
English, 1848
Given by Dr W.L.
Hildburgh, F.S.A.
V&A: A.32–1926

above right
**228 Young Woman
by Richard Garbe**
Ivory, h.34.5cm
English, 1946
V&A (Anonymous loan)

Chapter 9

WOOD

Sculptors have used wood for figurative carvings and ornamental architectural work since ancient Egyptian times. Wood sculpture was produced all over Europe from the Middle Ages onwards, particularly in Germany, Spain, Italy, France, Britain and the Netherlands.

Types of Wood

Diverse types of wood were used in different regions. In South Germany sculptors favoured limewood, while in North Germany the guilds restricted the sculptor to oak. Oak was also widely used in the Netherlands, northern France and England. Walnut was popular further up the Rhine valley in Germany, in the Netherlands and France, but Italian, Spanish and Alpine wood carvings were generally of pine or poplar.

Carvers always tried to use wood of good quality, without knot holes or of irregular, twisted forms. The Nuremberg sculptor Veit Stoss was one of the few sculptors to master the immense problems of using imperfect timber. He is known to have carved in inferior limewood on occasion, because he was sometimes supplied with timber of slightly lower quality by the city. In other centres, such as Ulm in Swabia, limewood was more easily available, since normally the carver bought the wood he needed from timber mills near the River Danube, after it had been floated down from more distant forests. The Ulm sculptor Michel Erhart, who was active in the late fifteenth and early sixteenth centuries, even had his own timber yard.

Preparation and Working of Wood

When a tree arrived in the workshop, the mature timber – 'green' wood was not suitable – was split in two with an iron wedge, so that it could be used for two figures or a number of reliefs. The reliefs might be made of separate planks fixed together with glue and dowels, sometimes strengthened by fabric on the back in order to control any movement in the wood. A piece of linen soaked in size (animal glue) would be applied. Movement in

**229 The Unfinished
Man
by Erhard Schön**
Woodcut
German, c.1533

the wood was caused by changes of temperature and humidity, and could potentially damage the polychromy or other surface decoration. The linen was therefore used to prevent cracks on the decorated surface, as well as to disguise defects on the wood, such as knots, or the joints between two planks.

If a freestanding figure was to be made, the back of the block was hollowed out; the core of the trunk was removed to avoid future cracking caused by internal tensions in the timber. The hollowed-out back was then often concealed with a separate piece of wood. If, however, the figure was to be placed in a niche, the hollow back might be left uncovered. Small-scale figures were generally carved in the round.

The next stage can be seen in Erhard Schön's woodcut *The Unfinished Man*, of about 1533 (plate 229). Here the carver is shown using a broad axe to rough out the form of the figure; his tools are depicted in the woodcut: a mallet and three chisels. The first of the chisels is a gouge, while the other two are skew-bladed firmers. The rough block was laid down horizontally on a workbench so that it could be worked. The carver would drill a hole in the top of the block of wood in order to fix a dowel, while the other end (the base of the figure) was steadied with an iron bar. This enabled him to both stabilize and rotate the wood block while he was carving (plate 230). The sculptor carried out the more detailed carving of the figure in this horizontal position. When this was completed the figure was ready to be painted.

The work of the sculptor normally ended there. The polychromy – the painted surface – was often essential for the finished appearance of the sculpture or the relief, and was not just a perfunctory stage in the making of the figure; the colour modified the form. The materials used for painting a sculpture resembled those used for panel painting. In Spain, for instance, renowned easel painters such as Velázquez were also trained as painters of sculptures.

**230 Reconstruction
of a wood carver's
workshop**
Photograph taken by
Ulrich Kneisse

Polychromy and Surface Treatments

When a wood figure had been sculpted, it would most often be given to the *estofador* (Spanish) or the *estoffieur* (French). This specialist would paint the surface to imitate the drapery. The flesh would normally be the last element of the surface to be treated, and this would have been carried out by the flesh-painter or *encarnador* (Spanish).

The wood was first sized with glue, produced from burning animal bones and skins, mixed with water. This was done in order to seal the surface. Then a preliminary ground was applied warm in several layers to the surface of the wood. In southern Europe this consisted of a mixture of gypsum (calcium sulphate), animal glue (size) and water. In northern Europe the gypsum was replaced by chalk (calcium carbonate).

In order to control movements of the wood, a piece of linen would sometimes be applied and fixed with the size. These movements, caused by changes of temperature and humidity, could potentially cause damage to the decoration applied to the surface of the wood. The linen was therefore used to prevent cracks on the decorated surfaces and to disguise defects in the wood, such as knots or joints. Depending on the quality of the carving, a greater or lesser number of layers of this preparatory ground, commonly known as gesso, were needed. If the carving was very fine, only a few thin layers of gesso would be applied in order to preserve the definition of the form created by the wood-carver. Fewer layers were usually applied to areas of the sculpture that were meant to be oil-gilded. This process consisted of applying an oleaginous mordant (a mixture of copal resin and linseed oil) on to the gesso, until the mordant became tacky to the touch, and then placing sheets of metal leaf (gold, silver or tin) to adhere to it.

A combination of oil- and water-gilding is commonly found in the same sculpture. The technique of applying metal leaf using water as the main component requires a small amount of animal glue to fix the metal leaf onto the ground. This technique is more laborious, though not necessarily more difficult than the oil-gilding: more layers of gesso are necessary, as well as the application of a red bole, often clay from Armenia. Both the gesso and the bole need to be smoothed down before the gold is applied. The bole is necessary for the burnishing of the metal leaf. If any imperfections exist, these will show after the burnishing process is completed and mar the final effect. Water- and oil-gilding give the illusion of solid metal, but can have different finishes, from being extremely polished to a duller, matte surface (plate 231).

The surface treatments of wood sculptures play with illusion, often imitating real materials. Sculpture with richly decorated

231 Reproduction of a section showing the lower torso based on plate 233, which shows the stages of decoration: gesso ground and the burnished bole before the application of gold leaf
Carved by Sofia Marques

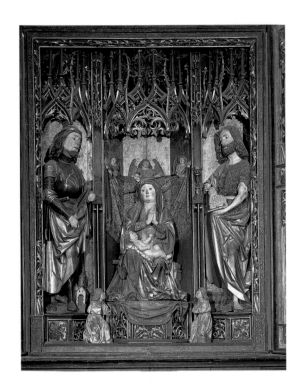

232 The Brixen altarpiece, probably by Philipp Diemer and Rupert Potsch
(detail)
Limewood and pine,
h.416cm
Austrian (South Tyrol),
c.1500–20
V&A: 192–1866

surfaces became widespread in Europe from the second half of the thirteenth to the early sixteenth centuries, especially in Germany and Spain, partly because of the prosperity of many donors, and because of the important devotional role played by these religious images and panel paintings. Gold, silver or tin, combined with opaque or translucent pigments, were employed to represent different fabrics and backgrounds. Pigments such as azurite, azurite with lead white, carbon black, copper resinate, madder, red lake, verdigris and Brazil wood would have been used, such as on the figure of the Virgin in the corpus of the *Brixen altarpiece* (plate 232).

Italian silk fabrics, woven with gold and silver threads and decorated with foliage, animals and birds, were represented in the carved draperies of the sculptures, and on the backgrounds of panel paintings, using a technique known as *pressbrokat* (pressed brocade). This technique consisted of gilding and painting on wax sheets that had previously been pressed into a mould, in order to create an impression of a patterned textile. The wax was gently warmed, so that it became pliable and could be applied to the most intricate curves of a figure. The resulting effect was an intricate design created by extremely fine raised lines, as seen in the cloth-of-honour held by three angels in the corpus of the *Brixen altarpiece* (see plate 232).

In conjunction with the technique used to represent brocade, the *sgraffito* (Italian) or *esgrafiado* (Spanish) technique was also widely used in the fifteenth to the eighteenth centuries. The prepared surface of the wood would first be gilded, and the gold leaf burnished. Then colour would be applied to the gilded surface. When almost dry, a design would be scratched onto the paint with a pointed tool, without damaging the gold underneath. The gold beneath the colour would be revealed, and elsewhere a metallic glow would shine through the translucent colour, creating a rich and luminescent effect (plate 233).

The medium used in medieval times for paint was egg tempera (egg, either the white or yolk, or both together) mixed with pigment. From the fifteenth century onwards, linseed oil, sometimes with the addition of a small percentage

right
233 St Sebastian
Boxwood, h.19.3cm
Spanish, c.1700–50
V&A: 175–1864

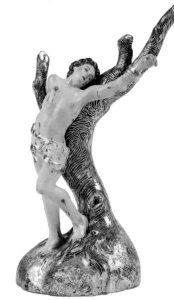

of protein (probably egg) or resin (colophony, dammar or mastic), combined with pigment, became more common. The oil medium made the colour shinier, while tempera gave a matte effect. Often matte was preferred for flesh tones.

The Spanish word *estofado* encompasses both *esgrafiado* (as described above) and free-hand drawing and painting in colour with a brush over burnished gold. Such painting could imitate precious stones, as well as floral and geometric patterns on fabric. Actual semi-precious stones were used in some cases, as well as pieces of coloured glass (often fixed to silver, tin or gold leaf) to imitate stained glass (altarpieces) and precious stones (plates 234 and 235).

Other textures could be created by cutting into the gesso surface of the sculpture before the application of colour or gilding. The gesso, covered with red bole, could also be gilded and, while the size used for fixing the metal leaf was still drying, punches pressed onto the gold. The shape of the punch marks could vary from being a simple circular shape to more elaborate floral and stylized designs. Certain punch marks can identify a specific period or region of production. The punches were sometimes applied directly to the wood, without a gesso layer, which suggests that the sculptures were not always meant to be painted. Some of Tilmann Riemenschneider's figures of the late fifteenth and early sixteenth centuries, for example, were clearly not originally intended to be polychromed (plate 236).

Patterns could also be produced in relief by building up layers of gesso on top of the smooth gesso layer. This raised decoration would then be gilded or painted; this technique can be referred to as *pastiglia* (plate 235). Often more than one of the above decorative techniques can be observed in the same sculpture or in a larger ensemble; this can be seen on the Brixen altarpiece (see plate 232), and is discussed in greater detail below.

Glazes, dyes and paint could also be used to give a wood sculpture a monochrome painted surface, sometimes imitating stone. Glazes were applied to wood sculptures whose carving was exceptionally detailed. The glazes were translucent and often fairly colourless, usually consisting of animal glue or oil. They protected the surface of the wood, enhancing its natural colour and the definition of both the grain of the wood and the carving. *The Cravat* by Grinling Gibbons, carved in limewood in about 1690, was intricately created in imitation of Venetian lace (plate 237). As on some of Tilmann Riemenschneider's sculptures (plate 236), a translucent glaze

left (top)
234 Seated Virgin
Oak, h.57cm
Mosan (Liège?), 1330–60
Given by Mrs
F. Leverton Harris
V&A: A.4–1929

left (middle)
235 Pieces of coloured glass imitating precious stones and raised decoration on the Seated Virgin
See plate 234

left (bottom)
236 Punchmarks applied to monochrome glazed wood on the group of Mary Salome and Zebede by Tilmann Riemenschneider
Limewood, h.119.4cm
German (Franconia),
c.1505–10
V&A: 110–1878

237 Cravat
by Grinling Gibbons
Limewood, h.24.1cm.
English, c.1690
Given by The Hon. Mrs
Walter Levy
V&A: W.181–1928

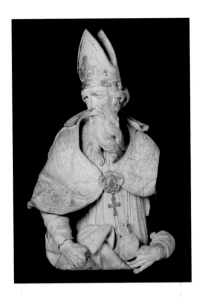

238 St Augustine
Limewood, h.106cm
South German,
c.1720–30
Given by Dr W.L.
Hildburgh, F.S.A.
V&A: A.2–1953

is the only surface treatment applied to the wood. The sculpture was once in the collection of Horace Walpole (1717–97) at Strawberry Hill; he greatly admired its illusionistic effect, and apparently sometimes wore it to tease and amuse visitors.

In the seventeenth and eighteenth centuries, especially in northern Europe, wood sculptures were often painted with successive layers of white lead-based mixtures of paint in order to imitate marble, which was fashionable at the time, but not readily available in countries such as Germany or Belgium, or simply too expensive. The late eighteenth-century South German figure of *St Augustine of Hippo* (now a bust, but originally a full-length figure) has been painted in this way, with additional areas highlighted in gold (plate 238).

The Contexts and Functions of Figurative Wood Sculpture

From the tenth to the thirteenth centuries the most prominent single figures in wood, made for churches all over Europe, were the Virgin and Child and the Crucified Christ. This tradition continued up to the twentieth century, but other wood sculptures, including individual saints and more complex monuments, such as the triumphal crosses with Christ on the cross flanked by the Virgin and St John, increasingly populated cathedrals and churches. The cult of the archangel Michael had become widespread in Europe by the fourteenth century, and generated numerous sculptures, such as this near life-size walnut figure of *St Michael*, probably carved in Paris in about 1325–50 (plate 239). Although marble was one of the principal materials for sculpture in Italy, wood was also used ubiquitously, for example in Siena in the fifteenth century, and in Naples in the eighteenth century. One example is the mid-fourteenth-century *Angel* from the circle of Nino Pisano, made in Pisa, which formed part of an Annunciation group (plate 240).

The altarpiece is generally the most prominent element in a church interior. It evolved from the thirteenth century onwards, when a painted wood panel (*pala*) was set behind the altar. During the fourteenth century it became the most important type of sculpture in wood in northern Europe. The structure of a winged altarpiece (plate 241) was dominated by the central panel, the corpus (1), and its figures. The wings (2) carried relief carvings, figures or narrative paintings; the predella (3) often contained busts of apostles or saints; the crowning superstructure (4) was usually decorated with finials and small figures.

One large example of this type is the so-called Brixen altarpiece in the V&A, which probably comes from the church of St Andrew in Klausen,

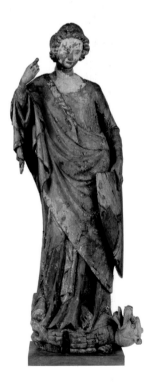

239 St Michael
Walnut, h.126cm
French, 1325–50
V&A: 526–1895

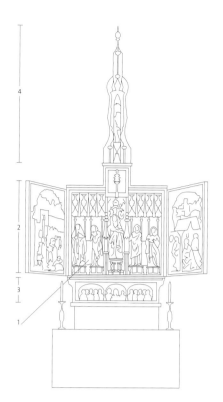

near Brixen/Bressanone in the Tyrol (see plate 232). It is likely to have been made by the sculptor Rupert Potsch and the painter Philipp Diemer, both of whom were active in Brixen in the first quarter of the sixteenth century. The high altarpiece for this church was commissioned in 1506. The corpus houses the figures of the seated Virgin, flanked by St Florian and St John the Baptist under canopies. Behind the Virgin three angels are shown holding the cloth-of-honour, while two angels kneel at her side. The crowning superstructure is missing, but the original fixing holes for it at the top are still visible. The reliefs on the wings depict *The Annunciation*, *The Presentation in the Temple*, *The Nativity* and *The Adoration of the Magi*.

For most of the year, and throughout Lent, the corpus was closed, displaying only the paintings on the back of the wings, which depicted further saints. The wings were opened for feast days, when the sculptures in the corpus could be seen in all their splendour. The predella originally contained three reliquary busts, but these are now missing. The complex programme of the altarpiece was not left to the artists, but was decided in this case by local dignitaries, 'the judges, the clergy and the burghers', mentioned in the contract between the patrons and the artists. Such documents were signed before work started, and often (as here) dealt in detail with the iconographic programme, the quality of the wood, the payments and the date of completion; sometimes a drawing approved by both sides was attached.

Many of the religious figures and reliefs housed in the V&A originally formed part of altarpieces, such as the six fourteenth-century figures of *Christ, the Virgin,* and the four *Apostles* (plate 242), and the early-sixteenth-century statue, probably of an Apostle, by the Spanish sculptor and painter

240 The angel of the Annunciation, Circle of Nino Pisano
Wood, h.183cm
Italian, c.1350–68
V&A: 7719–1861

left (above)
241 Diagram of an altarpiece

left
242 Christ and the Virgin with four apostles
Oak, h.31.8cm; 33cm; 33cm; 32.4cm; 31.8cm; 32.4cm
Probably Mosan (Liège), 1350–1400
V&A: 412 to 416–1889

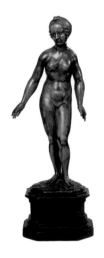

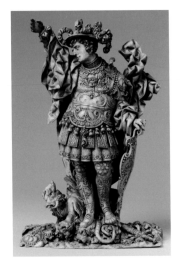

**243 An apostle
by Alonso Berruguete**
Polychromed and gilt
walnut, h.83cm
Spanish, c.1526–33
V&A: 249–1864

top (left)
**244 One of the three
goddesses from the
Judgement of Paris
by Daniel Mauch**
Pearwood, h.25.8cm
German, c.1500–10
V&A: A.4–1956

top (middle)
**245 St George and the
Dragon by Master HL**
Boxwood, h.27.8cm
Upper Rhenish or
Netherlandish, c.1530–40
Given by Dr W.L.
Hildburgh, F.S.A.
V&A: A.30–1951

top (right)
**246 Reverse of plate
245 showing the
roughly carved back**

Alonso Berruguete (plate 243). This figure, painted and gilded in the *estofado* technique, was originally an integral part of a large altarpiece in the church of St Benito in Valladolid, dating from the late 1520s.

At the end of the fifteenth century in northern Europe a new class of small-scale autonomous figures and reliefs emerged. Although they often had devotional connotations, they were viewed primarily as virtuoso objects in their own right. A figure of one of the three goddesses (probably Venus) from the *Judgement of Paris* of about 1500 by the Ulm sculptor Daniel Mauch is a typical example (plate 244). The composition derives from a renaissance plaquette of the *Judgement of Paris* by the Paduan Master, who signed his works with the initials I.O.FF., of about the same date, but Mauch's approach is nevertheless rooted in late gothic traditions of stylized forms, rather than being based on observation of anatomical details, seen in the slightly inept contrapposto. This class of sculpture was also produced by sculptors in Ulm. Michel Erhart, for example, provided humanist clients with such small-scale secular figures as early as the 1470s.

Often such small-scale sculpture could be of outstanding virtuoso quality, such as the relief of *St George and the Dragon*, probably made in about 1530–40 by Master HL, an anonymous artist active in the Upper Rhine area (plate 245). Master HL made a number of altarpieces in a distinctive style, of which several survive in this area. He seems to have left for the Netherlands when Lutheranism led to the official abolition of religious images. This ban affected the commissioning of larger religious sculpture in the Upper Rhenish cities such as Strasbourg and Freiburg-im-Breisgau, and many sculptors consequently turned to the production of small-scale pieces. Although this sculpture carved in high relief has an ostensibly religious subject, it is clearly not a devotional piece, and its appeal must always have resided in its intricately sculpted surface. But the virtuosity of the carved drapery and the richly decorated breastplate and leg harness contrast with

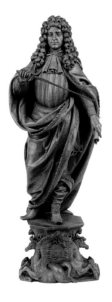

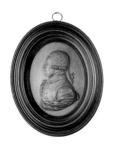

the roughly carved back, which still has remains of bark (plate 246). This contrast between the highly worked artistry and the natural form of the wood must also have been valued, underlining as it did the skill of the artist.

Both of these sculptures must have been made above all for collectors, and may have been intended for a cabinet of curiosities or *Kunstkammer*. Such cabinets emerged in the sixteenth century, at the courts of the Habsburg Emperor Rudolf II in Prague and François I at Fontainebleau, but were also formed by aristocrats, wealthy merchants, and even prosperous scholars, such as Paulus Praun (1548–1616) in Nuremberg, and Basilius Amerbach (1533–91) in Basel. The latter's collection is now housed in the Historisches Museum in Basel, while Praun's collection was dispersed in the early nineteenth century.

From the sixteenth century onwards, images of rulers and prominent figures such as ambassadors and statesmen became increasingly fashionable. An example of this class of sculpture is the boxwood figure of a man in armour, possibly James II when Duke of York, probably made by a Netherlandish sculptor who was active in England in about 1660 (plate 247). Another example is the boxwood bust of a man, possibly George Washington (1732–99), by the British sculptor P.H. Leader, carved in about 1790–1800 (plate 248). Boxwood can be carved in fine detail because of its density, and is used for small-scale pieces, as the trunk of a box tree is comparatively small in diameter.

Grinling Gibbons was one of the most renowned British sculptors during the second half of the seventeenth and early eighteenth centuries, and excelled in wood carving. Born in Rotterdam of British parentage, he was trained in the Netherlands before he settled in England, first in York and eventually in London, where he worked for the aristocracy and the Royal Court. His relief *The Stoning of St Stephen*, probably made in about 1680, is made up by layers of wood fitted together (plate 249). It is an outstanding piece of carving, which he produced early in his career to demonstrate his extraordinary abilities.

NJ and SM

left (above)
247 Man in Armour, possibly James II when Duke of York
Boxwood, h.38.5cm
English, c.1660
Given by The Art Fund
V&A: A.17–1936

left (below)
248 Unknown man, possibly George Washington by P.H. Leader
Boxwood, h.18.2cm
English, c.1790–1800
V&A: A.24–1939

below
249 The Stoning of St Stephen by Grinling Gibbons
Limewood and lancewood, h.184cm
English, c.1680
V&A: 446–1898

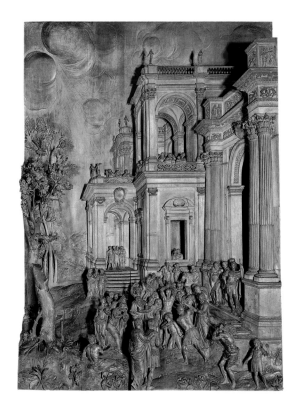

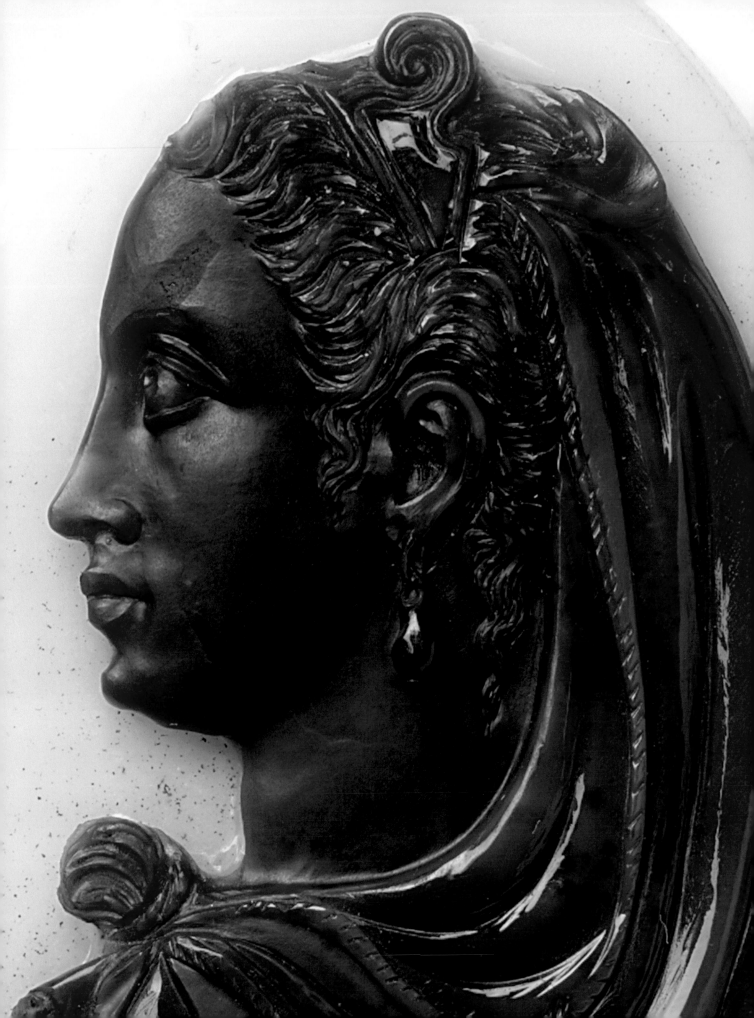

Chapter 10

SEMI-PRECIOUS MATERIALS

Rock Crystal

Rock crystal is a translucent variety of quartz, which occurs in cavities in rocks worldwide. Its coldness when touched led to the belief in former times that it was water transformed by the gods into permanent ice, hence the name crystal, from the Greek 'krystallos'. In his treatise *On Divers Arts*, written in the first half of the twelfth century, Theophilus (c.1070–1125) described the material as 'water hardened into ice, which is then hardened through many years into stone'. He explained the technique of cutting and polishing rock crystal as follows:

> Take some chaser's pitch and put it on fire until it melts. Then cement the crystal with it to a long piece of wood of comparable thickness. When it is cold, rub it with both hands on a piece of hard sandstone, adding water, until it takes on the shape you want to give it. Then rub it on another stone of the same kind until it becomes completely smooth. Now take a flat, smooth lead plate and on it put a moistened tile which has been abraded to dust with saliva on a hard hone-stone and polish the crystal on it until it becomes brilliant. Lastly, put some tile dust moistened with saliva on a goat skin that is neither blackened nor greased, stretched on a piece of wood and fastened on the underside with nails. Rub the crystal on this until it is completely clear.

Theophilus also described how to drill into and cut up rock crystal. He does not, however, discuss how to make vessels, an operation which required great skill and experience. The vessel was probably rough-cut with a saw into the required shape. Then, with special instruments and drills used in combination with an abrasive, probably water and sand, or a paste composed of diamond dust, the rock crystal was hollowed out (plate 250). The outer surface was finished using a bow lathe, which was a spindle to which either a drill or a small wheel was attached. The abrasive used was generally sand.

250 Diagram of techniques for hollowing out a rock crystal ewer

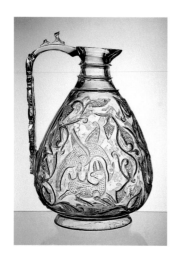

251 Ewer
Rock crystal, h.19.5cm
Egypt, c.1000
V&A: 7904–1862

252 Ewer
Rock crystal mounted
in gold, h.21.5cm
French, c.1300–50
Jones Bequest
V&A: 857–1882

Rock crystal has been worked since ancient times. It flourished in the Roman Empire, and the tradition continued in Egypt in the tenth century during the reign of the Fatimid dynasty (909–1171). After their downfall in the second half of the twelfth century, the Fatimids' collections of works of art, including rock crystal objects such as ewers, basins and flasks, were dispersed. Some of them were transformed into reliquaries and entered church treasuries, such as those in Venice, Paris and Quedlinburg; others formed part of European aristocratic collections, for example those of the Medici in Florence and the Habsburgs in Prague and Vienna.

The ewer in the V&A (plate 251) of the early eleventh century is an outstanding example of the superb craftsmanship of the Fatimid workshops. It is elegantly decorated with a 'tree of life' arabesque, and the central composition, repeated on both sides of the ewer, depicts a falcon attacking a gazelle. The clear surface is superbly polished. It forms part of a group of rock crystals which are stylistically linked, and which are housed in several European collections. All are closely related to a ewer in the Treasury of San Marco in Venice with the inscribed name of the Fatimid caliph al Aziz (r.975–96).

The foundations of rock crystal carving in Europe were laid in South Italy and Sicily in the late twelfth and thirteenth centuries under the Hohenstaufen dynasty. Saracene craftsmen from Egypt found employment in Sicily, and carved exceptionally large rock crystal vessels. This required far more skill and experience than carving the relatively small pieces, which were produced around the same time in the Rhine and Meuse regions. These northern European rock crystal carvings formed parts of reliquaries, altar crosses, portable house-altars and monstrances.

The thirteenth century also saw the establishment of two new centres of rock crystal carving in Paris and Venice. The first statutes of the guild of the *Cristalliers et Pierriers de pierre natureus* (Rock crystal- and Stone-carvers of natural stone) in Paris were set down in 1259, and the tax register of 1292 mentioned 18 *cristalliers*. Over the following two centuries, exquisite vessels were made for the Church, the aristocracy and especially for royalty. King Charles V of France (1337–80), for example, owned no less than 42 carved rock crystal vessels.

Most of the vessels produced in Paris during the fourteenth and fifteenth centuries were faceted (described in the inventory of Charles V as '*à pluseur quarres*'), which augmented the reflective qualities of the surface. A typical example of this technique is a ewer, which was made in Paris in about 1300–50 from a piece of rock crystal with scarcely any natural flaws (plate 252). Emperor Charles IV (r.1346–78) helped establish Prague as another

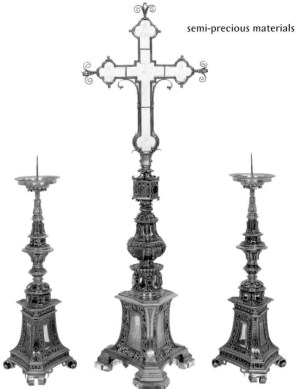

important centre of rock crystal carving in the fourteenth century.

In Venice, vessels, flasks, goblets, candlesticks and crucifixes, although smaller than those made in Paris, were produced, but by the end of the fifteenth century the craft declined. This was because of the new centres in Milan and Rome, where artists used more sophisticated methods, such as the intaglio technique for figurative scenes in rock crystal plaques, rather than the more traditionally decorated pieces in Venice. Magnificent examples of the intaglio technique are to be found on an altar cross (plate 253), which has been ascribed to Valerio Belli and which was probably made in Rome in about 1515–

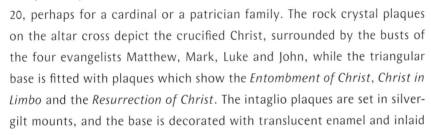

20, perhaps for a cardinal or a patrician family. The rock crystal plaques on the altar cross depict the crucified Christ, surrounded by the busts of the four evangelists Matthew, Mark, Luke and John, while the triangular base is fitted with plaques which show the *Entombment of Christ*, *Christ in Limbo* and the *Resurrection of Christ*. The intaglio plaques are set in silver-gilt mounts, and the base is decorated with translucent enamel and inlaid with small discs of polished jasper, lapis lazuli and chalcedony. The figurative plaques on the cross are engraved on the reverse, while the plaques of the candlesticks are undecorated.

From the middle of the sixteenth century onwards, hardstone carving was dominated in Italy by a Milanese family, the Miseroni. The founder of the workshop was Gasparo Miseroni, who worked for the Medici, the papal court and the other European courts. Members of the family moved to Prague in 1588 to work for Emperor Rudolph II (r.1576–1612) and established one of the most prolific workshops outside Italy. This was to last until 1684, when Ferdinand Eusebio Miseroni died. A vase and cover of about 1650–60 (plate 254) with gilt bronze mounts (probably later replacements for more precious enamelled silver-gilt mounts) has been ascribed to Ferdinand Eusebio. The vase is

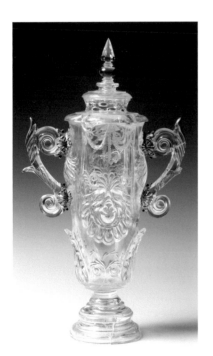

253 Altar cross and candlesticks by Valerio Belli
Rock crystal mounted in silver gilt with lapis lazuli, jasper, chalcedony and enamel
h.84.8cm (cross)
h.50.5cm (candlesticks)
Italian (Rome),
c.1515–20
V&A: 757–1864 and
M.61/61a–1920

left
254 Vase and cover probably by Ferdinand Eusebio Miseroni
Rock crystal mounted in gilt bronze, h.43cm
Bohemia, c.1650–60
V&A: A.22/22a–1977

richly decorated with grotesque masks on the front and back of the bowl, and projecting leaves. Beneath the lip are intaglio-cut festoons of foliage with birds and insects. Products of the Miseroni workshop were not only prized by contemporary princely collectors, but also by connoisseurs in the nineteenth century, such as the Rothschild family. This vase was acquired from their collection at Mentmore in 1977.

Amber

Amber was regarded as a medicinal, even magical substance, from ancient times up to the eighteenth century. Not only were its rich translucent red-gold colours felt to be supernaturally beautiful, but the nature of its actual formation was unknown at that time, and so its mysterious origins contributed to its apparent power. Amber is a fossilized resin, originally shed by conifers and deciduous trees tens of millions of years ago. The most common type of amber used for European works of art during the baroque period was Baltic amber, dredged up from the Baltic Sea, and found on the beaches or dug up from land nearby on the Baltic coast. The Baltic Sea is a relatively young sea (100,000 years old), and prior to its existence prehistoric trees grew on what is now the seabed, producing plentiful supplies of resin, which then fossilized over long periods of time into amber.

Amber has been carved since prehistoric times, and numerous objects worked in the material survive from the classical era, as well as the early medieval period. During the fourteenth century the material was used to make rosary beads, not only in centres near the Baltic coast, such as Bruges and Lübeck, but also in London. Amber beads have been found on the site of rosary-makers' workshops in the city of London at Baynard's Castle dating from this time. It was a valuable trading material; its retrieval from land or sea in the Baltic area was vigorously controlled by the Teutonic Knights, who ruled there during the fourteenth and fifteenth centuries. They enforced strict penalties on those who illegally claimed it, and retained a share of the profits from its sale.

During the sixteenth and seventeenth centuries amber was fashioned into highly wrought decorative works of art which could be given as diplomatic gifts. Friedrich Wilhelm, the Great Elector of Brandenburg (1620–88), commissioned amber objects both for his own collection and to be given to his peers in other European courts, such as the Habsburg Emperor Leopold II (1647–92) in Vienna. Such gifts evoked the place of origin of the material, as well as the skilled craftsmanship of the makers of the objects.

Most of the ambers in the V&A are of Baltic origin and date from the seventeenth century. In many cases amber is combined with other

materials, such as ivory or metal foil, which enhance the amber. Some objects made of amber are religious in subject matter and apparent function, while others are clearly secular. However all such works of art would have been primarily regarded as objects to be admired and treasured, perhaps in a cabinet of curiosities, rather than functioning as liturgical objects or to be used for everyday purposes, such as drinking vessels or writing boxes.

Most pieces of amber are small in size. For this reason many amber objects are mosaics of smaller pieces ingeniously fitted together, or mounted on a wood carcase. Amber is an organic material which is relatively easy to carve, of about the same degree of hardness as ivory. It can, however, fracture if a hidden fault is revealed, and it is also difficult to carve finely detailed high reliefs; the construction and design of amber objects often reflect the challenges posed by the material.

Gamesboards were on occasion made from amber. Small pieces of amber were ideal for the different colour squares required for a chess-board. One such gamesboard was made in Königsberg, in what was then Prussia and is now Russia (plate 255). It is dated 1620 and illustrates the varied techniques used for amber: painted metal foil placed under translucent amber panels shines through, revealing its design and at the same time enhancing the amber's lustre and colour. What appear to be minute ivory reliefs under other clear amber panels are in fact carved in white or creamy amber. This opaque form of amber is relatively rare and was highly valued. It has this appearance because when the prehistoric resin dried, bubbles of air or water were trapped within it, giving it a foamy quality. The gamesboard is mounted on a wood framework, onto which the amber panels have been fixed. It is unlikely this gamesboard was actually used, partly because amber is a fragile material and can be accidentally chipped. Its relatively undamaged condition suggests that it was treasured as a work of art above all.

Another object with an apparently secular function is a bowl made of panels illustrating the *Labours of the Months* (plate 256). This too dates from the seventeenth century, and may also have been made in Königsberg. The panels are carved in low relief, and are almost certainly based on engraved sources. The form of the bowl is reminiscent of Baltic goldsmiths' work of the same date, and indeed many amber objects of this date recall contemporary silver vessels, such as tankards.

255 Gamesboard
Oak, amber, ivory, tortoiseshell and metal foil, l.39.3cm
Prussia (Königsberg), now Russia (Kalingrad), 1620
V&A: W.15–1910

256 Bowl
Amber and metal mounts, h.7.5cm
Prussia (Königsberg), now Russia (Kalingrad), c.1650
Given by Dr W.L. Hildburgh, F.S.A.
V&A: A.9–1950

257 Crucifix
Amber and ivory on
wood core, silver gilt
halo, h.66.7cm
Polish, Gdansk (Danzig),
c.1680–1700
V&A: 4064–1856

Devotional objects, such as house-altars and crucifixes, might also be made of amber. One such crucifix (plate 257) combines amber with pierced ivory carvings showing scenes from *The Passion* on its base. The creamy-white ivory stands out against the warm amber background. Wood has been used as the carcase of both the base and the cross itself. The figure of Christ is carved in the round from one fairly large piece of amber, with two smaller pieces for the outstretched arms dowelled into the shoulders. This is not unusual: crucifix figures in other materials, such as ivory, marble and wood, are usually constructed with the arms as separate pieces dowelled in, because the span of the outstretched arms would necessitate much wastage if they were cut along with the rest of the body from what would have to be one block of material. The sculptural quality of the amber corpus here, and the fact that ivory is combined with amber on the base, strongly suggest that this piece was made in Danzig in the mid-seventeenth century.

A rare Sicilian amber in the V&A's collection depicts *The Rest on the Flight into Egypt*, the amber being set against a lapis lazuli background, the whole mounted in a gilt metal frame (plate 258). The richness of materials used enhances what seems to be a devotional object, although once again it must have been perceived above all as a highly wrought work of art. It is likely to have been made in the seventeenth century, and is probably based on an engraved source.

Most ambers are anonymous, and can only be attributed to an individual on the basis of stylistic comparisons with other works, or occasionally from contemporary documentary records. A number of artists working in the material were attached to guilds, and the records of their names can very occasionally be linked with surviving pieces. Christoph Maucher worked in amber and ivory in Danzig in the late seventeenth century. Exceptionally he was not a member of a guild, but seems to have carried out work for aristocratic and royal

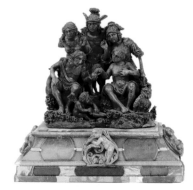

left
258 The Rest on the Flight into Egypt
Amber on lapis lazuli, slate backing and gilt metal
surround, h.27.5cm; Sicily, c.1680–1700
Given by Dr W.L. Hildburgh, F.S.A.; V&A: A.12–1950

right
259 The Judgement of Paris by Christoph Maucher
Amber on wood core, metal foil, h.19.7cm
Polish, Gdansk (Danzig), c.1690–1700
V&A: 1059–1873

patrons, including Friedrich Wilhelm, Elector of Brandenburg (1620–88). *The Judgement of Paris* is carved from a particularly large piece of amber (plate 259). This lively figure group, depicting a mythological subject, is typical of Maucher's style. Although it seems to be complete in itself, it once surmounted a large casket or cabinet, now lost; this is indicated by fixings underneath the base. Moreover, comparisons can be made with other amber figure groups on surviving cabinets. The base is adorned with carved amber putti and decorative elements formed by incised carvings of landscape scenes on panels of clear amber which are set on gold-coloured metal foil. The landscape designs are thus given a luminous quality, reflecting and amplifying the glowing colours of the amber.

Mother of Pearl

Due to its iridescent quality and rarity, mother of pearl was felt to be magical from medieval times onwards; it was thought to be apotropaic (to keep away harm), and to have medicinal benefits, not unlike amber, pearls, rhinoceros horn, and other exotic substances, also used for costly works of art. Mother of pearl is the lining of a mollusc shell; it was imported into Europe – usually to Venice in the first instance – from the Red Sea, the Persian Gulf or the Indian Ocean. From Venice, quantities were transported to Germany and the Netherlands, and dealers sold the raw material at fairs or markets, or direct to goldsmiths. In the Middle Ages mother of pearl was often used for rosary beads, and from the fifteenth century onwards reliefs of the material were mounted by goldsmiths as pendants, or set into handles for cutlery, swords or daggers. Some goldsmiths may have carved the substance themselves, or perhaps directly employed carvers in their workshops, but it is also likely that specialist mother of pearl workshops existed, although no record of these survives.

Many mother of pearl carvings were made in South Germany during the fifteenth century. Several hundred are recorded, but not all of these are extant. In the early nineteenth century Franciscan monks in Palestine (one of the places of origin of the material) made mother of pearl baptismal spoons and other small decorative objects with Christian subjects. These were sold to European visitors to the Holy Land (plate 260). Often, as here, they were partly painted in red and green. Earlier mother of pearl carvings also occasionally show traces of colour and sometimes gilding; usually, however, the pigments and gold have been lost with the passage of time.

Carvings in mother of pearl are frequently religious in subject matter, and indeed the luminous quality of the material probably imparted an additional spiritual meaning; some carved reliefs were attached to house-altars or

260 Baptismal spoon
Mother-of-pearl,
l.19.5cm
Palestinian, c.1800–30
Given by Mrs Matthews
V&A: A.57–1938

261 The Agony in the Garden
Mother-of-pearl,
h.6.5cm
South Germany,
c.1460–1500
Given by Mr T.
Whitcombe Green
V&A: A.46–1929

262 Alexander receiving the family of Darius by Jean Gaulette
Mother-of-pearl
French, c.1680–1700
Given by Alfred
Williams Hearn
V&A: A.34–1923

reliquaries, though the majority are pendants made either to be worn singly or as attachments to rosaries. Their generally small size and rounded shape dictated the scale of the objects for which they could be used.

The relief showing *The Agony in the Garden* (plate 261), made in South Germany and dating from the second half of the fifteenth century, almost certainly derives from an engraving. Many German engravings, especially those by the so-called Master ES, an anonymous German artist active in the fifteenth century, were used as sources for mother of pearl carvings. Because finely detailed work was not possible, the shell would be carved with a simplified composition, which might be adapted to fit its size and shape.

Jean Gaulette's *Alexander Receiving the Family of Darius* (plate 262), made in France and dating from the late seventeenth century, is an ambitious secular composition, again derived from an engraving, which has been skilfully adapted to the convex elliptical shape of the shell, showing the artist's virtuoso technique. This classical subject depicts Alexander the Great and the family of his defeated enemy Darius, who had asked Alexander to care for his wife and children as he lay dying on the battlefield. It is a pendant to the same artist's relief of the *Triumphal Entry of Alexander into Babylon*, also in the collection. Both reliefs may have been made to be mounted on a cabinet, and could even have formed part of a series showing the deeds of the Greek emperor. As well as being used for religious objects, mother of pearl was also valued by owners of cabinets of curiosities in the seventeenth and eighteenth centuries.

Jet

Jet is a fossilized form of vegetable matter found in seams in the earth; despite its proverbial black colour, it belongs to the geological group known as brown coal or lignite. It can be found in different parts of Europe and North America, but particularly rich quantities exist on the north coast of Spain, in the region near Santiago de Compostela, as well as near Whitby in Yorkshire. Both of these areas have been renowned for jet objects at different times. Jet from Whitby was generally mounted as mourning jewellery in the nineteenth century, while in Spain jet was employed above all for small sculptures and badges to be sold to pilgrims to the shrine of St James at Santiago from the twelfth century onwards. Like amber, jet was also thought to have medicinal and even magical qualities; an Arab physician at the court of Zaragoza in the late eleventh and early twelfth centuries (when much of Spain was under Muslim rule) noted that jet amulets were sometimes hung round the necks of infants to protect them

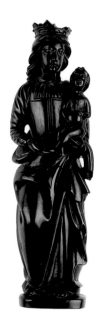

from the evil eye. This practice continued during the Christian era.

Due to its dark colour and potentially fractious texture, jet is normally carved in broad forms. The jet-carvers working in the region of Santiago were almost certainly not trained formally as sculptors, and the images are often stylized and repetitive; for this reason they are difficult to date precisely, and they are always anonymous. The jet-carvers belonged to a guild founded in the fifteenth century, and the guild's ordinances or rules dictated the quality of the raw material, as well as ensuring that the practice of carving it was restricted to guild members.

The *Virgin and Child* (plate 263) and *St James the Greater* (plate 264) were probably both made in the seventeenth century in Santiago de Compostela. These subjects, along with crucifixes and shells (the symbol of St James the Greater), were especially popular images with pilgrims. Here St James is shown with his shell and a drinking gourd hoisted on a walking staff, in his guise as a pilgrim himself. The relief is mounted in silver with a metal loop at the back so that it could be secured as a badge to a hat. The statuette of the Virgin was almost certainly once mounted on a socle. It is partly worked at the back, suggesting it was intended to be seen in the round.

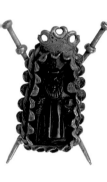

Coral

Coral is the name given to the skeleton formed by colonies of coral polyps and can be carved. Its organic shape and tendrils are often exploited by sculptors to produce unusual forms, although its brittle quality means that it cannot be worked in any detail. It was carved during the eighteenth century in Sicily, near one of the sources of the raw material. *The Assumption of the Virgin* (plate 265) shows how a popular devotional subject could be portrayed on a small scale, but with monumental effect. Such a piece would probably have been used as a devotional object.

Gem-Engraving and Cameos

The Victorian artist James Ronca earned his living carving cameos from gemstones and shell. For many years he produced the cameo portraits of Queen Victoria and Prince Albert that were mounted as the Royal Victoria Order, the Queen's personal award. A process set, given by Ronca to the Museum in 1874 (plate 267), demonstrates clearly how an engraver would set about cutting a shell cameo, from its earliest state, the shell itself, to the finished article – in this case a portrait of John Everett Millais RA, the pre-Raphaelite painter. The intermediate stages demonstrate how the carver cut a rough blank and sketched onto it a pencil outline of the portrait. Outer

left (top)

263 The Virgin and Child
Jet, h.13.4cm
Spanish (Santiago de Compostela),
c.1600–1700
Given by Dr W.L. Hildburgh, F.S.A.
V&A: A.10–1953

left (bottom)

264 St James the Greater
Jet with silver mounts
h.4.7cm
Spanish (Santiago de Compostela),
c.1600–1700
Given by Dr W.L. Hildburgh, F.S.A.
V&A: A.16–1953

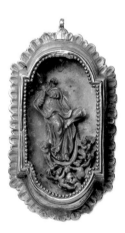

265 The Assumption of the Virgin
Coral in silver frame
h.4.5cm (figure)
Sicily, c.1720–30
Bequeathed by Henry L. Florence
V&A: A.31–1917

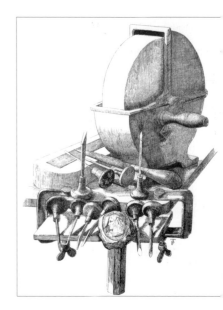

layers of the shell were then removed and the area surrounding the profile cleared right to the 'ground' or bottom layer of the shell. In the final state, fine details such as hair are silhouetted against the dark polished ground, while traces of the upper layer are retained to give colour and relief to the head.

Substituting a harder basic material in place of the shell, using different tools and more abrasive grinding materials, and adding a great deal more time to the process, the same principle can be applied to gemstone cameo engraving. Common to both is the partial stripping away of different layers of material to create an image. Miniature drills, chisels and gouging, grinding and polishing tools are used in the painstaking process (plate 266). The two cameos illustrated, the first abandoned by its engraver some way into the process (plate 268), and the second similar in design but completely finished (plate 269), give some idea of the type of work involved. Any naturally occurring layers of contrasting colours within the stone are exploited, being cut away or retained to form and enhance the image, as in this cameo of *Jupiter Ammon* cut from a stone with three layers (plate 270). Although by Ronca's time gem-engraving equipment was relatively sophisticated, this was in essence the method which had been used from antiquity for the carving of these miniature works of art.

The ancient gem-engravers selected materials for their durability, beauty and rarity, and different stones required different skills. Some were believed to have magical or medicinal powers, and many of the earliest carved gems had either practical uses as seals, or were kept as amulets with protective and healing properties. For intaglios, the macrocrystalline quartzes – rock crystal, amethyst, citrine, and smoky and rose quartz – were used. For cameos, engravers often favoured materials which displayed clear distinct layers of colours, such as layered agates, including onyx and sardonyx, and some jaspers.

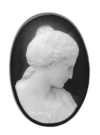

History, Use and Collecting

Some of the earliest engraved gemstones were made in ancient Greece and Egypt and date from around 800 BCE. The image of the sacred scarab beetle was carved in many stones to be worn as a charm, or with the underside incised as a seal, as in this Etruscan fifth or early fourth century BCE stone, later set as a ring (plate 271). Simple intaglios were made as seals, cut into the surface of cylinders of marble, and later the harder chalcedony (plate 272).

Cameo-carving developed in Greece, and Greek engravers took their skills to Imperial Rome. Large and elaborate cameos were prized, and portraits, imperial triumphs, religion and myth were among the subjects in demand. During the reign of the emperor Augustus (31 BCE–14 CE), magnificent state cameos and even whole vessels cut from a single stone and carved with many cameos were highly treasured. The best held great status and were worn as state or personal ornaments, or kept as prized jewels, the finest becoming famous and spawning many imitations. The craft declined in the fourth century CE, to re-emerge again in the Byzantine period, when cameos were cut from a variety of jaspers and other gemstones. From the thirteenth century in France and Italy, new cameos were being produced and, together with antique gems, were used in jewellery and to embellish the treasures of the Church, such as reliquaries, crosses and book covers. The *Shrine of the Three Kings* in Cologne Cathedral (plate 273), a highly precious large reliquary decorated with gold and enamel, is encrusted with over 300 engraved gems, many of them Roman.

During the renaissance many ancient skills were revived, among them the 'lost' classical art of gem-engraving. As with painting and sculpture, the revival began in Italy and spread from there to other European countries. Cameos and intaglios were made and acquired for many reasons. They were owned as single objects of private devotion or pleasure, as symbols of prestige and for personal adornment. The two cameos illustrated were probably made as aids to contemplation and prayer. In the cameo of the *Annunciation* (plate 274), dating from the first half of the thirteenth century, the confronted figures still evoke the stiff, formal style of a Byzantine mosaic, but the lily in the vase and the life-like exposed leg of the archangel point forward to the naturalism of the renaissance. In the later *Virgin and Child Enthroned* (plate 275) of about 1475–1500, the elaborate gothic architecture of the canopy suggests a northern European origin, and as with many engraved gems the image is probably taken from an earlier painting or engraving.

271 Cameo of a scarab beetle, intaglio of a faun on reverse
Amethyst, in later gold setting, h.14.5mm
Etruscan, c.450–300 BCE
Given by John Webb
V&A: 8765–1863

272 Intaglio stamp-seal of two figures holding a cross
Chalcedony, h.29mm
Persian (now Iran), c.400–500
Given by Alfred Behrens
V&A: A.36–1928

left (top)
274 Cameo of the Annunciation
Layered agate (sardonyx), in later gold setting, h.33.5mm
Italian (Venice), c.1250
V&A: 7552–1861

left (bottom)
275 Cameo of the Virgin and Child enthroned
Layered agate (sardonyx), in later gold setting, h.32mm
Netherlandish or German, c.1475–1500
V&A: 7540–1861

273 Shrine of the Three Kings
Copper, gold, gilded silver, enamel,
gemstones (unengraved and
engraved), h.1.53m
German (Cologne), c.1200
Cologne Cathedral
© Dombauarchiv Köln, Matz und
Schenk

**276 Intaglio of the
Judgement of Paris
by Valerio Belli**
Rock crystal, h.51mm
Italian, c.1500–45
Given by Dr W.L.
Hildburgh, F.S.A.
V&A: A.23–1942

**277 Intaglio of the
Adoration of the
Shepherds
by Giovanni Bernardi**
Rock crystal, with gold
and ultramarine on
reverse, h.88mm
Italian, c.1525–50
V&A: A.12–1938

Rock crystal intaglios were often combined with precious metals in the form of sumptuous caskets, candlesticks and vases. The *Judgement of Paris* (plate 276), by the great rock crystal engraver Valerio Belli, is linked to a group of bronze plaquettes of the same subject. The medallist and gem-engraver Giovanni Bernardi's *Adoration of the Shepherds* (plate 277) shows how engraved rock crystals could be enhanced: analysis has shown that a soft paste of gold, ground and mixed with wax and honey, was pressed into the cavities on the reverse. A second layer of ultramarine and wax completes the splendid effect.

In the secular world, carved gems were collected and commissioned by rich and powerful patrons and rulers such as Isabella d'Este (1474–1539) and the Medici in Italy, and later Philip II (1527–98) in Spain, Elizabeth I (1533–1603) in England, Emperor Rudolf II (1552–1612) in Prague and Henri IV (1553–1610) in France, who wished to be seen as potent and enlightened figures in the mould of the great classical emperors. Part of the panoply of prestige, often mounted in jewelled settings, carved gems were given as diplomatic or courtly gifts, or kept as small objects for private devotion

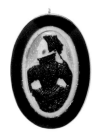

and enjoyment. This cameo portrait of *Elizabeth I* (plate 278) is one of about 30 of the Queen which survive, many apparently originating from the same specialist workshop. In her right hand Elizabeth holds a sieve, an emblem present in some of the painted portraits of her, and thought to symbolize her attributes of chastity or the power of discernment. The portrait of *Philip II* (plate 279) may be the work of Leone or Pompeo Leoni, or Jacopo da Trezzo, all sculptors, medallists and gem-engravers who worked for the Spanish king, Philip II. A medal of Philip II by da Trezzo can be seen in *Medals and Plaquettes*. Although close in date of production, these two gems differ a great deal in design and character: the cameo of Elizabeth is a cipher, stiff, splendid and ornate yet ultimately detached – a mere badge of power. The cameo of Philip is a true portrait, full of the dignity of observed character and life – a piece of miniature relief sculpture.

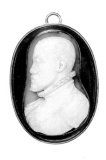

Thomas Howard, 2nd Earl of Arundel (1585–1646), a connoisseur and purchaser of antiquities, formed one of the first English gem collections. He bought ancient, renaissance and contemporary carved stones, some once owned by the Gonzaga, dukes of Mantua, in Italy. A small number of Arundel gems are now in the Museum's collection. *A Pair of Lovers, possibly Mars and Venus* (plate 280) is traceable back to Arundel via the collection of George Spencer, 4th Duke of Marlborough (1739–1817), who acquired the Arundel gems by sale and descent. The dramatic yet enigmatic scene is common to a group of gems, and stems from a bronze plaquette by Giovanni Bernardi. *Lady in a Veil* (plate 281) was also most probably acquired by the Duke of Arundel, before passing to Marlborough. After the sale of the Marlborough gems in 1899 it disappeared from view, to resurface in the 1970s when it was bought by the Museum. In this highly sophisticated late renaissance work, which is part of a small group of similar cameos, the unknown virtuoso engraver has cut the bust entirely from the dark upper layer of the stone, using the contrast with the white lower layer to full effect, and combining matte and polished areas of carving to evoke the contrasts between flesh, fabrics and hair.

During the late eighteenth and early part of the nineteenth centuries, neo-classicism – a renewed interest in the classical arts – permeated all aspects of the fine and applied arts, from painting and sculpture, through architecture, furniture and other domestic designs, fashion and jewellery. Sculptors turned towards the subject matter and style of the classical masters, and artists such as Johann

left (top)
278 Cameo portrait of Elizabeth I
Layered agate (sardonyx), in later gold setting, h.51mm
Italian, French or English, c.1575–80
V&A: 1603–1855

left (middle above)
279 Cameo portrait of Philip II possibly by Leone Leoni, Jacopo da Trezzo or Pompeo Leoni
Layered agate, in later silver-gilt mount, h.48 mm
Spanish, c.1570–80
V&A: 2628–1855

left (middle below)
280 Cameo of a Pair of Lovers, possibly Mars and Venus after Giovanni Bernardi
Layered agate (sardonyx), in later gold setting, h.42mm
Italian, c.1550–1600
V&A: A.25–1921

left (bottom)
281 Cameo portrait of a Lady in a Veil
Layered agate (sardonyx), h.72mm
Probably Italian, c.1550–1600
Purchased with the aid of Richard Falkiner and Thomas Heneage
V&A: A.45–1978

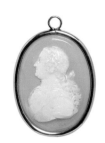

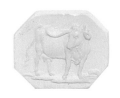

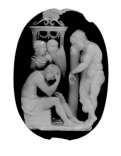

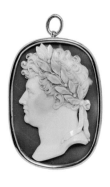

Lorenz Natter, Nathaniel Marchant and Edward Burch studied and applied the principles of the gem-engravers of antiquity, settling in Rome where they could see and copy antique sculptures at first hand.

In 1754, Natter, the German-born goldsmith, medallist and engraver of seals and gems who cut this portrait of *Ferdinand, Duke of Brunswick* (1721–92) (plate 282), published a treatise on the methods used by the gem-engravers of antiquity. Burch, who aimed to emulate the great Greek and Roman engravers, was one of the most celebrated gem-engravers in eighteenth-century England and produced works of great delicacy, like this intaglio seal stone of a *Cow* (plate 283). Burch may also be the engraver of the cameo of *Achilles Mourning for Patroclus* (plate 284). This cameo is an illustration of how, throughout the renaissance and later periods, popular mythological subjects persisted and were returned to by engravers. This image of a scene from the Trojan War, which occurs on a number of cameos of different periods and is sometimes known as 'The Tears of Achilles', was taken from a renaissance cameo, which in turn was a copy of a Roman relief. Giuseppe Girometti, a dominant figure in the first half of the nineteenth century, also worked in Rome and commanded high prices for his grand cameos of heads of state, such as this portrait of George IV (1762–1830) (plate 285).

The Grand Tour, that essential part of a gentleman's education, opened up the newly excavated sites of classical Italy and the treasures of the renaissance to a wealthy, and increasingly informed audience. Introduced to such artists while on the Tour, some Grand Tourists became their patrons, supporting them and taking their work back to place in cabinets alongside their family portraits and in their great libraries. Enthusiasm for hunting down and acquiring antiquities and modern versions of them, including the easily portable carved gems, flourished, and important collections were formed. These include that of the Duke of Marlborough in England, who owned over 700 gems, 230 of them from the Arundel collection, as well as that of the Empress Catherine II (1729–96) in Russia, who owned 10,000. Both were also patrons of contemporary engravers.

At one point gem-engravers to Catherine the Great, William Brown and his brother Charles worked in London and at the French and Russian courts. Their stones, often simply signed 'Brown' and so not attributable to one particular brother, are characteristically on a minute scale and deftly realized. In this tiny cameo of *Venus*

rising from the sea (Venus Anadyomene) (plate 286), the skill of the carver and his exploitation of the material is consummate. The gem consists of a 'sandwich' of layered jasper. The top greenish layer has been partially removed to reveal the figure of Venus cut out of the white middle layer. The dolphin and semi-translucent waves are cut from what remains of the top layer, and delicate traces have also been retained to colour Venus's hair and wreath. While the pose and iconography are standard for this subject, the Brown cameo is intimate and fresh, a completely successful miniature sculpture in a stone measuring just 29mm by 12 mm.

Dating Gems

The reliable dating of carved gems has often proved problematic; relatively few are signed, and their small size, as well as the similarities between ancient and modern methods of manufacture, can be confusing. Among the thousands of gems offered by dealers to eager collectors of antiquities were many that appeared ancient but were in fact modern copies. The result was sometimes embarrassment and even scandal.

Benedetto Pistrucci was a Roman gem-engraver and medallist who settled in London in 1815 and eventually became Chief Medallist at the Royal Mint, designing the official Coronation medals for King George IV and Queen Victoria. In 1812 the respected antiquary and collector Richard Payne Knight (1750–1824), who left his collection of gems to the British Museum, paid an unscrupulous dealer 500 guineas for a beautiful fragmentary *Head of Flora* (plate 287), firmly believing it to be a fine ancient piece. Payne Knight was outraged and incredulous when Pistrucci recognized the gem as his own work. The proud owner found it impossible to believe that the gem was not ancient, repeating angrily to Pistrucci, 'This is the finest Greek cameo in existence'. The disagreement continued between the two men, despite Pistrucci's being able to point to a hidden identifying mark in the carving, and later engraving another similar 'fragment' to prove his authorship. This minuscule cameo of a baby girl (plate 288), signed by Pistrucci, portrays the infant daughter of his friend Archibald Billing (1791–1881), a doctor and gem enthusiast who wrote a book on gem-engraving, and himself modelled the wax from which the cameo was taken.

A scandal on a larger scale blew up around the collection belonging to the wealthy Polish Prince Stanislas Poniatowski (1754–1833). When a number of Poniatowski's gems were put up for sale in 1839 it became clear that the elderly prince had either been duped into buying or had knowingly commissioned around 2,500 intaglios purporting to be the work of the greatest classical engravers, many with spurious signatures. These were

286 Venus rising from the sea (Venus Anadyomene) by William or Charles Brown
Layered jasper, h.29mm
English, c.1770–1800
V&A: 7913–1862

287 Head of Flora by Benedetto Pistrucci
Layered agate, h.23mm
Italian, c.1810
British Museum

288 Cameo of a baby girl by Benedetto Pistrucci
Layered agate, h.18mm
English, c.1820–50
Bequeathed by Miss A.F. Long
V&A: A.4–1940

289 Intaglio of the wooden horse being drawn into Troy
Cornelian, with filigree gold mount, w.52.5mm
Italian, c.1800–30
V&A: 946–1853

below left
290 Tray from a set of 24 containing 1,251 casts of gems, and two accompanying manuscript catalogues by Bartolommeo and Pietro Paoletti
Plaster, paper and wood,
d. (tray) 320mm
(handlists) 215mm
Italian, c.1820
Given by Lady Campbell
V&A: repro.1864-156,
tray 14

far right (top)
291 'Book' of 50 casts of gems from the Royal Collection, Berlin
Plaster, paper and wood,
d.220mm German,
c.1890
V&A (Sculpture Section)

far right (bottom)
292 Tray from a set of four cabinets containing 15,800 casts of gems by James and William Tassie
Sulphur, paper and wood, d.295mm
English, c.1790
V&A: 748 to c–1870
tray 218

in fact modern fakes, made by a small group of engravers living in Rome at the time, probably including the renowned Luigi Pichler and Giuseppe Girometti. The intaglio of the wooden horse being drawn into Troy (plate 289) is a typical example of the style of many of the Poniatowski gems, with its exaggeratedly lengthy lines and self-consciously 'noble' style. The Poniatowski affair did much to undermine confidence in the market for carved gems; after the scandal broke, Poniatowski gems changed hands for a few shillings – the price of their gold mounts as scrap. Ironically, had it been known that they were the work of two of Rome's most respected contemporary engravers, their true value would have been much higher.

Reproductions of Gems

The practice of making casts of engraved gems, and thus of circulating their images, was common from ancient times, and became widespread among Roman connoisseurs in the eighteenth century. In London from the 1760s onwards, the Scotsman James Tassie, and later his nephew William Tassie, sold casts of engraved gems made from a hard vitreous paste which James had helped to develop and which could be coloured to resemble gemstones, as well as in 'enamel' or white glass, and the cheaper sulphur and plaster. Demand was huge, and Tassie built up a collection of moulds taken from hundreds of cabinets all over Europe, from which he made his casts. Eventually the Tassie catalogue encompassed over 20,000 items. A set was ordered by Catherine the Great, and in 1791 R.E. Raspe (1737–94),

author of *The Adventures of Baron Münchhausen*, produced a two-volume catalogue of the collection.

The sale of casts of gems boomed as they became an essential souvenir of the Grand Tour, and firms set up in business to sell boxes of trays with identifying lists (plate 290), or casts in boxes disguised as books for the library shelf (plate 291), but none would rival the comprehensive scope of Tassie. Intellectuals and writers caught the fever: Goethe, Byron, Shelley and Keats – who used a head of Shakespeare to seal his letters and was inspired to write a sonnet on a gem of Leander given to him by a friend – were all enthusiasts and bought the inexpensive casts to keep about them. Today the reproductions form an important archive of the many gems which were once known and have now disappeared from view. One such for many years was the fine cameo of the *Lady in a Veil* (see plate 281). Appearing among Tassie's casts and listed as in the collection of Baron Stosch (plate 292), its subsequent whereabouts were unknown until it emerged on the London art market in 1978 and was acquired by the Museum.

Shell Cameos

Shell cameo-cutting, a far quicker and easier process, using cheaper basic materials than gem-engraving and with generally more crude results, has a shorter history, emerging in the sixteenth century in Italy and France, and attaining huge popularity in the 1800s. By the mid-nineteenth century, virtual mass production for the Italian tourist trade of often poorly produced gems, as well as the cheaper shell cameos, was impoverishing the image of gem-engraving, and the craft was in decline. Huge numbers of copies of the most popular subjects proliferated and could be bought for very little. Despite this, the best shell cameo-carvers still produced work of fine quality, as shown by this pair of souvenir portraits by Giovanni Dies (plate 293), Raffaele Pistrucci's head of the Duke of Wellington (plate 294), and Ronca's gossamer-fine head of Millais (see plate 267).

In 1899, the Marlborough collection, with its small nucleus of Arundel gems, was sold and scattered. The great private aristocratic collections formed in the eighteenth and nineteenth centuries are almost all now dispersed, many gems finding their way into public collections where they can be seen. Other once-famous engraved gems are lost, known for the moment only by their dim ghosts which survive among the crowded drawers of Tassie's casts. **LC, NJ and MT**

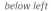

below left

294 Cameo of Arthur Wellesley, 1st Duke of Wellington
probably by Raffaele Pistrucci
Bullmouth helmet shell (Cypraecassis rufa), h.51mm
English, c.1840
V&A: A.25–1977

below

293 Cameos of unknown woman and man
by Giovanni Dies
Bullmouth helmet shell (Cypraecassis rufa), in original leather case, h.52mm (each)
Italian, c.1800–35
Given by Professor and Mrs J. Hull Grundy
V&A: A.118 and A.119–1978

Chapter 11

PLASTER MODELS, PLASTER CASTS, ELECTROTYPES AND FICTILE IVORIES

The use of what we now term plaster in sculpture, painting and architecture can be traced back to Egyptian times, when craftsmen used it to coat walls which would then be painted, and for making casts of body parts or statues. It is most likely that it was in use before this time across the world, with different mixtures and for different purposes, because the core ingredients have always been readily available, inexpensive, easy to use and durable. The V&A's collection of plaster sculptures covers a wide range of styles, periods, uses and origins. The largest single group of plasters is that of reproductive casts made and collected by the V&A from the nineteenth century onwards, which will be discussed in detail later in this chapter.

Plaster can be used in a wide range of contexts, forming a vital role in the production of bronze sculptures and medals as the initial model, or as an intermediate stage between a clay or wax model and the cast bronze. It is used for architectural decoration, as moulds in relief or in the round, as well as for finished works of sculpture. Plaster casts have been taken of people and animals, both living and dead. Death-masks were often used for tombs or for posthumous portrait busts, such as the bust illustrated here of the eighteenth-century politician Sir George Savile (plate 295). One visitor to the studio of the sculptor Joseph Nollekens commented on the plaster mask taken after Savile had died that 'the veins were still pulsing with the last beats of his charitable heart'. Casts of various parts of the human body were also taken from living subjects and used for a variety of reasons, including portrait sculpture, but also as examples to follow in creating modelled figures in clay when a life figure was unavailable (plate 296).

295 Sir George Savile by Joseph Nollekens
Marble, h.75.9cm
English, 1784
Given by Dr W.L. Hildburgh, F.S.A.
V&A: A.16–1942

296 The right hand of Sir Joseph Edgar Boehm by Edouard Lanteri
Plaster and wood,
l.19cm
English, c.1882
Given by the Executors of the late Sir J.E. Boehm
V&A: 1892–125

297 Roundel in the form of a stylized vine leaf
Stucco, h.15cm
Iraq, 836–80
V&A: A.87–1922

The term plaster has changed in meaning and context throughout its history, and its identification is complicated by the use of the terms stucco and scagliola to describe some plaster works. In terms of architectural decoration, plaster, stucco and scagliola can be differentiated by the additions and methods used for changing the properties – in particular the strength – of the mixture. Alternatively it can be described in a more art historical way: stucco and scagliola were materials used for architectural interiors and decoration, while plaster was a less refined material employed in architecture until the introduction of the Italian stucco. However this is problematic, because from the nineteenth century onwards the term stucco ceased to be used to describe contemporary architectural decoration, and was only used to describe historical plaster decorative work. Scagliola is a term still in use today to describe a material and a process that imitates a wide variety of different types of stone, as well as its use in the past as a casting material. Different ingredients are used, including pigments to create a material made for a wide range of functions, from plinths and pedestals to floors and fireplaces.

Plaster is most commonly made from one of two stones, gypsum rock (calcium sulphate) or limestone (calcium carbonate). However it is impossible to tell from which of these stones a particular example of plaster is made without complex scientific analyses. The description of works as either stucco or plaster is therefore usually because they are historical or traditional terms that have been passed down over time. Gypsum rock is used to make what is also termed plaster of Paris, this name originating from the large gypsum deposits in the hills around Paris. Gypsum can be found all over Europe, and has traditionally been used for making sculpture models and reproductive casts.

Plaster for modelling and moulding is traditionally made by first heating the gypsum rock or limestone to a very high temperature to drive off moisture, but without burning the material. The resulting material is then ground to a fine powder before being mixed with water. Many different ingredients could be added to the mixture, depending on the requirements. These include hair, glue, resin, oils, alcohol, sand and marble dust, as well as chemical compounds such as alum, which could lengthen or shorten the drying time of the resulting plaster or change its texture or durability.

Decorative plaster

There were two main methods used to create architectural decorations in relief and in the round. One was to carve the material once it was in place on the wall or ceiling, either while it was still moist or after it had dried.

The other was to create a mould, which could be used in two ways. It might be placed over the plaster while it was still moist, after having been applied to the wall or ceiling, or liquid plaster could be poured into a mould and left to dry before being attached to its architectural context. In order to stop the mould from sticking to the plaster, a layer of soap, varnish, oil or a similar releasing agent was applied to the mould beforehand. Specialist plaster craftsmen developed their own recipes through experience and experimentation, and usually worked alongside an architect or sculptor who had been commissioned to complete a piece of work.

Some of the earliest examples of plasterwork described as stucco in the V&A's collections are in the Middle Eastern collection, and come from a ninth-century Iraqi palace-city in Samarra (plate 297). These objects formed part of the decoration of the palace and were carved from gypsum plaster. The plaster would be applied to the walls in successive layers, the topmost layers being the most pure and refined of all the mixtures, and then carved with tools similar to those used in wood-carving.

Carved plaster was used extensively to decorate the Alhambra, the only surviving Islamic palace in Spain. The palace was begun by 'Abd al-Rahman I' in Granada in the 880s. It was still being worked on when the Christian monarchs Ferdinand and Isabella conquered Granada and saw the forced surrender of the last Muslim territory in Spain in 1492. The plaster fragments illustrated are symptomatic of the problems of identifying plaster as a material used both for decoration and reproduction. Some plasters said to be from the Alhambra are in fact nineteenth-century casts, while others are original pieces removed from the palace. Only analysis of the plaster and the pigments can confirm which is which, because mere observation is not enough to distinguish them. One of the fragments illustrated here (plate 298) has been identified as an original piece of stucco from the Alhambra. The other fragment (plate 299) is almost certainly a later cast that was subsequently painted to resemble the original.

In Italy the practice of plasterwork was rediscovered following excavations of Roman ruins around the turn of the fifteenth century. Whole rooms were revealed to have plaster-coated walls painted with figures and patterned decorations. Giovanni da Udine, one of Raphael's assistants, apparently experimented at length with different methods and ingredients until he produced a material that was almost identical to that found in the ruins. Giorgio Vasari's treatise on techniques, first published in the mid-sixteenth century, includes a chapter entitled 'How works in White Stucco are executed, and of the manner of preparing the wall underneath for them, and how the work is carried out'. According to Vasari, White

298 Panel with carved geometric designs, and an inscription in Arabic: 'There is no conqueror but God', from the Alhambra, Granada
Plaster, h.56cm
Spanish, 1330–50
V&A: A.176–1919

299 Panel with painted foliage designs, cast from the Alhambra, Granada
Painted plaster, h. 31cm
Spanish, probably
c.1830–70
Given by Sir Henry
Howorth, through The
Art Fund
V&A: A.10-1913

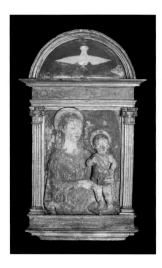

**300 Virgin and Child
after the marble by
Domenico Rosselli**
Stucco, h.61.5cm
Italian, 1575–1600
V&A: 6–1890

**301 Virgin and Child
after the lost marble
by Donatello**
Stucco, h.95.3cm
Italian, c.1450
Given by Dr W.L.
Hildburgh, F.S.A.
V&A: A.1–1932

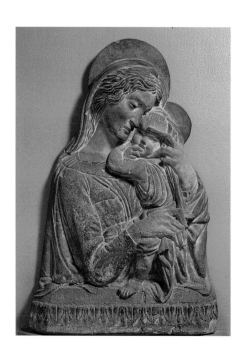

Stucco was made from marble dust combined with powdered crystalline limestone, used for decorative purposes and was also called stucco-duro. Baldwin-Brown, who annotated a 1907 edition of Vasari's treatise, stated that the words stucco and plasterwork were interchangeable. Stucco could, however, be used to describe refined white plaster, and was therefore distinct from the plaster used for rougher under-layers. Vasari recommended using a wooden mould for white stucco before it had fully hardened, but was not too soft, in order to realize the decorative pattern. For higher relief or figurative work, Vasari noted that iron or wood armatures should be used to support the stucco.

Marble originals were often reproduced in plaster to be used as domestic interior decorations from the fourteenth century onwards, especially in Italy. Stucco, terracotta and papier-mâché reproductions of works by recognized masters were sold in large numbers, at much lower cost. The two pieces illustrated here (plates 300 and 301) are likely to be the products of this demand, as they have both been identified as versions of marbles by the renowned Florentine sculptors Domenico Rosselli and Donatello.

For decorative schemes which required figures in the round, the use of plaster reached a peak in Italy in the seventeenth century. Plaster was ideally suited to elaborate decorative schemes, as it allowed figures and scenes to be depicted in high relief and in the round; these could be highly coloured or gilded. They were displayed at various heights within the interior owing to plaster's relative lightness in comparison with the far weightier marble. Gianlorenzo Bernini combined plaster with bronze and different coloured marbles for the *Cathedra Petri* in St Peter's in Rome to achieve complex scenes, using plaster to manipulate figures into positions that would have been too delicate or too high up in the composition for marble or bronze. The scene created was like a three-dimensional, highly coloured and gilded painting that extended into the viewer's space (plate 302).

The art of the stuccoist seems to have been introduced into Britain during the reign of Henry VIII, when he employed Italian craftsmen to assist with the building of the royal palace of Nonesuch when construction started in 1538. This was distinct from the art of the plasterer at the time, plaster being known as a less refined mixture, used as a building material and made of lime, sand and water, often using chopped animal hair to provide strength. The plaster introduced by

the Continental specialists contained marble dust to create a more refined substance that, because it was not as strong, was placed over armatures made from wood or metal.

Plaster used for interior decoration in Britain was until the eighteenth century less elaborate than that produced in Italy, with many repeating patterns in low relief, sometimes depicting stylized figures and animals, but most often with leaf or flower motifs. The architect Robert Adam was a pioneer in creating new and fashionable styles of plaster decoration, having spent four years in Italy before returning to Britain. Neo-classicism represented a revival in interest in Greek and Roman architecture and decoration, which developed following archaeological discoveries at sites such as Pompeii during the mid to late eighteenth century (plate 303). Adam employed his own

firm of plasterers, and even patented his own recipe for the plaster he used in his decorative schemes. This fashion for plaster decoration led to the increased use of mass-produced moulds, and by the nineteenth century architectural plasterwork had become industrialized and was less creative.

Plaster models

Another major use of plaster throughout the history of the making of sculpture has been to make models from which a marble could be carved, or a bronze cast. Sculptors would use plaster to make the model from scratch, or model in clay or wax and subsequently cast it in plaster. Alfred Stevens' two full-size plaster models for the monument to commemorate the Duke of Wellington were created to be placed in St Paul's Cathedral for inspection by members of the government, who had commissioned the monument in 1858 (plates 304 and 305). These were meant to be presentation models, made in addition to the models Stevens had to make for the bronze-casting process. Stevens first had to create an armature of brick and wood that would support the plaster. The full-size models were finally finished in 1867, by which time Stevens had convinced the government that it was not necessary to exhibit them in the cathedral. The final work could therefore be started using the models already constructed. Stevens had great difficulty keeping his models in good condition, and at one point they cracked badly, most probably because they were stored in a temporary, uninsulated metal hut. This incident exemplifies the brittle nature of plaster, which can be

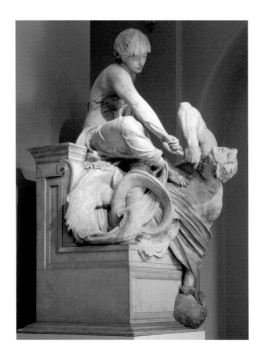

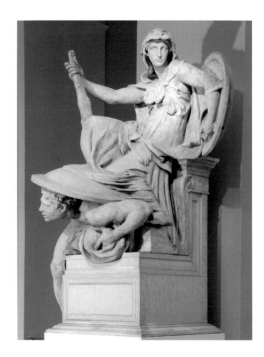

left
304 Truth and Falsehood by Alfred Stevens
Plaster, h.228cm
English, c.1866
V&A: 321A–1878

right
305 Valour and Cowardice by Alfred Stevens
Plaster, h.236cm
English, c.1866
V&A: 321B–1878

easily chipped or damaged, as well as being susceptible to changes in humidity and temperature.

Small plaster models were much easier to handle and keep safe from damage, as well as being the traditional size for initial presentation pieces. In the late nineteenth century Auguste Rodin used plaster to experiment with different figures and combinations of figures. The extensive collection of plasters found after his death indicates that for Rodin plaster was more than just an intermediate stage in the creation of a full-size sculpture. Rodin modelled the plaster into busts and figures as well as detached body parts such as hands and legs (plate 306). He then used wet plaster, wax or clay to alter the original model or attach new body parts. The entire model was then used to create a finished work in bronze or marble (see *Bronze and Lead*), or a new plaster model would be cast from it, or it might be dipped in fresh wet plaster to provide a uniform surface. Different versions of the same subject may therefore exist, with varying degrees of detail and changes in texture. The plaster could be worked and reworked, and each stage saved, in a way that clay or wax could never be. Rodin kept versions to illustrate each stage, showing that plaster did not have to be just one intermediary model, but could be etched, filed, carved, modelled with clay, dipped, cast and even highly polished.

After about 1900, European and American sculptors started to become interested in using materials not traditionally associated with sculpture, as well as using traditional materials in new and different ways. Plaster was still employed as an intermediary stage for the creation of marble and bronze works, as well as in the decoration of interiors and exteriors, however it had rarely been used to create a finished work of art. This is probably because of its status as both an ornamental and a reproductive material.

Of the two pieces illustrated here, both by Gilbert Bayes, one is cast in bronze and the other is made of plaster but finished to look like bronze (plate 307). The sculptor Charles Sergeant Jagger, in his 1933 handbook *Modelling and Sculpture*, devotes a chapter to the 'Bronzing of Plaster Models', indicating that this was still a common practice in the twentieth century, as it had been in the eighteenth century. At that time artists such as John Cheere produced bronzed plasters in order to supply a demand for reproductions of popular contemporary and historical sculpture.

left

306 Drawer of plaster body parts made by Auguste Rodin

Musée Rodin, Paris

307 The Lure of the Pipes of Pan by Gilbert Bayes

(top)
Bronze, h.47cm
English, 1932
Given by The Gilbert Bayes Charitable Trust
V&A: A.3–2004

(bottom)
Plaster, h.48.2cm
English, 1932
Given by The Gilbert Bayes Charitable Trust
V&A: A.4–2004

Bronzing was, however, anathema to many European sculptors in the early twentieth century, who believed that a sculpture conceived in one material should not be transferred to, or made to resemble, another material. Academic sculptors continued to use plaster as an intermediary stage in the production of bronze and marble works; however at the same time other sculptors started to carve directly semi-hardened plaster, instead of modelling it while soft. Other new materials, such as concrete, cement and artificial stone were also increasingly available to be carved or cast. Plaster has continued to be used both sculpturally and decoratively, but its use as a reproductive material dwindled with the increased use and sophistication of photography.

Plaster Casts

The word 'reproduction' conjures up an image of something that is a copy, an imitation, possibly a substandard duplicate of an original work of art. But reproductions of sculpture and architecture have formed an intrinsic part of the Museum's collections from the outset, and these plaster cast and electrotype reproductions are far from inferior. The original motivation for adding reproductions to the Museum's collections was two-fold. Reproductions were acquired from the 1850s up to the early twentieth century to fill gaps in the collections of so-called 'original' works of art, but they were also collected as important examples in their own right. This was especially the case with large-scale monuments such as the twelfth-century façade of the Cathedral at Santiago de Compostela, the 'Pórtico de la Gloria', moulded and cast on behalf of the Museum in 1866 (plate 308).

308 Plaster cast by Domenico Brucciani of Master Mateo's façade of the Pórtico de la Gloria on installation in the Architectural Courts in 1873
Plaster, h.10.5m
c.1866
V&A: 1866–50

309 The production of a cast of the head of Queen Elizabeth I from the effigy by Maximilian Colt in Westminster Abbey (1605–7)

The ever-increasing demand for students, as well as interested individuals, to have access to copies of the most important works of classical and renaissance art led to the extensive use of plaster of Paris by a host of manufacturers (plate 309). Although the collecting of plaster casts of antique sculpture became popular among connoisseurs as early as the mid-sixteenth century, the nineteenth century saw the mass appeal of plaster reproductions.

The Making of Plaster Casts

Before a plaster cast could be made, a negative mould had to be taken of the object to be replicated. This could be taken from another cast, or from the object itself. The initial mould was usually made by mixing wax with gutta-percha, a rubbery latex product taken from tropical trees. These two substances formed a mould that had a slightly elastic quality, so that it could easily be removed from the original object. When mixed with water, plaster can be poured into a prepared mould, allowed to set, and then removed to produce a finished solid form. The resulting plaster cast is an exact replica of the original object, and is usually obtained by using a complex series of piece moulds. These piece moulds, or sections of moulds, were made up in a sequence and held together in the 'mother mould' to form a mould of a whole object. This was the only way that such a complex three-dimensional object could be replicated, as piece moulds can be easily removed from each cast as it is made. The moulds would be coated with a separating or parting agent to prevent the newly poured plaster sticking to them. The smooth liquid state and slight expansion while setting allowed the quick drying plaster to infill even the most intricate contours of a mould. The piece moulds were treated with linseed oil to prevent them from absorbing the plaster when poured.

Mr Bullen, who was formerly a pensioned Sergeant of the Royal Engineers, was Foreman of Moulders at the South Kensington Museum for 12 years around the 1880s. During that time he was responsible for overseeing the taking of casts on behalf of the Museum from a number of monuments. He was sent to India, and under the instruction of Lieutenant

Most pieces of sculpture have 'undercuts' – awkward shapes that make it difficult to remove the original object after the casting process without causing damage. The solution to this problem is to make the mould in several individual sections, as illustrated here (plate 309).

Sections of the mould are shown partly assembled. Once fully assembled, the inside of the 'mother' mould is coated with a separating or 'releasing' agent to prevent the pouring plaster from adhering to the surface of the mould.

Once the pouring plaster has set, the sections of the mother mould can be disassembled to reveal a duplicate cast of the original object. The resulting cast is removed from the mould. Seams on the surface of the cast, caused by the joins between the sections of the mould, would then be smoothed.

Versions of this cast were included in the *Catalogue of Plaster Casts* (1939), issued by the Museum's cast-selling service, and were available at a cost of 10s 6d (52p).

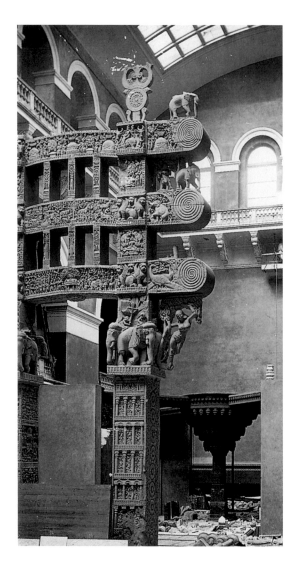

H.H. Cole, Superintendent of Archaeological Survey of India, North West Provinces, made moulds and casts of the eastern gateway of the Sanchi Tope, the massive Buddhist monument at Sanchi in India. Originally displayed in one side of the Architectural Courts (the original name for the Cast Courts), unfortunately this cast no longer survives (plate 310). Bullen was also responsible for moulding the cross-shafts at Irton, Gosforth and Wolverhampton. In 1881 he was asked by Museum officials to detail how he might go about making a cast, and his explanation provides a valuable insight into contemporary methods of casting:

I should first of all get my materials, plaster, & lime, then commence at the base, or at any point of the figure that was desirable to make up any mould in pieces so that it would come off easily, care being taken that the mould is made of sufficient thickness, not allowing any wood to be placed in it. When dried and oiled, the mould placed together in its case would last for years & be fit to take any number of casts from.

310 Plaster cast of the eastern gateway of the Sanchi Tope in the eastern Architectural Court in 1872
Plaster, h.10.2m
c.1870
V&A: 1870–16

right
311 Plaster cast of Michelangelo's Madonna and Child (Bruges Madonna)
Painted plaster, h.128cm
c.1871
V&A: 1872–62

The fine lines or seams that stand proud of a cast show the joins where the various tight-fitting piece moulds have been held together in the mother mould to produce the final cast. The casting lines on the Museum's cast of Michelangelo's *Bruges Madonna* are clearly visible (plate 311). These were possibly intentionally left to illustrate the complexity of the casting process, the authenticity or accuracy of the likeness of the reproduction to the original, and the overall skill of the caster. Unlike the majority of 'finished' plaster casts, these lines have not been smoothed to replicate the surface of the marble original. The massive cast of Trajan's column (shown in the Museum in two sections) is a tremendous feat of both engineering and casting. Displayed in the Architectural

Courts from the time of their opening in 1873, it provided the opportunity for students (and others who did not have sufficient means to travel to Rome), to see this iconic monument of the classical world. The cast of the column is made up of sections of plaster reliefs that are attached to an inner chimney built of brick. Each section was individually numbered so that the column could easily be assembled like a giant jigsaw puzzle (plate 312).

The plaster cast of Giovanni Pisano's marble pulpit in Pisa Cathedral, originally carved in 1302–10, is an ensemble of separate casts that together show the pulpit as it stood in 1865 when it was cast by Giovanni Franchi (plate 313). The original pulpit had been dismantled in 1602 following a fire in the cathedral. It was rebuilt in 1627 using some of the sculpture from the pulpit, while other pieces were displayed elsewhere in the cathedral. In the mid-nineteenth century, growing interest in the original configuration of the pulpit led to its reconstruction in 1865, from which our cast is taken. The V&A cast is therefore particularly important, as it records the pulpit at a particular moment in its history, and differs from the pulpit's appearance today.

A gelatine or glue mould was used by Franchi for the panels; this was particularly useful in moulding objects with deep undercuts. The flexibility of the material ensured that the original would not be damaged, and unlike piece moulds, a gelatine mould left no seams on the finished cast. Because of the architectural nature of this cast, as well as its weight and height,

above left
312 Plaster cast of one half of Trajan's column when installed in the Architectural Courts in 1873
Plaster,
total height 35.6m
c.1864
V&A: 1864–128

above right
313 Plaster cast by Giovanni Franchi of Giovanni Pisano's Pisa Cathedral pulpit
Plaster, h.4.62m
c.1865
V&A: 1865–52

Franchi would also have used wood or metal armatures or rods inset into the setting plaster of Paris to provide additional support to the finished cast. The surface of the plaster was often treated or painted to resemble the colour or material of the original object, as here. Some casts were painted in black or brown paint, polished or lacquered to make the surface appear bronzed or gilded.

Electrotyping

Reproductions of metal objects could be created using a process called electrotyping, a form of casting using electricity. As with plaster casting, close copies of an original object can be created. Elkington, a Birmingham-based firm, were pioneers of this manufacturing process, and fully exploited what was to become a commercially lucrative market. The process was similar to that of electroplating – silverplating of an object by electrolysis – a process that was patented by Elkington in the 1840s. Electroplating involves placing a base metal object in a chemical bath or vat, in which the plating metal or desired surface of the final cast is dissolved. When an electrical current is passed through the bath it gradually causes the plating metal to stick to the surface of the object.

In electrotyping the process is almost identical, but a cast of the original object is initially taken and this functions as the mould from which further copies can be made. The surface of this mould would be coated to make it electro-conductive. The same electro-chemical process as electroplating is then used, so that when an electrical current is passed through the bath it causes a thin layer of metal (usually copper) to become deposited onto the prepared mould. The mould is left submerged in this bath until the desired layer of thickness is achieved. The metal cast is then removed from the mould and finished by chasing, or smoothing off the raised edges to create a perfect replica. Elkington's were given permission to take moulds of objects in the Museum's collections in October 1853, at their own risk, which they then reproduced in base metals, and further finished by electroplating them in gold, silver or bronze. Such replicas were marked with an official South Kensington Museum stamp, as well as with the Elkington name, and were marketed and sold by Elkington's.

This relationship between a commercial company and the South Kensington Museum was a mutually beneficial one. Henry Cole (1808–82), the first Director of the South Kensington Museum (later known as the Victoria and Albert Museum), was fully aware of the educational benefits derived from the production of both plaster cast and electrotype reproductions. At the Exposition Universelle de Paris (Paris International Exhibition) of 1867,

attended by some 15 million visitors, Elkington's display of electrotypes proved a great success, and this may have helped Cole galvanize support for the International Convention for Promoting Universal Reproductions of Works of Art. The agreement, formulated by Henry Cole with the aim of promoting appreciation of art, called for the mutual 'exchange of copies of objects' across European collections. He persuaded 15 European princes to sign the agreement that marked the beginning of a systematic campaign of acquisition of plaster casts, electrotypes and photographic reproductions of objects from various European collections for the Museum at South Kensington, and for other public collections of reproductions across Europe.

Although Elkington's was clearly predominant, and their copies were deemed of 'superior quality', supplied complete with 'extra quantity of silver and gilding to render them serviceable for private use', they did not have exclusive rights to reproduce Museum objects, and the London firm of Messrs Franchi and Sons was also given authority to act as electrotypists on behalf of the Museum. The majority of electrotypes produced by Elkington's and Franchi were copies of small-scale objects, and were intended for domestic use and study. However, both companies also produced electrotypes as well as plaster reproductions of larger works of art, including two sets of electrotype doors made for the South Kensington Museum. The doors from Augsburg Cathedral were reproduced by Elkington's in 1874 at a cost of £288, while the great doors originally created by Lorenzo Ghiberti for the baptistery at Florence, the so-called Gates of Paradise, were cast in 1867 by Franchi for the high sum of £950 (plate 314).

314 Electrotype by Messrs Franchi & Sons of Lorenzo Ghiberti's Baptistery door at Florence Cathedral (known as the Porta del Paradiso or Gates of Paradise)
Electrotype, h.7.67m
c.1867
V&A: 1867–44

However, plaster casts far outnumber electrotypes in the Museum's collections. Probably the cost of electrotypes was prohibitively high and the expense could only be justified for such major works. While electrotype reproductions of figurative or monumental works were limited, the Museum actively acquired electrotypes of medals, again with the aim of complementing its already extensive holdings of cast and struck medals. Electrotype medals produced by Elkington were acquired by the Museum mainly in 1857 and 1867. The nineteenth-century founder, Ferdinand Liard, was also particularly important in this field. Liard reproductions of medals, weighted so as to resemble the originals, are often so well executed that they are mistaken for originals. The majority of the Liard electrotype medals were added to the Museum's collection in 1893.

The Manufacture of Casts

The manufacture of plaster cast and electrotype reproductions of works of art was at its height during the mid- to late-nineteenth century. It was a lucrative business, and specialist companies produced well-illustrated catalogues aimed at meeting the demands of enthusiastic individuals or collectors, as well as museums and art schools. Private individuals, many of whom were architects, acquired large cast collections for themselves. Perhaps the most well preserved private collection in existence is that accumulated by Sir John Soane (1753–1837), who amassed the large and varied collection that is still displayed in the Sir John Soane's Museum in London. Soane often recorded the makers' names in his journals and ledgers.

Replication using piece moulds that could be reused enabled the cheap and widespread copying of works of art. Italian manufacturers, including Oronzio Lelli and Manifattura di Signa, both based in Florence, produced a wide range of quality casts of what were deemed to be canonical works in the history of art. Sometimes these replicas were offered in a range of different sizes, made possible by the development of the reducing machine, or as selected portions of the original object, such as the head, lips and eyes of Michelangelo's *David*. Museums, including the South Kensington Museum, were valued customers of such firms. Lelli, the manufacturer most widely represented in the Cast Courts, provided the Museum with a number of important casts, particularly of large-scale architectural pieces, including the Cantoria from Florence Cathedral by Luca della Robbia and the monument to Carlo Marsuppini by Desiderio da Settignano.

The general interest in reproductions led to the development of another technique closely related to plaster casting. The Desachy process,

developed by the French modeller André Desachy, was patented in 1856. Desachy produced decorative plasterwork as well as reproductions of works of art that he sold through his Galerie Desachy in Paris. The process to which he gave his name used plaster to cover surfaces moulded from stiffened woven fabric, usually linen or canvas. The South Kensington Museum acquired an early product of the Desachy process in 1858 with the cast of Michelangelo's *Moses*, at a cost of £45. The entry for this cast in the Museum's reproductions register highlights the contemporary novelty and interest in the technique, which resulted in a lightweight cast, despite its overall height of 2.36m: 'This cast is made by the De Sachy process, plaster on linen and weighs only 168lbs [76.2kg]' (plate 315).

315 Cast by André Desachy of Michelangelo's Moses
Plaster on linen,
h.2.36m
c.1857
V&A: 1858–278

Domenico Brucciani

Some of the most impressive casts in the Museum's collections were commissioned from the major cast manufacturer, or *formatore*, of the day, Domenico Brucciani (1815–80). Born at Lucca in Italy, Brucciani established a Gallery of Casts in Covent Garden in 1837. When it was rearranged in August 1864, the *Art Journal* described it as 'The best arranged saloon of its kind'. He had close links with the British Museum, and was *formatore* there from 1857. His masterwork for the South Kensington Museum was the great cast of the twelfth-century doorway to the Cathedral at Santiago de Compostela, the Pórtico de la Gloria, cast in 1866, but which could only be shown in its entirety when it was installed in the Architectural Courts in 1873. In a report on the casting, Brucciani detailed the difficulties and misunderstandings he encountered:

> They (the people of Santiago de Compostela) had got a notion into their heads that I should either destroy or injure their beautiful Gloria and it was not until some of the models had been taken from the moulds already completed that they were satisfied. Their praise became most eulogistic when they inspected the productions of the most delicate and difficult details brought forth without the slightest detriment to the original.

316 **The cast-making**
workshop at the V&A
in the 1940s

At the same time another form of reproduction, that of photography, was also used by the Museum. Thurston Thompson (1816–68), the Museum's official photographer, was sent to Santiago to take detailed photographs of the monument to complement the casts undertaken by Brucciani. When Brucciani died in 1880, *The Builder* noted that 'although chiefly a plasterman in calling, he was an artist at heart'. The Brucciani company continued after the death of its founder, but demand for casts declined in the early part of the twentieth century, as teaching methods and tastes changed and the poor state of the original moulds resulted in a decline in the quality of the casts produced. However, the importance of the Brucciani company was certainly recognized, and when it failed, it was taken over by the Board of Education in 1922, to be run by the V&A as a Museum service. It was renamed the Department for the Sale of Casts, and catalogues of casts available for sale were published to tie in with the art schools syllabus. At the outbreak of the Second World War the service was suspended and its staff seconded to work on restoring marble sculpture housed in the Museum. Despite sustaining financial losses, the service was maintained until it was finally closed down in 1951 (plate 316).

Fictile Ivories

The Arundel Society, founded in 1848, also provided a significant contribution to the promotion of reproductions of a diverse range of works of art. The Society initially published reproductions of engravings and prints in the late 1840s with the aim of disseminating them to a wider general public. It later offered reproductions of original antique and medieval ivory carvings in fictile, or artificial ivory. The majority of these reproductions were made using a mould made from gutta-percha mixed with wax. The wax allowed some movement when this mould was removed from the original ivory. However this procedure could not be used on delicate ivories with deep undercuts or high relief, and in these instances a series of intricate piece moulds had to be made.

The important collection of ivories already in the South Kensington Museum was complemented by the fictile ivories made of plaster of Paris that were also acquired for the Museum, by the authority of the government body, the Science and Art Department. This collection of nearly a thousand examples was catalogued and published in 1876 by J.O. Westwood, in which he describes the process of taking moulds from the original ivories. Some are seen in frames behind Margaret Longhurst, an authority on medieval ivory carvings (plate 317). The making of the fictile ivories on behalf of the Arundel Society was originally undertaken by Messrs Franchi, but on the death of Giovanni Franchi this transferred to Elkington's. The dissemination of fictile ivories was not limited to the South Kensington Museum. The Science and Art Department ensured that such replicas were made available to art schools and museums to encourage their study, and large collections of fictile ivories are still held at the Wolverhampton Art Gallery and elsewhere.

317 Margaret Longhurst (1882–1958) Keeper of Architecture and Sculpture at the V&A 1938–42

The Architectural Courts

Originally the Architectural Courts contained not only plaster casts and electrotypes, as they do today, but also objects of architectural interest, including architectural models and the *rood-loft* from the cathedral at 's Hertogenbosch in the Netherlands (see plate 6). Although this initially caused some confusion, it illustrates the educational fervour that existed, and the

desire to display significant monuments, whether original or not. As well as collecting reproductions for display, the South Kensington Museum was also instrumental in disseminating information on the reproductions it held. Casts of antique sculpture, acquired by the Museum between 1882 and 1884, were comprehensively catalogued by Walter Copland Perry in 1887. These casts, described as a 'Museum of Casts from the Antique', were displayed separately as a group in galleries 22–24, the galleries to the south of the garden. When the cast collection was rationalized in 1907, the majority of these classical casts were transferred to the British Museum. Despite being described in Museum papers as an 'incongruous white elephant', the cast of Trajan's column was fortunately not included in this transfer.

In the late nineteenth and early twentieth centuries, changing opinion and discussion on the value of casts within Museum collections placed the collection in danger. In the early part of the twentieth century, casts were considered by many as inferior copies that had no place in a museum with original works of art. The smallest fragment of an original object was deemed more worthy than a cast of an entire monument.

The 'Question of Casts' in relation to the collection held at South Kensington was a key topic for discussion and was minuted in The Report of the Committee of Re-Arrangement (July 1908). While the Committee recognized the value of the existing collection, it reiterated that 'the Museum is primarily of originals, and that the proper function of the casts included in it is to supplement or fill gaps in the series of originals'. Any additions to the collection would only be made under special circumstances and considered on an individual basis.

Perhaps unsurprisingly, the last hundred years have seen few notable additions to the cast collection at the V&A. From the thousands of casts that were acquired at the pinnacle of cast collecting during the 1870s and 1880s, acquisitions after the Architectural Association gift of 1916 have amounted to under 100. The Architectural Association gift of around 1,660 casts, formerly at their premises in Tufton Street, London, were originally held by the Royal Architectural Museum. Many of the casts had formerly belonged to John Ruskin (1819–1900) and the architect L.N. Cottingham (1823–1854). The largest group of post-1916 cast acquisitions, consisting of only 23 casts, was given by the Trustees of the Crystal Palace in 1938. Crystal Palace had a substantial cast collection but this was all that survived the disastrous fire there in 1936.

The casts at the V&A today provide a unique record of what is intrinsically a Victorian collection. Some record objects that no longer exist, but more generally they preserve the appearance of an object or monument as it

was in the mid to late nineteenth century when the cast was taken. But historians, students and artists have taken a renewed interest in recent years, and the sympathetic refurbishment and redisplay of the galleries in the early 1980s has helped to ensure their continued attraction.

Although the significance of the Museum's cast collection is predominantly historical, it also performs another function, as a valuable resource for today's contemporary artists. Plaster is still used by sculptors, and although methods of casting have advanced, the principles remain unchanged. The use of plaster by the contemporary artist Rachel Whiteread illustrates the continued versatility and timelessness of the material. Whiteread's work has concentrated on creating solid forms from vacant, empty spaces by taking plaster casts of the insides of objects or rooms. *Room 101*, a plaster cast of the interior of Room 101 at BBC Broadcasting House, formed a major temporary installation in the Museum's Italian Cast Court from October 2003 to June 2004 (plate 318). **DB and RC**

**318 Room 101
by Rachel Whiteread**
Plaster
English, 2003
Temporary installation
in the Cast Courts at
the V&A

Chapter 12

FAKES

The re-evaluation of earlier styles during the nineteenth century, in particular gothic and renaissance, led to the creation of a range of historicizing sculptures, from simple copies and imitations to 'improved' and restored pieces, and objects that were deliberately made to deceive. Such works were produced from the late eighteenth century onwards to satisfy the demands of both collectors and museums.

The subject of the production and acquisition of fakes is a large one. There is not room available here to give a survey; but, instead, by selecting two personalities intimately connected with it, it is possible to illustrate some of the key features. Two of the most important figures in this context in the second half of the nineteenth century were the collector and dealer Frédéric Spitzer (1815–90) (plate 319), and the collector George Salting (1835–1909) (plate 320), who lived most of his life in London. Spitzer was born in Vienna, but subsequently moved to Germany and started dealing in works of art in Aachen in about 1850, maintaining his shop until at least 1868, when he moved to Paris. He continued to work as an art dealer there for the rest of his life, forming an enormous collection of antiques, including sculpture, furniture, goldsmiths' work, maiolica, glass, tapestries, and arms and armour, mostly medieval and renaissance objects, including a certain number of faked pieces commissioned by Spitzer himself. His

far left
319 Frédéric Spitzer
Taken from the frontispiece to *Le Musée Spitzer* by Edmond Bonaffé, Paris, 1890

left
320 George Salting
c.1900

right (top)

**321 Miniature altar
probably by Alfred
André**
Ebony, rock crystal,
lapis lazuli, gold,
enamel, precious and
semi-precious stones,
h.42cm
French, c.1860–70
The central panel with
The Flagellation is by
Annibale Fontana
Italian, c.1600
Salting Bequest
V&A: C.2464–1910

right (middle)

**322 Design for a
miniature altar
by Reinhold Vasters**
Pen and watercolour on
paper, h.86.1cm
German, c.1850–60
V&A: E.2586–1919

right (bottom)

**323 Design for a
miniature altar
by Reinhold Vasters**
Pen and ink on paper,
h.46.1cm
German, c.1850–60
V&A: E.2779–1919

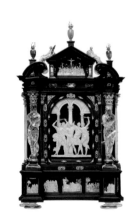

starting points for the fakes were apparently genuine early pieces, which were used as prototypes for the nineteenth-century works manufactured in similar styles. Most of these fakes went undetected, and the value of Spitzer's collection was estimated at 12 to 14 million French francs when it was sold after his death. The sale lasted from 17 April to 16 June 1893, and among the many buyers was Salting, who sat prominently in the front row of bidders; he spent more than £40,000, a gigantic sum at that time.

Salting was an Australian, born in Sydney, who inherited an enormous fortune after the death of his father in 1865 when he permanently settled in Britain. With this immense wealth he formed his magnificent collections when he permanently settled in Britain, which he left to the nation at his death in 1909. His paintings were bequeathed to the National Gallery, the prints and drawings to the British Museum, while the oriental porcelain, renaissance bronzes, sculpture, maiolica, ivories, medals and plaquettes went to the V&A. These collections comprised a number of pieces purchased at the Spitzer sale that show the different gradations of adaptations and embellishing of objects, as well as completely new fabrications.

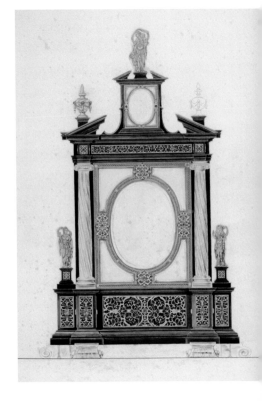

The renaissance bronze statuette *The Shouting Horseman* by Andrea Briosco, *Riccio*, dates from about 1510 and is one of the most important sculptures from the Salting collection, acquired at the Spitzer sale (see plate 87). While it was with Spitzer it was restored – the three legs on which the horse stands are largely modern – and repatinated. The restorations were carried out in the workshop of Alfred André (1839–1919), a Parisian goldsmith and restorer. André was in close contact with Spitzer and produced several new works for his collection, as well as undertaking restorations. He set up a workshop which practised various decorative arts techniques, working together with other goldsmiths and hardstone carvers. While the *Shouting Horseman* was in André's studio he made a copy of it, and many modern pastiches later entered private collections and museums.

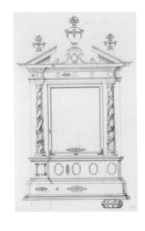

Another piece from the Salting collection, a miniature altar made of ebony with rock crystal, lapis lazuli, gold, enamel and precious and semi-precious stones, may also come from André's workshop (plate 321). Only the central rock crystal panel depicting the *Flagellation* originates from around 1600; the rest of the structure (the wood case, the rock crystal columns, the lapis lazuli plaques, the enamels and figures) was almost certainly made up in the second half of the nineteenth century. More than 1,000 designs for such objects were produced by the Aachen goldsmith Reinhold Vasters, and are now in the V&A (plates 322 and 323).

Small-scale figures and reliefs in hardwood were particularly highly esteemed by collectors. Three examples bought by Salting at the 1893 sale shed light on Spitzer's dubious practice. The first is a medallion in boxwood (plate 324), which depicts the *Betrayal of Christ* in the foreground and the *Agony of Christ* in the background. The relief is rather clumsily carved, and the style of the armour of the soldiers is a mixture of elements of the fifteenth and sixteenth centuries. Added to this is the inscription, written in a semi-literate style in ink on the back: 'Secolo XVI. Estylo de Alberto Durer de Nuremberg', which erroneously suggests a close relationship with the famous Nuremberg artist. From around 1600 up to the early twentieth century Dürer was not only highly regarded as a painter but was also believed to practise sculpture. In the nineteenth century especially, pieces of wide-ranging quality were ascribed to him, and sometimes Dürer's monogram AD was inscribed on them, or, as here, an inscription referring to the artist was designed to make the object more attractive for the collector.

The second example is a relief showing the figure of *Death at a battle* (plate 325), which was thought to be a model by the so-called Master of the Leaf Frieze, who was active in the first quarter of the sixteenth century, producing models in boxwood which were disseminated to be reproduced by craftsmen in lead or bronze. However, the dwarf-like figures exhibit disproportionate muscular bodies and facial types which are uncharacteristic of the first half of the sixteenth century. The presence of the figure of Death with an hour-glass, a subject which cannot be found in any sixteenth-century medals or plaquettes, is a typical nineteenth-century addition. Spitzer owned several such pieces in boxwood – their present locations are unknown – which were fabricated at the time to enhance his collection of models.

The third example, a boxwood figure of the *Seated Virgin and Child* (plate 326) was originally classified as from Flanders, and dated to the end of the fifteenth century, but the inconsistencies in the style and manufacture suggest it dates from the second half of the nineteenth century. Other

324 The Betrayal of Christ
Boxwood, h.7.5cm
German or French,
c.1850–60
Salting Bequest
V&A: A.501–1910

325 Death at a battle
Boxwood, h.2.95cm
German, c.1850–80
Salting Bequest
V&A: A.502–1910

326 The Virgin and Child
Boxwood, h.14.5cm
German, c.1850–80
Salting Bequest
V&A: A.533–1910

**327 Plate illustrating
northern gothic
sculpture in Spitzer's
sale catalogue of 1893**

**327 Plate illustrating
northern gothic
sculpture in Spitzer's
sale catalogue of 1893**

opposite left
**328 The Virgin, St John
and Mary Magdalene
at the foot of the
Cross**
Oak, h.73.5cm
German or
Netherlandish,
c.1850–80
Salting Bequest
V&A: A.532–1910

versions of the composition exist in semi-precious materials such as bloodstone, porphyry, ivory (in the possession of Spitzer's heirs), while others in boxwood and marble are known, indicating that many versions were made to be sold to a wide range of collectors.

The plate illustrating northern gothic sculpture in Spitzer's sale catalogue (plate 327) reveals the collector's taste. The majority of the single figures and groups are in the style prevalent in the Netherlands in the late fifteenth and early sixteenth centuries. This was probably because his activities in Aachen brought him into close contact with dealers and

sculptors in Belgium. The latter primarily worked in the neo-gothic style, producing altarpieces, statues, reliefs and choir stalls for churches and chapels. The stylistic features of these are similar to those of the sculptures in Spitzer's collection. The group of *The Virgin, St John the Evangelist and St Mary Magdalene at the Foot of the Cross* (plate 328) demonstrates the skill of the nineteenth-century carver in imitating late gothic sculpture, despite the slight stylistic inconsistencies in the approach. Another relief of *The Lamentation Over the Dead Christ* from the Spitzer collection came to the Museum not through George Salting, but was acquired from a London dealer, F.W. Lippmann (A.15–1912). It too is based on earlier Netherlandish sources, in this case sculpture of about 1460–70, although some elements point to the costume style of the early sixteenth century. This relief was probably a pendant to the *Circumcision*, also a nineteenth-century product, based on reliefs made in Antwerp in about 1520.

From the end of the eighteenth century onwards, medieval ivories were highly regarded among collectors. Over four decades Spitzer himself amassed a large collection of ivories, ranging from the sixth to the fifteenth centuries. Salting was also a keen collector of medieval ivories, which he bequeathed to the Museum. Although he acquired many genuine pieces, some were later in date, including two ivory statuettes bought at the Spitzer sale, which were both thought to be of fourteenth-century origin at the time they were bequeathed to the Museum.

329 The Virgin and Child
Ivory, h.42cm
Italian, c. 1830–50
Salting Bequest
V&A: A.550–1910

The *Standing Virgin and Child* (plate 329) is based on the life-size marble figure of the Virgin in Trapani in Sicily. This statue was made in the fourteenth century, and soon became the focus of pilgrimages and was one of the most copied devotional images in Italy. The present Virgin was probably not intended as a fake, but a copy made in the nineteenth century for devotional purposes. The other figure of the Virgin (plate 330) is almost certainly the work of a nineteenth-century ivory carver who copied a fourteenth-century ivory. The production of ivories in historicizing styles in the nineteenth century flourished in a number of centres, including Cologne, Milan, Toulouse and Córdoba. Although not always made to deceive, unscrupulous dealers often sold them as genuine objects to their clients. **NJ**

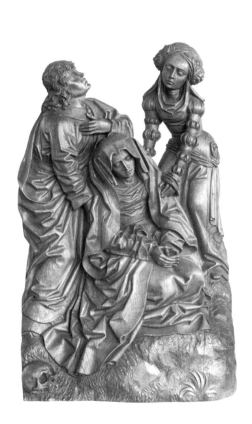

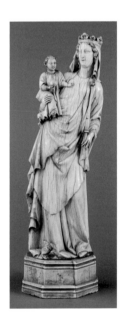

330 The Virgin and Child
Ivory, h.40.5cm
French, c.1850–80
Salting Bequest
V&A: A.549–1910

Glossary

Aftercast A replica *cast*, generally in metal although sometimes in *clay*, *terracotta* or *plaster*, taken from moulds of an existing sculpture.

Agate A naturally coloured *gemstone* which is banded and much favoured for *cameos*. The term refers to a wide selection of *chalcedony*, which is a form of *quartz*.

Alabaster A fine-grained form of the stone *gypsum*, composed of hydrous calcium sulphate and used widely by sculptors for centuries. Resembling marble, but softer and more prone to abrasion, it varies in colour from translucent yellow-ochre to pinks and browns, and often displays veins of deeper colour. So-called calcite alabaster is a superficially similar material and often used by ancient Greek and Roman craftsmen for ointment vessels and trinkets. Technically speaking it is a different mineral (calcium carbonate), being a form of marble and a much harder, heavier and water-resistant stone.

Alabasterer or **Alabasterman** A medieval term for a person who made their living from either carving or selling alabaster sculptures.

Alloy A combination of two or more metals melted together, and benefiting from the required virtues of each. Metals are usually alloyed to modify qualities such as hardness, colour, melting point and malleability, altering the dominant metal's original properties for more desired ones. See *bronze*.

Amber A fossilized resin varying in colour from golden yellow, through rich oranges and reds to shades of brown. Occasionally it can be white, dark brown, blue or green.

Amethyst A clear purple or violet form of the mineral *quartz*, much favoured for *intaglios*, and related to *rock crystal*, which is the colourless form of quartz.

Annealing The process of heating and slowly cooling metal or glass to restore its strength and malleability. This usually takes place after a metal has become brittle or is displaying signs of cracking, often as a result of hammering.

Armature A construction, usually made of metal or wood, that internally supports *clay*, *plaster*, wax or other materials used to construct a sculpture. The starting point onto which the material is applied, an armature serves to bear the weight of a model or *cast* and hold any stance or forms of the composition in place. It is also used for plaster decoration in relief, when wood or metal supports are inserted into a wall at varying lengths to support the plaster laid over the top.

Bas relief A French term for low relief (*basso-rilievo* in Italian),

where figures project only slightly and no part is entirely detached from the background. See *relief*, *haut relief*.

Base A general term for a support or block onto which a sculpture can be fixed or mounted and which can also be termed a socle, plinth or *pedestal*.

Blank The piece of blank metal which is stamped by the die in die-struck medal-making.

Brass An *alloy* of *copper* and zinc, typically yellow in colour, and usually also containing varying amounts of other elements, such as lead and tin. Less malleable than pure copper, but stronger and easier to cast, brass has predominantly been used for utilitarian objects such as candlesticks, as well as for *cast* sculpture.

Bronze An *alloy* of *copper* and tin that often contains other elements such as zinc and lead. Harder and more durable than brass and used extensively since antiquity, bronze alloys vary in colour from silvery hues to rich, coppery reds.

Bronzing Generally the process of colouring a plaster cast in imitation of a *bronze*, but also used when imparting a bronze appearance to other metals and non-metallic materials.

Callipers A device with two moveable 'jaws' to measure the distance between two points. Particularly used to copy sculptures or to make reduced or enlarged versions.

Cameo A small carving in low relief, often in shell or a hardstone such as onyx, where the ground is of one colour and the *relief* of another. While the origin of the term is uncertain, it may derive from the Hebrew for 'charm' or 'relief', or from the Greek for 'on the ground', ie the image is on the background.

Carve The process of taking away hard material from a given volume. Used in wood, stone, *marble* and *plaster*, it is the act of cutting or incising the medium into the desired form using knives, chisels, gouges, points and hammers.

Casing See *investment*.

Cast 1.(verb) To produce an object by pouring a liquid material, such as *bronze*, into a *mould*, or to reproduce an object, for example in *plaster*, by making a negative mould of the object which can then be used to cast it. An artist may also choose to cast from life real objects such as leaves or lizards, or parts of a body, often referred to as moulage or life casting. 2. (noun) A sculpture produced by this means. See *lost-wax casting* and *sand casting*.

Chalcedony A Microcrystalline variety of *quartz* sometimes used in miniature sculpture.

Chasing The working of a *bronze* or lead sculpture after casting, where the surface is tooled using chisels, punches and other tools to create and define details and decoration.

Clay Decomposed igneous rock and shifting constituent minerals that form a paste when combined with water, which becomes hard when fired (see *terracotta*). Worked wet, often over an *armature*, to achieve the final form, it varies in colour from whitish-yellow to red-brown depending on its iron content.

Copper In its pure form, a naturally occurring red-coloured metal that is often used for *repoussé* work due to its malleable nature. As an *alloy* it is the main constituent of *bronze* and *brass* and is also used for plating and inlay.

Core The solid internal portion set in a *mould* used in the process of *casting* a hollow piece of sculpture, and often later extracted to lessen the weight. In *lost-wax casting* the amount of space left between the core and the mould (occupied by wax before it is 'lost') determines the thickness of the cast metal.

Cornelian A red variety of *chalcedony*, a form of *quartz*, much favoured for *seals* and *intaglios*. Its red colour is due to the presence of iron components which vary the colour from deep red to pink.

Cypraecassis Rufa Commonly known as helmet shell. The shell of this Indo-Pacific species is regularly used for carving *cameos* in which the colour is layered pale cream over orangey-red. Other varieties have also been used for this ancient art, but the thick shell of Cypraecassis Rufa is preferred by sculptors executing carving in *bas relief*.

Effigy A likeness or image of a person, usually in three-dimensional form, often used in association with the dead.

Electrotype The reproduction of a sculpture by coating a *mould* taken from it with metal (usually copper) by means of electrolysis.

Faux From the French meaning 'false', and said of any false effect given to a sculpture. For example, 'faux marble' is reconstituted marble powder incorporated into resin.

Fettling The cleaning and trimming away of rough edges and unwanted mould seams from the surface of a *plaster*, wax or *terracotta* sculpture before firing and of a *bronze* sculpture after casting.

Fictile ivory A *plaster cast* of an ivory carving.

Field The blank area of a medium on which the design is placed.

Figurative Of or portraying human or animal figures.

Fire-gilding The process whereby the surface of a metal object is coated with a gold-mercury mix and then heated so the mercury burns off, leaving only the gold.

Firing Exposing a clay body to heat in a kiln to harden it (see *terracotta*). An *investment* casing containing wax can also be fired in order to melt away the wax. This is an integral part of the *lost-wax* process.

Formatore Italian for a maker of *moulds* (*forme*), the term is particularly applied to *plaster,* moulds and *casts*.

Founder's mark A sign or stamp on a sculpture denoting the firm, foundry or individual responsible for its casting.

Foundry The building or establishment in which the casting of *bronze* or lead by the *lost-wax* or *sand casting* methods takes place.

Gate The point at which molten metal enters a *mould*.

Gelatine A material made from animal glue that is malleable when warm and can be used to make flexible *moulds*.

Gemstone Varieties of minerals selected for their beauty, durability or rarity, cut and polished for ornamental purposes.

Gesso The Italian word for chalk (akin to gypsum), and a powdered form of the mineral calcium sulphate (gypsum). Traditionally mixed into a paste with water and glue to provide a smooth surface and absorbent primer coat for painting or *gilding*.

Gilding The application of gold leaf to a surface (usually wood, metal or stone) using an adhesive generally consisting of linseed oil boiled with a drier colouring agent. See *fire-gilding* and *parcel gilt*.

Grog An inert filler such as pulverized brick, or pottery mixed with clay or plaster, used for both *moulds* and *cores* and for objects *cast* and modelled. When added to clay it reduces plasticity, raises the firing temperature and makes it more stable and can also alter its appearance.

Gutta-percha A natural resin or latex made from the sap of a variety of trees found mainly in the Malayan archipelago, the most common being the Isonandra Gutta tree. This forms a rubbery material that can be easily modelled or used for *moulds*.

Gypsum See *plaster*.

Haut relief The French term for high or deep relief (*alto-rilievo* in Italian), where the sculpted figures project from the background. See *relief* and *bas relief*.

Incuse From the Latin *incusus*, meaning to hammer, stamp or hollow out by engraving, it applies to coins and *plaquettes* which exhibit the same image but are convex on one side and concave on the other.

Intaglio From the Italian *intagliare*, meaning to 'cut in' or

'engrave': any carving incised into the surface of a material.

Investment The investment *mould* is a heat-resistant mould designed to receive the molten metal for casting. It requires three main qualities to survive the casting process namely form making, heat resistance and strength. Materials that provide these qualities include *clay* and *plaster* for form making; sand, crushed fired clays and ashes for heat resistance; and hair, hemp, asbestos and glass fibre for strength.

Jasper A hard, fine-grained dense form of opaque *chalcedony*. It occurs naturally in a range of colours, usually caused by iron in the composition, resulting in red, yellow, brown or green colours, and was much favoured for inlays and carvings.

Jet Fossilized wood millions of years old and black in colour, sometimes carved into statuettes or reliefs, and also used for jewellery. Plentiful deposits are to be found in the region of Santiago de Compostela in Spain, and in Whitby in Yorkshire.

Kunstkammer or **Cabinet of Curiosities** A collection of finely worked art objects often made from exotic materials. Many such collections were formed by royal and aristocratic collectors from the sixteenth to the eighteenth centuries.

Lapis Lazuli A bright blue hardstone with golden specks. Often used for *intaglios* and decorative inlays. The source of the pigment *ultramarine*.

Layered agate A banded *gemstone* often favoured in the making of *cameos*. See *agate*.

Limestone An organic sedimentary rock formed from the remains of fossil deposits and composed mainly of calcium carbonate. Limestone that can be polished is more commonly known as *marble*, which is composed mostly of calcite (a crystalline form of calcium carbonate) and widely used in sculpture. See *plaster*.

Lost-wax casting The process of *casting* metal sculpture. Initially a model of the original object is made in wax and encased in a heat-resistant *mould*, known as the *investment*. The mould is heated so that the wax melts away (hence 'lost wax'), so leaving a cavity in its place. This space is then filled with molten metal which when solidified, creates a virtually identical replica of the original wax model. See also *gate* and *sprue*. (See *Bronze and Lead* and *Medals and Plaquettes*.)

Maquette A small-scale model for a larger sculpture.

Marble A hard type of *limestone* (more or less crystallized by metamorphosis) that can be given a high polish and often displays veins. As one of the most costly materials, it is highly prized. In its powdered form it can be used to create bonded marble *casts* or '*faux*' marble as an alternative to *plaster* as a casting material. Resin can be loaded with marble powder, as can a cement mix.

Mixed media The term is generally used when two or more media are used in a single work of art, eg metal and wood, or metal, wood and stone. Mixed media can include plastics, fibres, and any man-made or natural element used to model or otherwise construct a sculpture.

Medium Referred to as the material used for a given sculpture. *Bronze*, *terracotta*, *plaster* and steel are all examples of media.

Model/modelling The building up or shaping of *clay* or other soft materials, such as *plaster*, to construct a sculpture, often using an *armature*. It is essentially an additive process, unlike *carving*, although cutting away can be used to achieve desired shapes.

Monochrome A work executed in a single colour, or a range of tones of a single colour.

Mother of pearl The smooth iridescent calcium carbonate lining in the shells of certain molluscs, for example pearl oysters, abalones and mussels. Often used for jewellery and inlay decoration, and also known as Nacre.

Mould A hollow, or negative container used in the process of *casting* to give its form to a substance placed within (wax for the bronze *lost-wax* process, molten bronze in the sand casting process; or *plaster*, cement, *marble*, etc.) and allowed to harden. Moulds can be made entirely of plaster, or of rubber with an outer plaster jacket (also called a mother mould). A one-piece mould that must be destroyed in order to extract the *cast* is called a waste mould, while a mould consisting of two or more separable pieces is called a piece mould. Moulds can also be mass produced for *relief* decoration in plaster and reused for repeating patterns.

Onyx A black and white parallel-banded variety of *agate*, which lends itself well to the making of *cameos*. Often used for decorative carving and panelling, the banding can vary in degree of translucency. When the dark layers are brown or brownish red it is often called *Sardonyx*.

Parcel gilt A partly gilt surface mainly used for decorative purposes and often found on silverware.

Patina/patination The surface finish of an object. This can occur naturally, for example, as a result of handling or environmental conditions, but can also refer to an artificial finish applied to an object. Patination is more usually associated with an applied treatment.

Pedestal The *base*, foundation, plinth, or support of a sculpture.

Piece mould See *mould*.

Plaquette A small-scale relief sculpture. Renaissance plaquettes were usually made of metal and often applied to adorn functional objects. The format was revived by French medal makers in the 19th century.

Plaster Commonly made from one of two stones, *gypsum* rock (calcium sulphate) or *limestone* (calcium carbonate). Gypsum was used to make plaster of Paris. The rock is heated to a very high temperature to drive off the moisture. The resulting material is ground to a fine powder, before being mixed with varying amounts of water to create a substance which can differ in texture, depending on the requirements.

Pointing Measuring the distance between specific points in order to reproduce a sculpture, usually in a smaller or larger version.

Polychrome A range of colours. Polychromed sculptures are painted and sometimes *gilded* in different colours.

Quartz A crystalline rock or mineral composed of silicon dioxide. It is very common and occurs in large crystal varieties such as *amethyst* and *rock crystal*, or as a fine-grained crystalline material such as *chalcedony* or *jasper*.

Relief Any work that projects from a background. The lowest is called *rilievo schiacciato* (literally squashed relief), where the projection is minimal; low relief is more defined, while high relief projects further still (see *bas relief* and *haut relief*). Hollow relief is when all the carving lies within a hollowed-out area below the surface plane.

Repoussé A raised design created when malleable metal is shaped by hammering from the back, or from the inside of an object.

Riser See *sprue*.

Rock crystal The clear, colourless form of the mineral *quartz*. Rock crystal may be naturally coloured purple (*amethyst*) or yellow (citrine) by the presence of iron.

Runner See *sprue*.

Sand casting A relatively inexpensive method of casting metal, using a sand *mould* that is held within a two-part metal or wooden frame called a flask. One half is filled with sand into which the *model* is placed, and the other, also containing sand, is placed on top. The two are then opened, a dowel removed to leave a vent (riser) through which gases can escape. The model is removed and *sprues* are cut into the sand to enable the molten metal to be poured in and to reach the cavity left by the model. The sand used is usually an extremely fine-grained silicate that is often slightly damp to enable it to hold together.

Sardonyx A white and red-brown banded variety of *chalcedony*, which is a form of *quartz*.

Scagliola A form of *plaster*, used with the addition of different ingredients and pigments to resemble *marble*.

Seal/sealstone A hard material engraved so that it can be used to make an impression by being pressed into a soft material. Ancient seals were used not only on documents to create identifying marks, but also as a form of lock on a cellar or store.

Shim A thin and often tapered or wedged piece of material, used to divide the separate elements of a *piece mould*, and generally made of *brass* or some other non-ferrous metal.

Skew-bladed firmer A chisel with both sides of the blade cut (bevelled) at an angle.

Smelt To melt or fuse mineral ores in order to separate the metallic constituents.

Socle See *base*.

Sprue In *casting*, there are two types of sprues. The channels through which the metal enters and runs through the *mould* (also known as runners) and those which allow the air and gases produced during the casting process to escape from the mould (also called risers and vents). See also *gate*.

Stucco A term broadly used to describe the material used for decorative plasterwork, generally made from limestone following the same process as *plaster*.

Surmoulage The practice of taking a *cast* from an existing *bronze* sculpture rather than from the artist's original.

Terracotta Italian for *fired* or baked *clay* and literally meaning 'cooked earth'. The surface can be *fettled*, or worked with tools and can be painted or glazed.

Turpentine A volatile liquid usually extracted from pine trees and used as a solvent, thinner or plasticizer.

Turquoise A blue-green mineral of hydrous copper aluminium phosphate, mainly prized in its polished blue form.

Ultramarine A precious blue pigment made by crushing *Lapis Lazuli* and mixing it into a paste with wax, resin and oil with hot water.

Undercuts A protruding part of sculpture which can, for example, prevent the safe and easy removal of the positive impression or the negative *mould*.

Vitreous paste A moulded glass, coloured with metal oxides.

Bibliography

V&A sculpture publications

Baxandall, M., *German Wood Statuettes 1500–1800* (London, 1967)

Baxandall, M., *South German Sculpture 1480–1530* (London, 1974)

Bilbey, D. with Trusted, M., *British Sculpture 1470 to 2000. A Concise Catalogue of the Collection at the Victoria and Albert Museum* (London, 2002)

Cheetham, F., *English Medieval Alabasters: With a catalogue of the collection in the Victoria and Albert Museum* (Oxford, 1984)

Hawkins, J., *Rodin Sculptures* (London, 1975)

Jopek, N., *German Sculpture 1430–1540. A Catalogue of the Collection in the Victoria and Albert Museum* (London, 2002)

Longhurst, M.H., *Catalogue of Carvings in Ivory*, 2 vols (London, 1927, 1929)

Maclagan, E.R.D., *Catalogue of Italian Plaquettes* (London, 1924)

Motture, P., *Catalogue of Italian Bronzes in the Victoria and Albert Museum. Bells & Mortars and Related Utensils* (London, 2001)

Pope-Hennessy, J. (assisted by Lightbown, R.W.), *Catalogue of Italian Sculpture in the Victoria and Albert Museum*, 3 vols (London, 1964)

Trusted, M., *Catalogue of European Ambers in the Victoria and Albert Museum* (London, 1985)

Trusted, M., *German Renaissance Medals. A Catalogue of the Collection in the Victoria and Albert Museum* (London, 1990)

Trusted, M., *Spanish Sculpture. A Catalogue of the Collection in the Victoria and Albert Museum* (London, 1996)

Whinney, M., *English Sculpture 1720–1830* (London, 1971)

Williamson, P., *An Introduction to Medieval Ivory Carvings* (London, 1982)

Williamson, P., *Catalogue of Romanesque Sculpture* (London, 1983)

Williamson, P., *The Medieval Treasury. The Art of the Middle Ages in the Victoria and Albert Museum* (London, 1986)

Williamson, P., *Northern Gothic Sculpture 1200–1450* (London, 1988)

Williamson, P. (ed.), *European Sculpture at the Victoria and Albert Museum* (London, 1996)

Williamson, P., *Netherlandish Sculpture 1450–1550* (London, 2002)

General

Baker, M. and Richardson B. (eds.), *A Grand Design. The Art of the Victoria and Albert Museum*, The Baltimore Museum of Art, Baltimore; Museum of Fine Arts, Boston; Royal Ontario Museum, Toronto; The Museum of Fine Arts, Houston; Fine Arts Museums of San Francisco, Victoria and Albert Museum, London (exh. cat.) (London and New York, 1997)

Bassett, J. and Fogelmann, P., *Looking at European Sculpture. A Guide to Technical Terms* (London, 1997)

Boström, A. (ed.), *The Encyclopedia of Sculpture* (3 vols) (New York, 2004)

Cennini, C., *Il Libro dell' Arte (The Craftsman's Handbook)* (New Haven, 1933)

La Sculpture. Principes d'Analyse Scientifique. Méthode et Vocabulaire (Paris, 1978)

Mills, J., *Encyclopedia of Sculpture Techniques* (Batsford, 2001)

Penny, N., *The Materials of Sculpture* (New Haven and London, 1993)

Rich, J., *The Materials and Methods of Sculpture* (New York, 1947)

[Theophilus] Theophilus, *The Various Arts, De Diversis Artibus*, trans. and ed. by Dodwell, C.R., (Oxford, 1986)

Trench, L. (ed.), *Materials and Techniques in the Decorative Arts. An Illustrated Dictionary* (London, 2000)

Turner J. (ed.), *The Dictionary of Art* (34 vols) (London and New York, 1996), also available as a subscription website (www.groveart.com)

Vasari, G., *On Technique* (2nd extended ed., 1568), translated by Louisa S. Maclehose (Dover edition, 1960)

Wittkower, R., *Sculpture, Processes and Principles* (Harmondsworth, 1977)

Working Practices

Atterbury, P. (ed.), *The Parian Phenomenon. A Survey of Victorian Parian Porcelain Statuary and Busts* (Shepton Beauchamp, 1989)

Baker, M., 'Limewood, Chiromancy and Narratives of Making. Writing about the materials and processes of sculpture', *Art History* 21, (1988), pp.498–530

Baker, M., 'Narratives of Making: The Interpretation of Sculptors' Drawings and Models', in *Figured in Marble. The Making and the Viewing of Eighteenth Century Sculpture* (London, 2000), pp.34–49

Goldstein, C., *Teaching Art: Academies from Vasari to Albers* (Cambridge and New York, 1996)

Huth, H., *Künstler und Werkstatt der Spätgotik* (Darmstadt, 1967)

Mackenney, R., *Tradesmen and Trades: The World of Guilds in Venice and Europe c.1250–1650* (London, 1987)

Martindale, A., *The Rise of the Artist in the Middle Ages and Early Renaissance* (London, 1972)

Pevsner, N., *Academies of Art: Past and Present* (Cambridge and New York, 1940)

Physick, J., *Designs for English Sculpture 1680–1860* (London, 1969)

Wax

Avery, C., 'La Cera sempre aspetta: Wax Sketch-Models for Sculpture', *Apollo* (March 1984), pp.166–76

Baldinucci, F., *Notizie dei professori del disegno da Cimabue in qua...*, Florence, 1681–8, vol.2, pp.555–88

Billing, A., *The Science of Gems, Jewels, Coins and Medals, Ancient and Modern* (2nd ed.) (London, 1875)

Harvey, A. and Mortimer, R. (eds.), *The Funeral Effigies of*

Westminster Abbey (Bury St Edmunds, 1994)

Hilloowala, R., *et. al.*, *The Anatomical Waxes of La Specola* (Florence, 1995)

Jim Murrell 1934–1994, Courtauld Institute Galleries (exh. cat.) (London, 1994)

Lightbown, R.W., 'Gaetano Giuilo Zumbo-1: The Florentine Period', *Burlington Magazine*, vol. CVI, (November 1964), pp.486–96

Lightbown, R.W., 'Le Cere Artistiche del Cinquecento', *Arte Illustrata* (June to September 1970), pp.46–55; (October to December 1970), pp.30–9

Motture, P., ' "Broken and repaired": Michelangelo's Wax Slave in the Victoria and Albert Museum', *Burlington Magazine*, vol. CXXXVIII (December 1996), pp.809–12

Murrell, V.J., 'Some Aspects of the Conservation of Wax Models', *Studies in Conservation*, 16, (1971), pp.95–109

Murrell, J., 'The Technique of British Wax Portraits: The Visual Evidence', *The Conservator*, 18, (1994), pp.41–9

Pyke, E.J., *A Biographical Dictionary of Wax Modellers* (Oxford, 1973)

Rackham, B., *Catalogue of the Schreiber Collection* (3 vols) (London, 1930)

Smith, J.P., *James Tassie 1735–1799, Modeller in Glass, a Classical Approach* (London, 1995)

Terracotta

Avery, C., *Finger Prints of the Artist: European Terra-cotta sculpture from the Arthur M Sackler Collections*, National Gallery of Art, Washington; Metropolitan Museum of Art, New York; Fogg Art Museum, Cambridge, Mass. (exh. cat.) (Cambridge, Mass., 1980)

Avery, C., *Giambologna, The Complete Sculpture* (Oxford, 1987)

Boucher, B., Brodrick, A. and Wood, N., 'A terracotta bust of Cardinal Giovanni de'Medici', *Antologia di Belle Arti* (Alvar Gonzalez-Palacios), nuova serie, nn.52–5, 1996, (La Scultura II), pp.32–9

Boucher, B. (ed.), *Earth and Fire: Italian Terracotta Sculpture from Donatello to Canova*, Museum of Fine Arts, Houston; Victoria and Albert Museum, London (exh. cat.) (New Haven and London, 2001)

Draper, J. and Scherf, G., *Playing with Fire. European Terracotta Models, 1740–1840*, Metropolitan Museum of Art, New York; Réunion des Musées Nationaux, Paris (exh. cat.) (New Haven and London, 2003)

Antony Gormley Field for the British Isles, Hayward Gallery (exh. cat.) (London, 1996)

Green, C.M., *Finds from the Site of Suffolk Place, Southwark*. Project submitted for the Museums Diploma Study Course, Department of Museum Studies, University of Leicester, October 1986

Lightbown, R. and Caiger-Smith, A., *The Three Books of the Potter's Art*, a facsimile of the manuscript on the Victoria and Albert Museum (London, 1980)

Luchs, A., 'Lorenzo from Life? Portrait Busts of Lorenzo de'Medici',

The Sculpture Journal, vol. IV, (2000), pp.6–23

Physick, J., *The Victoria and Albert Museum. The history of its building* (London, 1982)

Pope-Hennessy, J., *Luca della Robbia* (Oxford, 1980)

Paolozzi Strozzi, B. and Zikos, D. (eds), *Giambologna glie dei, gli eroi*, Museo Nationale del Bargello (exh. cat.) (Florence, 2006)

Bronze and Lead

Avery, C. and Radcliffe, A., *Giambologna. Sculptor to the Medici 1529–1608*, Royal Scottish Museum, Edinburgh; Victoria & Albert Museum, London; Kunsthistorisches Museum, Vienna (exh. cat.) (London, 1978)

Avery, C., *Giambologna. The complete sculpture* (London, 1987)

Avery, V. with Dillon, J., *Renaissance and Baroque bronzes from the Fitzwilliam Museum, Cambridge*, Daniel Katz Limited, London (exh. cat.) (London 2002)

Baker, M., ' "Squabby Cupids and Clumsy Graces": Garden Sculpture and Luxury in Eighteenth Century England', *Oxford Art Journal*, no. 8, (1995), pp.1–18; reprinted idem in *Figured in Marble. The Making and Viewing of Eighteenth-Century Sculpture* (London, 2000), pp.119–27

Baratte, S., *et. al.*, *Les Bronzes de la Couronne*, Louvre, Paris (exh. cat.) (Paris, 1999)

Beattie, S., *The New Sculpture* (New Haven and London, 1983)

[Vannoccio Biringuccio] *The Pirotechnia of Vannoccio Biringuccio. The Classic Sixteenth-Century Treatise on Metals and Metallurgy*, trans. and ed. by Smith, C.S. and Gnudi, M.T. (New York, 1990)

Blum, A. (ed.), *The Colour of Sculpture 1840–1910* (London, 1996)

Butler, R. and Glover Lindsay, S. (eds.), *European Sculpture of the Nineteenth century*, National Gallery of Art, Washington (Oxford University Press, 2000)

Christie's, *Barye Bronzes: An important private collection, including rediscovered modèles from the Sculptor's Atelier Sale*, 25 April 2003 (New York)

Crowther, H., *Lead Garden Ornaments* (London, 1920)

Davidson, B.F. with Stone, R.E., *Severo and the Sea-Monsters* (New York, 1997)

Davis, J., *Antique Garden Ornament* (Suffolk, 1991)

Dent Weil, P., 'A Review of the History and Practice of Patination', in Floyd Brown, B., *et. al.*, *Corrosion and Metal Artifacts – A Dialogue between conservators and archaeologists and corrosion scientists* (Houston, 1991), pp.77–92

Dorment, R., *Alfred Gilbert* (New Haven and London, 1985)

Droth, M., 'Small sculpture, c. 1900: the "New Statuette" in English sculptural aesthetics', in Getsy, D.J. (ed.), *Sculpture and the Pursuit of a Modern Ideal in Britain c.1880–1930* (Aldershot, 2004), pp.141–66

Droth, M., Scholten F. and Cole, M., *Bronze. The Power of Life and Death*, Henry Moore Institute, Leeds (exh. cat.) (Leeds, 2005)

Eliott, P., *Sculpture en taille directe en France de 1900 à 1950* (Saint-

Remy-lès-Cheveuse, 1988)

Elsen, A.E., *Rodin* (London, 1974)

Elsen, A.E. (ed.), *Rodin Rediscovered,* National Gallery of Art, Washington (Washington, 1981)

Evelyn, P., 'Hubert Le Sueur's equestrian bronzes at the Victoria and Albert Museum', *The Burlington Magazine*, vol. CXXXVIII (Feb 1995), pp.85–92

[Pomponius Gauricus] *Pomponius Gauricus De Sculptura (1504)*, ed. and trans. by Chastel, A. and Klein, R. (Geneva, 1969)

Hughes, R. and Rowe, M., *The Colouring, Bronzing and Patination of Metals* (London, 1982)

Kowal, D and Meilach, D.Z., *Sculpture Casting* (London, 1972)

Krapf, M. (ed.), *Franz Xaver Messerschmidt 1736–1783*, (Ostfildern-Ruit, 2003)

Le Normand-Romain, A., *Rodin: The Gates of Hell*, Musée Rodin (Paris, 2002)

Le Normand-Romain, A., *La sculpture dans l'espace, Rodin, Brancusi, Giacometti* (exh. cat.) (Paris, 2005)

Lebon, E., *Dictionnaire des fondeurs de bronze d'art, France 1890–1950* (Perth, 2003)

Leithe-Jasper, M., *Renaissance Master Bronzes from the Collection of the Kunsthistorisches Museum, Vienna* (Washington, 1986)

Meijer, B. (ed.), *Giambologna tra Firenze e l'Europa* (Florence, 2000)

Motture, P. (ed.), *Large Bronzes in the Renaissance,* Studies in the History of Art 64, National Gallery of Art, Washington (New Haven and London, 2003)

Pincus, D. (ed.), *Small bronzes in the Renaissance*, Studies in the History of Art 62, National Gallery of Art, Washington (New Haven and London), 2001

Pivar, S., *The Barye Bronzes*, Antique Collectors' Club (Redbridge, 1974)

Poletti, M. and Richarme, A., *Barye* (Gallimard, 2000)

Read, B., *Victorian Sculpture* (New Haven and London, 1982)

Scholten, F., *et. al.*, *Adriaen de Vries 1556–1626*, Rijksmuseum, Amsterdam; Nationalmuseum, Stockholm; The J. Paul Getty Museum, Los Angeles (exh. cat.), in association with Waanders, 1998

Rodin, Royal Academy of Arts, London; Kunsthaus, Zurich (exh. cat.) (London, 2006)

Scholten, F., *et. al.*, *Willem van Tetrode, Sculptor (c.1525–1580)*, Rijksmuseum, Amsterdam; Frick Collection, New York (exh. cat.) (Amsterdam and New York, 2003)

Scholten, F. with Van Langh, R. and Visser, D., *From Vulcan's Forge. Bronzes from the Rijksmuseum, Amsterdam 1450–1800*, Daniel Katz Limited, London; Liechtenstein Museum, Vienna (exh. cat.) (London, 2005)

Stone, R.E., 'Antico and the Development of Bronze Casting in Italy at the End of the Quattrocento', *The Metropolitan Museum Journal* 16, (1982), pp.87–116

Stone, R.E., 'Severo Calzetta da Ravenna and the indirectly cast bronze', *Burlington Magazine*, vol. CXLVIII (Dec. 2006), pp.810–19

Stone, R.E., White, R. and Indictor, N., 'Surface composition of some Italian Renaissance bronzes', *Working Group 16. Resins: Characterization and Evaluation. ICOM Committee for Conservation 1990. 9th Triennial Meeting Dresden, Preprints* (1990), 2: pp.568–73

Wainwright, C., 'A Barbedienne Mirror. Reflections on nineteenth century cross Channel taste', *NACF Review* (December 1992), pp.86–90

Warren, J., *Renaissance Master Bronzes from the Ashmolean Museum, Oxford. The Fortnum Collection*, Daniel Katz Limited, London (exh. cat.) (London, 1999)

Wasserman, J.L. (ed.), *Metamorphoses in Nineteenth-century Sculpture* (Cambridge, Mass., 1975)

Weaver, L., *English Leadwork, its Art and History* (London, 1909)

Medals and Plaquettes

Allen, L.L., *The World's Show: Coincraft's Catalogue of Crystal Palace Medals and Tokens 1851–1936* (London, 2000)

Attwood, P., *Artistic Circles: the Medal in Britain 1880–1918*, travelling exhibition (exh. cat.) (London, 1992)

Attwood, P., *British Art Medals 1982–2002* (London, 2002)

Attwood, P., 'Promoting the Medal in France 1889–1939', *The Medal*, no. 44, (Spring 2004), pp.36–59

Avery, C., *Renaissance and Baroque Bronzes in the Frick Art Museum* (Pittsburgh, 1993)

Beaulah, G.K., 'The Medals of the Art Union of London', *The British Numismatic Journal*, vol. XXXVI, (1967), pp.179–85

Brown, L., *A Catalogue of British Historical Medals 1760–1960* (3 vols) (London 1980–95)

Cordellier, A. (ed.), *Pisanello, le Peintre aux Sept Vertus*, Musée du Louvre, Paris; Réunion des Musées Nationaux, Paris; Museo di Castelvecchio, Verona (exh. cat.) (Paris, 1996)

Coullaré, B. and Desnier, J.-L., *L'essor de la Médaille aux XIXe et XXe siècles* (Wetteren, 2003)

Département des Monnaies. Médailles et Antiques, Le portrait d'autrefois, Bibliothèque Nationale (Paris, 1980)

Dorment, R., *Alfred Gilbert* (New Haven and London, 1985)

Dutton, P., 'The Dead Man's Penny. A short history of the next-of-kin memorial plaque', *The Medal*, no. 29, (1996), pp.30–41

Forrer, L., *Biographical Dictionary of Medallists* (8 vols) (London, 1904–30)

Gunston, I., Powell, F. and Solowiej Wedderburn, D., 'Trialogue', *The Medal*, no. 40, (Spring 2002), pp.78–85

Hawkins, E. (ed.), Franks, A.W. and Grueber, H.A., *Medallic Illustrations of the History of Great Britain and Ireland to the Death of George II* (2 vols) (London, 1885); plates, 18 vols and index, London, 1904–11

Hill, G.F., *A Corpus of Italian Medals of the Renaissance before Cellini*

(2 vols) (London, 1930; reprinted Florence, 1984)

Hill, G.F. and Pollard, G., *Renaissance Medals. Complete Catalogue of the Samuel H. Kress Collection* (London, 1967)

Hôtel de la Monnaie. La Médaille au temps de Louis XIV (exh. cat.) (Paris, 1970)

Hôtel de la Monnaie. La Médaille en France de Ponscarme à la fin de la Belle Époque (exh. cat.) (1967)

Hughes, R. and Rowe, M., *The Colouring, Bronzing and Patination of Medals* (London, 1982)

Jones, M., *Medals of the French Revolution* (London, 1977)

Jones, M., *The Art of the Medal* (London, 1979)

Jones, M., 'The First Cast Medals and the Limbourgs', *Art History* (March 1979), vol. 2, no. 1, pp.35–44

Jones, M., *A Catalogue of the French Medals in the British Museum, AD 1402–1610*, (vol. I), (London, 1982)

Jones, M., 'Medal-making in France 1400–1650: The Italian Dimension', *Italian Medals. Studies in the History of Art*, vol. 21, (Washington, 1987) pp.57–71

Jones, M., *French Medals 1600–1672. A Catalogue of the French Medals in the British Museum*, (vol. II), (London, 1988)

Jones, M. (ed.), *Designs on Posterity: Drawings for medals* (London, 1994)

Leavitt Bourne, M., 'Danuta Solowiej. Traces of Feelings', *The Medal*, no. 32, (Spring 1998), pp.105–7

Le Monnaie de Paris, *Catalogue Géneral Illustré des Éditions* (vols 1–3) (1977, 1978)

Mann, N. and Syson, L. (eds), *The Image of the Individual: portraits in the Renaissance* (London, 1998)

Marx, R., *Les Médailleurs Français Depuis 1789* (Paris, 1897)

Marx, R., *Les Médailleurs Français Contemporains* (Paris, 1898)

Marx, R., *Les Médailleurs Modernes à l'Exposition Universelle de 1900* (Paris, 1901)

Middeldorf, U., *Renaissance Medals and Plaquettes: Catalogue* (Florence, 1983)

Nocq, H., *Tendences Nouvelles* (Paris, 1896)

Powell, F., *Drawn from the Well. Felicity Powell*, Victoria and Albert Museum, London (exh. leaflet) (London, 2002)

Reinis, J.G., *The Portrait Medallions of David d'Angers* (New York, 1999)

Roth, N., ' "Now is the time": Felicity Powell's tribute to John Charles Robinson', *The Medal* no. 42, (Spring 2003), pp.75–82

Scher, S.K. (ed.), *The Currency of Fame. Portraits of the Renaissance*, The National Gallery of Art, Washington DC; Frick Collection, New York (exh. cat.) (New York, 1994)

Scher, S.K. (ed.), *Perspectives on the Renaissance Medal* (New York, 2000)

Solowiej Wedderburn, D., RECALL Contemporary Sculpture with the Sculpture Collection, Victoria and Albert Museum, London (unpublished, 2001)

Syson, L., 'Size immaterial: hand-held sculpture of the 1990s' (exh. cat.), *The Medal*, no. 35, (Autumn 1999), pp.3–32 (also published separately)

Syson, L. and Gordon, D., *Pisanello, Painter to the Renaissance Court* (London, 2001)

Taylor, J., *The Architectural Medal: England in the Nineteenth Century* (London, 1978)

Trusted, M. (ed.), *Pistrucci's Capriccio: A Rediscovered Masterpiece of Regency Sculpture*, Sir John Soane's Museum, London; Waddesdon Manor, Buckinghamshire (exh. cat.) (Salisbury, 2006)

Marble and Stone

Baker, M., *Figured in Marble. The Making and Viewing of Eighteenth-Century Sculpture* (London, 2000)

Butters, S.B., *The Triumph of Vulcan. Sculptors' Tools, Porphyry, and the Prince in Ducal Florence* (2 vols) (Florence, 1996)

Conti, G., Lisanti, V., Mannoni, T., *et. al.*, *Marble in the World* (Carrara, 1986)

Ford, R., *Gatherings from Spain* (introduction by B. Ford) (London, 1970; 1st edition 1846)

Honour, H., 'Canova's Studio Practice I, The Early Years', *The Burlington Magazine*, vol. CXIV, (March 1972), pp.146–59

Honour, H., 'Canova's Studio Practice II, 1792–1822', *The Burlington Magazine*, vol. CXIV, (April 1972), pp.214–29

Montagu, J., *Roman Baroque Sculpture. The Industry of Art* (New Haven and London, 1989)

Rockwell, P., *The Art of Stoneworking: a reference guide* (Cambridge, 1993)

Smith, J.T., *Nollekens and his Times* (2 vols) (2nd ed.) (London, 1829)

Alabaster

Cheetham, F., *Alabaster Images of Medieval England* (Woodbridge, 2003)

Firman, R.J., 'A Geological Approach to the History of English Alabaster', *Mercian Geologist*, vol. 9, no. 3, (March 1984), pp.161–78

Ramsay, N., 'Alabaster', in Blair, J. and Ramsay, N. (eds.), *English Medieval Industries: Craftsmen, Techniques, Products* (London, 1991), pp.29–40

Stone, L., *Sculpture in Britain: The Middle Ages* (2nd ed.) (Harmondsworth, 1972)

Ivory and Bone

Avery, A., *David Le Marchand 1674–1726. 'An Ingenious Man for Carving in Ivory'*, National Gallery of Scotland, Edinburgh; British Museum, London; Leeds City Art Gallery, Leeds (exh. cat.) (London, 1996)

Barnet, P. (ed.), *Images in Ivory: Precious Objects of the Gothic Age*, Detroit Institute of Arts, Detroit; Walters Art Gallery, Baltimore (exh. cat.) (Princeton, 1997)

Caubet, A. and Gaborit-Chopin, D. (eds), *Ivoires de l' Orient Ancien aux Temps Modernes*, Musée du Louvre, Paris (exh. cat.) (Paris, 2004)

Cutler, A., *The Craft of Ivory. Sources, Techniques, and Uses in the Mediterranean World: A.D. 200–1400* (Washington DC, 1985)

Estella, M.M., *La Escultura Barroca de Marfil en España. Las Escuelas Europeas y Las Coloniales* (2 vols) (Madrid, 1984)

Gaborit-Chopin, D., *Ivoires du Moyen Age* (Fribourg, 1978)

MacGregor, A., *Bone, Antler, Ivory & Horn. The Technology of Skeletal Materials since the Roman Period* (London and Sydney, 1985)

St Aubyn, F. (ed.), *Ivory: A History and Collector's Guide* (London, 1987)

Theuerkauff, C., *Die Bildwerke in Elfenbein des 16.–19. Jahrhunderts* (Berlin, 1986)

Wood

Baxandall, M., *The Limewood Sculptors of Renaissance Germany* (New Haven and London, 1980)

Kahsnitz, R. and Bunz, A., *Carved Altarpieces: Masterpieces of the Late Gothic* (London, 2006)

Tångeberg, P., *Mittelalterliche Holzskulpturen und Altarschreine in Schweden. Studien zu Form, Material und Technik* (Stockholm, 1986)

Von Ulmann, A., *Bildhauertechnik des Spätmittelalters und der Frührenaissance* (Darmstadt, 1984)

Semi-precious materials

Babelon, E., *Catalogue des camées antiques et modernes de la Bibliotheque Nationale* (Paris, 1897)

Billing, A., *The Science of Gems, Jewels, Coins and Medals, Ancient and Modern* (2nd ed.) (London, 1875)

Brown, C.M. (ed.), *Engraved Gems: Survivals and Revivals*, Studies in the History of Art, 54, Center for Advanced Study in the Visual Arts (Washington, 1997)

Bury, S., *Jewellery 1789–1910* (London, 1991)

Büttner, A., *Perlmutt. Von der Faszination eines göttlichen Materials* (Petersberg, 2000)

Contadini, A., *Fatimid Art at the Victoria and Albert Museum* (London, 1998)

Dalton, O.M., *Catalogue of the Engraved Gems of the Post-Classical Periods in the Department of British and Medieval Antiquities and Ethnography in the British Museum* (London, 1915)

Distelberger, R., *Die Kunst des Steinschnitts. Prunkgefässe, Kameen und Commessi der Kunstkammer* (Vienna, 2002)

Eichler, F. and Kris, E., *Die Kameen im Kunsthistorischen Museum* (Vienna, 1927)

Furtwängler, A., *Die Antiken Gemmen* (3 vols) (Leipzig and Berlin, 1900)

Hahnloser H.R. and Brugger, S., *Corpus der Hartsteinschliffe des 12.–15. Jahrhunderts* (Berlin, 1985)

Henig, M., *Classical Gems: Ancient and Modern Intaglios and Cameos in the Fitzwilliam Museum, Cambridge* (Cambridge, 1994)

Kris, E., *Meister und Meisterwerke der Steinschneiderkunst in der Italienischen Renaissance* (Vienna, 1929; reprinted 1979)

Kris, E., *Catalogue of the Postclassical Cameos in the Milton Weil Collection on Permanent Loan to the Metropolitan Museum* (Vienna, 1932)

Pazaurek, G.E., *Perlmutter* (Berlin, 1937)

Penny, N. (ed.), *Patronage and Collecting in the Seventeenth Century: Thomas Howard Earl of Arundel*, Ashmolean Museum, Oxford (exh. cat.) (Oxford, 1986)

Raspe, R.E., *A Descriptive Catalogue of a General Collection of Ancient and Modern Engraved Gems...Taken from the Most Celebrated Cabinets in Europe by James Tassie, Modeller* (2 vols) (London, 1791)

Rudoe, J., 'Eighteenth- and nineteenth-century engraved gems in the British Museum; collectors and collections from Sir Hans Sloane to Anne Hull Grundy', *Zeitschrift fur Kunstgeschichte*, 59, 1996, pp.198–213

Sax, M., 'Recognition and Nomenclature of Quartz Materials with specific reference to Engraved Gemstones', *Jewellery Studies*, vol. 7, 1996), pp.63–72

Scarisbrick, D., 'The Arundel Gem Cabinet', *Apollo*, CXLIV, (August 1996, pp.45–8

Scott, J., *The Pleasures of Antiquity: British Collectors of Greece and Rome* (Yale, 2003)

Seidmann, G., *Portrait Cameos: Aspects of their History and Function, Cameos in Context*, ed. M. Henig and M. Vickers, (Oxford, 1993)

Smith, J.P., *James Tassie 1735–1799, Modeller in Glass, a Classical Approach* (London, 1995)

Thompson, L. Beatrice, 'On the Working of Shell Cameos', *The Art Journal*, 1898, pp.277–80

Vollenweider, M.L., *Die Steinschneidekunst und ihre Künstler in spätrepublikanischer und augusteischer Zeit* (Baden-Baden, 1966)

Plaster Models, Plaster Casts, Electrotypes and Fictile Ivories

Baker, M., *The Cast Courts*, Victoria and Albert Museum masterpiece sheet (London, 1982) [available online via the Museum's website]

Baker, M., ' "A Glory to the Museum". The Casting of the Pórtico de la Gloria', *Victoria and Albert Museum Album, I* (London, 1982), pp.100–8

Bankart, G., *The Art of the Plasterer* (London, 1908)

Beard, G., *Stucco and Decorative Plasterwork in Europe* (London, 1983)

Beattie, S., *Alfred Stevens* (London, 1975)

Cellini, B., *Treatises on Goldsmithing and Sculpture* (trans. by C.R. Ashbee) (New York, 1967)

Corradori, F., *Elementary Instructions for Students of Sculpture* (New York, 2002)

Irvine, L. and Atterbury, P., *Gilbert Bayes: Sculptor, 1872–1953* (Shepton Beauchamp, 1998)

Jagger, C.S., *Modelling and Sculpture in the Making* (London, 1933)

Pollen, J.H., *A Description of the Trajan Column* (London, 1874)

Pollen, J.H., *A Description of the Architecture and Monumental Sculpture in the South-East Court of the South Kensington Museum* (London, 1874)

Westwood, J.O., *A Descriptive Catalogue of the Fictile Ivories in the South Kensington Museum* (London, 1876)

Fakes

Fälschung und Forschung (exh. cat.) (Berlin and Essen, 1976–7)

Jones, M. (ed.), *Fake? The Art of Deception*, British Museum (exh. cat.) (London, 1990)

Jones, M. (ed.), *Why Fakes Matter. Essays on Problems of Authenticity* (London, 1992)

Kurz, O., *Fakes. A Handbook for Collectors and Students* (London, 1948)

Natale, M. and Ritschard, C., *L'Art d'Imiter. Images de la Renaissance Italienne aux Musée d'Art et d'Histoire* (Geneva, 1997)

List of artists mentioned in the text

Antonio Abondio 1538–91

Robert Adam 1728–92

Bartolomeo Ammanati 1511–92

Catherine Andras 1775–1860

David D'Angers 1788–1856

Pier Jacopo Alari Bonacolsi, called Antico c.1460–1528

Thomas Banks 1735–1805

Ferdinand Barbedienne 1810–92

Ernst Barlach 1870–1938

Antoine-Louis Barye 1796–1875

Gilbert Bayes 1872–1953

Antonio Begarelli 1490s–1565

John Bell 1811/12–95

Valerio Belli c.1468–1546

Antonio de'Benintendi c.1480–after 1528

Giovanni Bernardi 1494–1553

Gianlorenzo Bernini 1598–1680

Alonso Berruguete c.1488–1561

Sir Joseph Edgar Boehm 1834–90

Pierre Antoine Hippolyte Bonnardel 1824–56

François Bossuit 1635?–92

Charles Brown 1749–95

William Brown 1748–1825

Domenico Brucciani 1815–80

Edward Burch 1730–1814

Agostino Busti, called Bambaia c.1483–1548

Girolamo Campagna 1549–1621

Antonio Canova 1757–1822

Agostino Carlini c.1718–90

Andrew Carpenter c.1677–1737

Francesco Carradorio 1747–1825

Albert Ernest Carrier-Belleuse 1824–87

Edward Carter-Preston 1894–1965

Bertha Gabriella Casella, called Ella 1858–1946

Louise Cornelia Casella, called Nelia 1860–1950

Benvenuto Cellini 1500–71

Benedetto Cervi, also called Pavese active 1500–32

Sir Francis Chantrey 1781–1841

Sir Henry Cheere 1703–81

John Cheere 1709–87

Benjamin Cheverton 1794–1876

Claude Michel, called Clodion 1738–1814

Achille Collas 1795–1859

Linda Crook b.1946

Aimé-Jules Dalou 1838–1902

Jacques-Antoine Dassier 1715–59

Giovanni Dies 1796–1839

François Dieussart c.1600–61

Donatello 1386–1466

Guillaume Dupré c.1574–1642

François Du Quesnoy 1597–1643

Joseph Durham 1814–77

Paul Egell 1691–1752

Philip Eglin b.1959

Gianfrancesco Enzola active 1455–78

Jacob Epstein 1880–1959

Michel Erhart c.1440/5–1522

Etienne-Maurice Falconet 1716–91

Francesco Fanelli 1590–1653

John Flaxman 1755–1826

Peter Flötner 1485/96–1546

Giambattista Foggini 1652–1725

Pietro Francavilla 1548–1615

Richard Garbe 1876–1957

Jean Gaulette active c.1670–1700

Matthes Gebel c.1500–74

Hubert Gerhard c.1550–1620

Giovanni Bologna, called Giambologna 1529–1608

Grinling Gibbons 1648–1721

John Gibson 1790–1866

Alfred Gilbert 1854–1934

Giuseppe Girometti 1779/80–1851

Karl Goetz 1875–1950

Antony Gormley b.1950

Isaac Gosset 1713–99

Friedrich Hagenauer 1490/1500–after 1546

Bernhard Caspar Hardy 1726–1819

Joachim Henne active 1663–1707

Nicholas Hilliard c.1547–1619

Charles Sargeant Jagger 1885–1934
Romain Vincent Jeuffroy 1749–1826
Caterina de Julianis active 1695–1742

Leonhard Kern 1588–1662
Hendrik de Keyser 1565–1621

Edouard Lanteri 1848–1917
P. H. Leader active 1790–1800
Nicolas Leclerc active 1487–1507
David Le Marchand 1674–1726
Pierre Charles Lenoir 1879–1953
Leone Leoni 1509–90
Pompeo Leoni c.1533–1608
Ferdinand Liard active 1880s
Jean and Paul Limbourg active 1390s–
 d.1416
John Charles Lochée 1751–91
Johann Christian Ludwig von Lücke
 c.1703–80

Nathaniel Marchant 1739–1816
Master HL active 1512–30
Quentin Matsys 1465/6–1530
Daniel Mauch 1477–1540
Christoph Maucher 1642–after 1721
Franz Xaver Messerschmidt 1736–83
Percy Metcalfe 1895–1970
Michelangelo 1475–1564
John Everett Millais 1829–96
Ferdinand Eusebio Miseroni 1639–84
Gasparo Miseroni 1518–73
Galeazzo Mondella, called Moderno
 1467–1528
Jakob Mollinarolo 1721–80
Henry Moore 1898–1986
John Francis Moore d.1809
Eley George Mountstephen
 active 1781–91
Hans Multscher c.1400–67
Peter Musson b.1977

Johann Lorenz Natter 1705–63
Henry Nocq 1868–1944

Joseph Nollekens 1737–1823
Nathaniel Palmer active 1829–46
Bartolommeo Paoletti fl.1820
Pietro Paoletti fl.1820
Matteo de' Pasti 1420–after 1467
Samuel Percy 1750–1820
Balthasar Permoser 1651–1732
Germain Pilon c.1535–90
Antonio Pisano, called Pisanello before
 1395–c.1455
Giovanni Pisano c.1245/50–1319
Benedetto Pistrucci 1783–1855
Raffaele Pistrucci 1818–99
Felicity Powell b.1961

Artus Quellin the Elder 1609–68
Artus (Arnoldus) Quellin 1653–after
 1686

Raffaello Sanzio, called Raphael 1483–
 1520
Hans Reichle about 1565/70–1642
Andrea Briosco, called Riccio 1470–
 1532
Tilman Riemenschneider about 1460–
 1531
The Rimini Master active c.1430–50
Andrea della Robbia 1435–1525
Luca della Robbia 1399/40–1482
Nicolò Roccatagliata c.1560–1633/6
Auguste Rodin 1840–1917
James Ronca 1826–after 1908
Domenico Rosselli about 1439–1497/8
Louis Oscar Roty 1846–1911
Louis-François Roubiliac 1702–62
Peter Rouw 1770–1852
John Michael Rysbrack 1694–1770

Jean de Saint-Priest active 1490–1516
Tommaso Saulini 1793–1864
Frédéric Sauvage 1786–1857
Erhard Schön c.1491–1542
Georg Schweigger 1613–90
Ronald Searle b.1920
Philip Senger active 1675–1704
Severo Calzetta da Ravenna active

1496–1543
Abraham Simon c.1622–92
Thomas Simon 1618–65
Mary Slaughter active c.1745
Claus Sluter c.1360–1406
Nathaniel Smith c.1741–after 1800
Massimiliano Soldani-Benzi 1656–1740
Danuta Solowiej-Wedderburn b.1962
Alfred Stevens 1817–75
Nicholas Stone 1586/7–1647
Veit Stoss 1445/50–1533
Hubert Le Sueur active 1602–58
Antonio Susini active 1580–1624
Godfrey Sykes 1824/5–66

Pietro Tacca 1577–1640
Francesco del Tadda 1497–1585
James Tassie 1735–99
William Tassie 1777–1860
Willem Danielsz van Tetrode c.1525–
 before 1588
Jacopo da Trezzo c.1514/19–89
Simon Troger 1683–1768
Pierre Turin 1891–1968
Marie Grosholz, called Madame Tussaud
 1761–1850

Giovanni da Udine 1487–1564
Leon Underwood 1870–1975

Reinhold Vasters 1827–1909
Andrea del Verrocchio 1435–88
Alessandro Vittoria 1525–1608
Adriaen de Vries c.1545–1626

Jean Warin bapt. 1607–d.1672
George Frederic Watts 1817–1904
Christoph Weiditz c.1500–59
Rachel Whiteread b.1963
Lazar Widmann 1699–1769
Leonard Charles Wyon 1826–91
William Wyon 1795–1851

Giacomo Zoffoli c.1731–85
Giovanni Zoffoli c.1745–1805
Gaetano Giulio Zumbo 1656–1701

Index

Illustration plate numbers appear in italic and follow the textual page numbers.